Blender Production

Creating Short Animations from Start to Finish

Roland Hess

Focal Press
Taylor & Francis Group

NEW YORK AND LONDON

First published 2013
by Focal Press
70 Blanchard Road, Suite 402, Burlington, MA 01803

Simultaneously published in the UK
by Focal Press
2 Park Square, Milton Park, Abingdon, Oxon OX14 4RN

Focal Press is an imprint of the Taylor & Francis Group, an informa business

Notices
Knowledge and best practice in this field are constantly changing. As new research and experience broaden our understanding, changes in research methods, professional practices, or medical treatment may become necessary.

Practitioners and researchers must always rely on their own experience and knowledge in evaluating and using any information, methods, compounds, or experiments described herein. In using such information or methods they should be mindful of their own safety and the safety of others, including parties for whom they have a professional responsibility.

Product or corporate names may be trademarks or registered trademarks, and are used only for identification and explanation without intent to infringe.

Library of Congress Cataloging in Publication Data
Application submitted

ISBN: 978-0-240-82145-0 (pbk)
ISBN: 978-0-240-82360-7(ebk)

Typeset in Bembo
by TNQ Books and Journals, Chennai

Contents

Contents

Contents

About the Book

Welcome to the book that used to be called *Animating with Blender*. It's assumed that before you start this book, you know your way around a little. Blender shouldn't be a mystery to you. Neither should animation. If it is, well, we have some books for that too.

In the online archive that accompanies this book [www.blenderproduction.com], you will find all of the production files for *Snowmen Will Melt Your Heart*. If you haven't watched the short-short yet, you will find it on the official site, as well as on Vimeo and YouTube. All of the production files that I have created are released under a Creative Commons Attribution-Noncommercial 3.0 Unsupported license. What that means is that you can use the files themselves – the textures, sets, models, etc. – in your own works as long as you credit the original creator. This also means that you can examine, copy, and redistribute the files in noncommercial ways: as part of a tutorial, a library, etc. Several of the files are CC licensed to other individuals. I have included a document called *licenses.txt* in the production archive that lists those files and their respective licenses.

One of the great truisms of learning a skill is that by the time you've finished a project, you're finally ready to begin it. This will certainly be true of your experience creating your first short animation. I hope this book functions as a bit of a substitute for some of that first-time experience, giving you a better shot than most people at finishing your work. So don't be too hard on yourself during your initial foray into animation. Well, be hard on yourself during production. But when you've put your short animation to bed for whatever reason and have called it "done," take one hard, critical look at the final product so that you can remember the lessons you've learned for the next time. Then forget the pain and bask in your accomplishment, just a little.

I would be remiss if I didn't take a moment at the beginning of this book (Fifth? Fifth!) for a brief thank you. To all of those who have made me, literally and otherwise – to the recently past, the not-so-recently but still always there, the old and the not-yet-old, to my love, to the young ones, and to a special feisty friend – I could fill a thousand pages with Thank You, and it would not be enough.

Chapter 1

An Overview of the Short Animation Process

Creating a Short Animation

Creating a short animation from start to finish is a complicated, time-consuming task. It uses all of the skills you have developed while learning your way around your three-dimensional (3D) software while calling for an even broader range: storytelling, asset and time management, organization, acting, and editing. As you work through the process, you will find that each step necessarily builds on everything that went before, and to shortchange or entirely skip one of the steps will lead, surely, to disaster.

No step in producing a short animation is difficult by itself. Certainly, no individual portion of the short animation process is harder to learn to do than, say, getting the hang of doing back handsprings or integral calculus. The steps themselves are fairly easy. It turns out that the single most difficult thing to do with a short animation is, simply, to finish it. Doing so takes dedication, lots of available time, a willingness to keep pushing through when things are less than fun, and, most importantly, a plan.

Avoiding Death by Natural Causes

No doubt you've seen a hundred animation projects announced on web forums, in chat rooms, and inside cozy little restaurants over too many coffees. Although born with zeal, they slowly fade away into a shadowy death.

Say, why'd that project die?

We're not sure. It just kind of… fell apart.

Oh. "Natural causes," then.

Natural causes, indeed. How do you keep your project from fading into the oblivion of natural causes? You need a plan.

Fortunately, there is a time-honored structure for actually finishing animation projects. It consists of three stages: **preproduction, production,** and **postproduction**. Mysteriously and oddly named, to be sure, but there they are.

Preproduction

Preproduction encompasses everything you do before you touch a single polygon of 3D. Story development, storyboarding, preparing a rough sound track, and assembling a story reel become the bedrock of the rest of your production. The time you spend here will make the modeling, animating, rendering, and compositing worthwhile.

1

Before anything else, though, comes the story. Without a good story, your production will be little more than a study or an extended animation test. A "good" story, though, is not only one that will interest or amuse your viewers, it is one that is producible with the time and resources that you have available. Choose too ambitiously, and you're on your way to "natural causes" before a pixel ever hits the screen.

A good subject for a short animation is more like a short short story (Figure 1.1) than a novel or any of the longer narrative forms. It will grab the viewer's interest, sympathy, or comedic sense almost right away. It will focus exclusively on expressing the theme of the story, or setting up the joke, if that's what you're going for. At

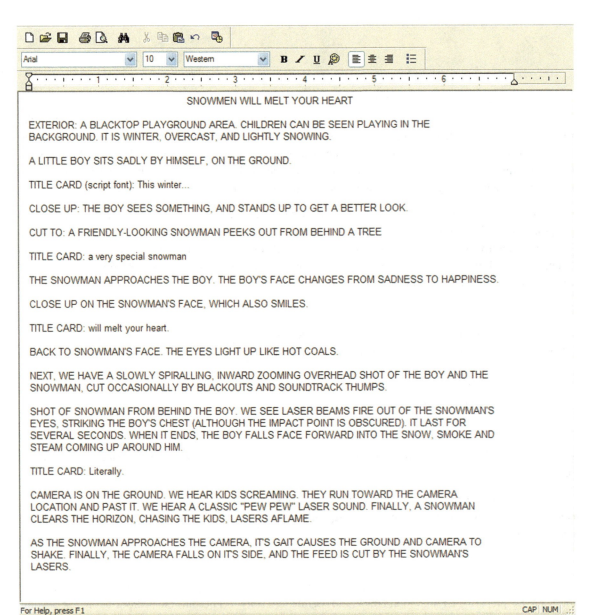

Figure 1.1 *A script.*

Figure 1.2 *Several digital storyboards.*

this stage, it is a balance between your resources and ambition, and you are advised to save the 20,000 character epic battles for later in your career.

Once your story is in order, you proceed to making storyboards. Storyboards are shot-by-shot (and sometimes pose-by-pose) breakdowns of your story, presented in a visual format as seen in Figure 1.2. Usually done as line illustrations, they help to organize your thoughts on how the written story will translate onto the screen. You don't have to be the world's greatest sketch artist to pull off an effective storyboard for your short animation, but the more time you spend on it, the less effort will be wasted later when it's time to actually animate.

With your storyboards in hand (or on a USB stick), you create a simple, very rough sound track. This is most easily done by sitting in front of a cheap PC microphone, speaking all of the dialogue, and making the sound effects with your mouth while you visualize the animation. It's crucial not to let anyone get his or her hands on this rough track, as it will probably be personally embarrassing and most likely cost you any chance of ever standing for political office.

Figure 1.3 *Storyboards assembled with a sound track.*

The temporary sound track is matched to the storyboards, so that it forms a primitive version of what will someday be your masterpiece (Figure 1.3). This rough representation of your animation is called the **story reel**. It will be the bible for the rest of your production.

Production

Now you get to do all the things you were aching to do from the start of the project: character design (Figure 1.4), construction (Figure 1.5-1.6), and, if you're a masochist, rigging (Figure 1.7). The process of modeling and rigging your characters reaches both backward and forward in the production process. It is informed by the themes of the story but bows to the requirements of animation and, later, to the minimization of render times.

At this point, lead character modeling can be finished, but as long as you organize your project properly and use the correct tools, things don't need to be completely finalized before animation begins. Unlike creating still images, surfacing (materials and texturing) can be skipped almost entirely at this stage.

With a good start on your characters, you set up your control rigs. This is the first place that good storyboarding pays off. You build and test your rigs to the specific actions your characters will take. It could be that one character never gets out of his or her seat—in that case, you can skip Inverse Kinematic leg controls. It could be that another character's face is never really seen—in this case, you can skip facial animation controls. By looking at who does what in your storyboards, you can decide what sorts of controls each character is going to need. Of course, you could spend several months creating a brilliant all-purpose rig for each character, but it would only be a waste of time, both now and later when the calculation of every bone takes its toll on render times.

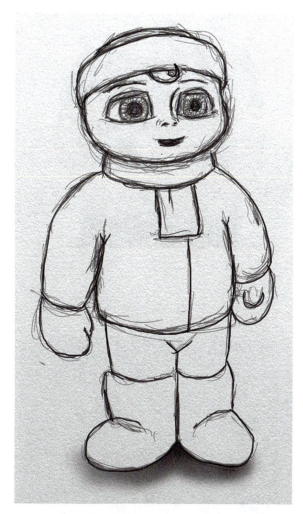

Figure 1.4 *Character sketch.*

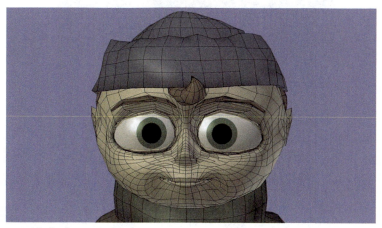

Figure 1.5 *Wireframe model of a character.*

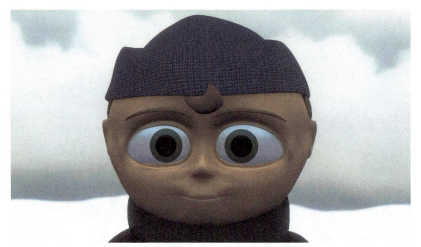

Figure 1.6 *The rendered character.*

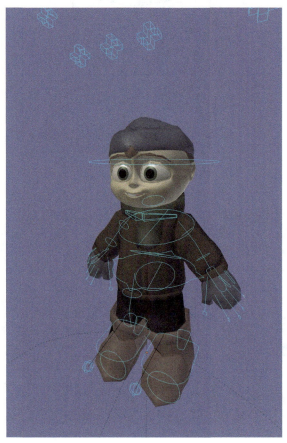

Figure 1.7 *A control rig and mesh for a character.*

Figure 1.8 *A roughed-in set, consisting of placeholder blocks.*

Along with the characters, you build rough sets, as in Figure 1.8. Really, all you need at this point are place-holders for final set elements—boxes that represent chairs, rocks, or statues of Abraham Lincoln. Whatever your animation needs.

When characters and rough sets are created, you can begin to build scenes, one file per shot from the storyboards, trying your best to match camera angles and composition in your 3D scenes to the images in the storyboards (Figure 1.9). You may find that certain things you had drawn for the storyboards don't work out so well when you have to re-create the scene in an environment that enforces the laws of size and proportion. In those cases, you can adjust your composition on the fly, or, if the change is drastic, rethink that part of the scene and redraw the storyboards.

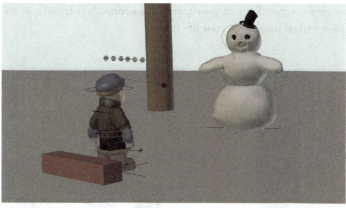

Figure 1.9 *A blocked scene featuring characters and a rough set.*

At some point during the character creation and rough set portion of the production, you need to obtain a quality recording of any dialogue that may occur in the animation. Environmental sounds will be filled in afterward, but any quality character animation that must accompany the spoken word needs to be built correctly from the beginning.

Only then, after weeks (or months) of buildup and work, do you actually get to animate. The best way to accomplish this stage is to lock yourself away from the rest of humanity so they won't see you obsessively performing the same intricate hand motion over and over in order to learn *exactly* how the fingers flare and

Figure 1.10 *A character during the animation process.*

in what order and position they come to rest when your character performs a specific motion. It's also better if no one sees you doing the silly walk that your character needs to perform, around and around and around. Regardless of the level of self-ostracism you choose, the process of animating will require time and patience. It may also require that you go back and adjust your models and rigs. If you've done things correctly, though, if you've followed the plan, this sort of minimal backtracking will not hurt the production (Figure 1.10).

As you complete the animation for each shot, you get to do what is probably more fun than any other single part of the process. You put your animated version of each shot back into the story reel, covering up the relevant portions of the storyboards, like Figure 1.11. With each new shot you finish, the story reel evolves from a series of still images into a moving compendium of your animation genius. And frankly, at this point you hope it's genius, because you'll have soaked months of your life into it.

Figure 1.11 *The story reel with several shots in place.*

After the final shot is animated, and you can stand to watch the whole full motion story reel without wincing too frequently, you finish the sets, surfacing, and lighting. Of course, what you do with the sets and lighting can be helped along by the storyboards and a careful analysis of the current state of the story reel. Just like rigging, you could spend a nearly infinite amount of time creating beautiful, detailed surfaces for every element of your imagined set. But it could be that only certain items and spaces that appear in close-up need that level of attention. Some things might appear at a distance, or only briefly, or may be moving so quickly that they are smudged by motion blur, and those elements can be given an appropriately smaller slice of your time.

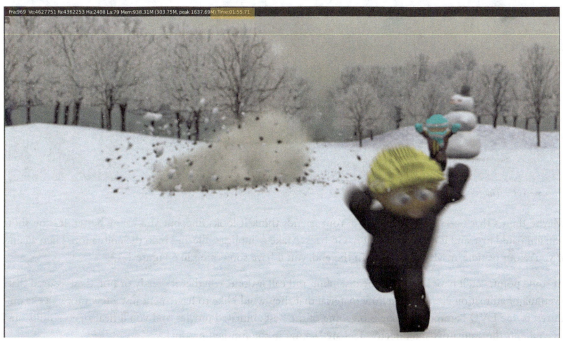

Figure 1.12 *Render time for a single frame out of thousands.*

And then, once you've surfaced, built, and lit appropriately, you render. Go get a cup of coffee. This is going to take a while (Figure 1.12).

Postproduction

So you have gigabytes of rendered frames that must be compiled into a final animation. You bring them into an editor that is designed for cutting audio and video sequences together. You watch it over and over, adjusting the timing of the cuts between the different shots so that the action seems to be continuous throughout, even though it probably isn't.

When the timing is right and the animation does exactly what you want it to do, you raid the kitchen and the garage for anything that will make noise. Turn on a microphone and act out the shots, trying to sync your noisemaking with what happens on the screen. Get a friend to help you, if you have any left. Find some music that suits the theme of the story and approximates the running length of the final cut.

Put the sound effects and music on top of the dialogue track you recorded earlier, and you are... finished?

Maybe.

Figure 1.13 *The editor with final shots in place.*

Maybe there's that one shot that bugs you. Your friends think it looks fine, but you know better. It's the shot you animated first, and it just doesn't cut it. Go back. Make a duplicate file and redo the animation. Then again, if you're out of time, maybe you won't. In the end, you'll have something like Figure 1.13.

At some point, you'll have to exert some discipline and call it done, whether it's ready or not. Rest assured that even major animation companies release material that they would like to have spent just a few more weeks on. Listen to the DVD commentary tracks on some of the best animated movies, and you'll hear open admissions of elements the animators and directors feel are lacking in the finished product.

The Importance of Following the Workflow

All of that was just the barest overview. It should be obvious that creating a decent short animation is a very specific and involved process. However, should you find yourself thinking, *Oh, well, I can just skip that step! What could possibly go wrong?* here is a brief list of what, exactly, could go wrong:

Problem: No story.

What happens: The animator begins by fully modeling detailed props and characters. The project has no direction and never passes the modeling stage. Doom!

Problem: Too much story.

What happens: After the third year of the project, you begin to think that you should have concentrated on the character of Pecos Rose, instead of her 14 sisters. Disaster!

Problem: No storyboards.

What happens: Without storyboards to guide your shot breakdown and composition, you waste countless hours/days/years of your life animating actions and creating and detailing elements that will never see a final render. Also, the vision of the story is created on the fly, which can lead to narrative and visual dead ends and more wasted work. Peril!

Problem: Creating detailed sets and surfacing before animation.

What happens: Much work is wasted, because things inevitably change during animation. That entire set of kitchen knives you painstakingly modeled and textured (with little food bits!) were part of a shot that was cut because the animation just didn't turn out well enough. Shame!

Problem: Poor asset organization.

What happens: You put weeks into a complex shot, then realize that you used the wrong versions of the set and characters, meaning that you either completely redo the entire thing or have it stick out in the final production like a line drawing at a Monet impersonator convention. Horror!

From these few examples, it may be apparent to you that most of the really crushing problems will come from skipping or short changing the preproduction steps. And really, if you've done the preproduction properly, you're not going to skip any of the normal production or postproduction steps.

Summary

The short animation process is a time-tested set of steps that, if followed, will help you to see your animation project through to completion. The process involves an extended preproduction phase, during which you develop the story and work out the overall timing through the creation of storyboards and a story reel. The production phase finds you working directly in your 3D application, building models and sets and actually performing the animation. Finally, postproduction is where you render your work and composite and edit it into a final animation.

The greatest mistake committed by first-time producers, and the one that will certainly kill a project, is to jump into the production phase without adequate preparation. Without a producible story and the planning provided by good storyboards, so much time will be wasted that the project will never see a successful end. Skipping the preproduction process is like furnishing your house before you draw up the blueprints, lay the foundation, and build the walls. It might seem quick and easy to put the decorative items into place, but it will almost certainly turn out poorly in the long run.

Although the workflow as presented in this book has its idiosyncrasies, it follows a proven formula. To ignore this formula is the animation equivalent of criminal negligence, and if you do it, I promise you that a bunch little key-framed lawyers will show up at your house, exhibiting crowd-simulated swarming behavior and waving tiny digital court documents in the air.

On the other hand, if you follow the steps and keep yourself focused on the process, in the end you will have something that few other people have accomplished: a successfully completed short animation project.

Chapter 2

Story Story Story

Objectives in This Chapter

- Determining what makes an engaging story.
- Writing it down.
- Evaluating your story scope, your resources, and reality.
- Answering the question, how long is my story?

If you don't have a good story, you will not have a successful short animation.

Of course, "good" could mean a lot of things. In the context of animation production, it means, specifically, both "engaging" and "producible."

It's not a shocker to hear that a story must be engaging, but the need is magnified when you are dealing with the limited run length of a short project. With only a couple of minutes of the viewers' attention available, you have to grab them right away, make your point quickly, and not stray from the theme.

That said, a weak story will not kill your production. An unproducible story, however, will. But as the "producibility" aspect involves every artist's favorite topic—math—we'll save it for last. On top of that, this chapter is light on illustrations and heavy on copy, so you visual types should prepare to exert some self-discipline right now and work your way through to the end. It will be a good exercise, as the ability to keep going even though you would rather not will be invaluable to your project in the coming weeks.

What Makes an Engaging Story?

The short animation format does not leave much room for traditional story development. Time is extremely limited and, as we will see later in the chapter, costly. Therefore, the story must do its job quickly and without extraneous elements. You will, essentially, be creating a visual short story.

The late author Roger Zelazny, a prolific writer of short stories, once said that his short stories were born either from a **plot**, a **character,** or an **image**. Sometimes an idea for a character is so resonant that you find yourself wanting to put him or her into every storyline you can think of. Other times, the plot will come first—a situation of interest that you just can't shake. And then, in a way that is probably already familiar to you as a digital still artist, a single image grabs you—a framed picture of a situation and characters in action. Any of these can be used to begin the story-building process, but the best finished products will include all three.

Plot versus Character

In many weaker stories, the *plot* defines the *character*. Much more difficult to do, though, is to have the characters drive the plot. Your characters will be put in different situations (though in a typical short animation there is probably only enough time to deal with one major situation), and the details of their characters should cause them to act in certain ways. Those actions will have consequences, which will cause other characters (possibly) to make choices, until a conclusion is reached. If you find that you have a plot before you have characters, make sure that the characters you eventually settle on fit the decisions they seem to make that drive the plot.

For example, if your plot requires someone to make clever, perceptive deductions for the action to progress, don't choose a "school bully" to fill that role. It wouldn't fit. If you choose an appropriate character, it may suggest other details that help you strengthen and continue the story.

Be careful, too, with a "plot-first" story that there will, in fact, be a character who can fit the role. If your plot requires a character to react with extreme anger in several situations, then to be instantly happy and instantly sad, you may have a problem. There are not many believable characters who would act that way (although a few spring to mind), making it tough to create an engaging story.

However, if you created the characters before the plot, the choices that they make will often lead the plot in directions you had never intended. This is actually okay and will often lead to a stronger story in the end. Remember, *character* drives *plot,* while at the same time a well-constructed plot will help a character to change in return.

A well-developed short story that is appropriate for animation will also include a **hook**, a **theme**, and a **turn** (sometimes called a "twist"). We'll discuss each of these essentials, as well as the previous three elements, as we look at how the story for *Snowmen* evolved.

Note
Plot, character, and an image—although the animation and mechanics of the story will make your project *watchable*, taking the time to get these three right will make it *memorable*.

The story for *Snowmen* was originally suggested by a decorative sign that I saw hanging in my own home. It read, "Snowmen Will Melt Your Heart." That's pretty cheesy in my book, and, of course, my mind wandered to a more literal interpretation than the one that was clearly intended. Here was my initial idea:

> A little boy sits by himself in the snow. A snowman walks up to him. The boy is filled with wonder.
> The snowman shoots lasers out of his eyes and literally melts the boy's heart.

I had no great aspirations for the story beyond being a simple thematic and visual gag. It looks and feels at first like some gooey, inspirational Christmas animation, but it turns into a story about children being destroyed by laser beams. Hopefully, I'll be able to pull it off for laughs, falling into the dark humor category, as opposed to simply being dark and horrible.

Note
Don't be afraid to change your story to make it better. Your characters, your plot points, your images—show them no mercy. Sometimes a story will evolve while you refine it to the point where it resembles almost nothing from the original idea. That is okay, as long as the whole thing still lights enough fire in you to pursue it as an animation project.

At this point, you have to let your creative instincts wander a bit. Talk the story through with some friends. Listen to them when they say, "Wouldn't it be a blast if…" or "Wouldn't it be awful if…" and let their ideas point you in new directions. Not every direction is equally valuable, though. What you are trying to do is to find a storyline that will help to develop a **theme**.

The theme of a story is sometimes seen as "the point of the story," but that's a simplification. A story's theme is its entire reason for being. The theme gives you hints about how events in the story should develop and what sorts of details should populate your world. To put it into terms a 3D artist can appreciate, the story itself is the 3D model, and the theme is a lamp. The lamp can shine on the model from different directions, with different shading and shadowing characteristics, and with different colors and patterns. Although the objects remain the same, different lighting will produce completely different effects for the viewer.

Even though *Snowmen* is pretty much a one-joke story, it still needs a theme. If I'm not being ironic about it, the theme is that sometimes life is just tough (you can be lonely), and if something seems too good to be true (a snowman wants to be my friend!), it probably is. When really distilled, it's a "don't talk to strangers" cautionary tale.

This isn't the most original idea in the world, but when it comes to theme, originality isn't important. There are a finite number of themes in fiction. What matters is your presentation and execution. An old story told well is significantly better than a new story told poorly.

With a theme in hand, many of the details and plot points began to arrange themselves. I could have taken it a straight and very dark route. That would be easy, but pointless. A kid is sad. A snowman kills him. That's actually pretty horrible and entirely lacking in appeal. To raise the appeal but maintain the theme, we can try to inject some humor into it. Making it a satire of the traditional uplifting holiday TV animation special will allow me to get away with much darker material than I normally would attempt, and the theme still comes through.

For many animations, and for your first project, a surprise will work nicely for the **hook**. Make the audience think one thing for a moment, then show them something different. I'm not talking about an *Aqua Teen Hunger Force* style non sequitur. Instead, it often works to show the viewer something brief that sets up one expectation but delivers something different, as long as that delivery still makes sense. People like to be pleasantly surprised.

In *Snowmen*, however, the hook is straightforward: the cuteness of the little boy and his sad plight attempt to immediately garner the viewer's sympathy. Whatever you choose, though, it needs to grab the viewer right away.

The **turn** is the punch line of your comedy. It is the last, ironic revelation of your tragedy. It is the final, horrible fate of your gothic horror. It is the resolution of your person versus the universe tragic-horror-comedy.

Snowmen's turn is obvious. Laser beams + heart. From there, it's all downhill, at least for the kids on the playground. Your turn might be more complex than that, but it should in some way give satisfaction to the characters, the action, and the theme, all at once. Creating the proper turn for your short animation story will probably be the most difficult part of the story creation process. There are certainly a lot of constraints to meet. In this case, the turn satisfies the needs of the character (he's no longer lonely), the theme (punishment for talking to strangers), and the action (laser beams!).

If you can't come up with something that satisfies your sense of the story, here are questions to ask yourself that can spur some new ideas:

- Are your characters' decisions driving the action, or are they merely tossed around by circumstance? If character-based decision drives the action, then ask yourself how the characters would resolve things

if he or she were creating the story. If your characters' decisions do not drive the action, then consider "circumstance/the universe/fate/God" to be a character, and ask it the same question.

- Tell someone else the story without delivering a conclusion. Act as though you have a conclusion but want the other person to guess what it is first. This seems underhanded and might feel like cheating, but you may be missing something obvious because you are so absorbed in the details. Or your friend might just be a better storyteller than you and deliver a great idea. If that's the case, be sure to credit your friend on the finished product.

- Act out the story (in a room with a lock, preferably), taking the place of the character most able to take action just before the turn. When it comes to that point, what do you feel you should do? Try it again, but act out the part of another, less powerful character and see if it suggests a new course of action.

- If your story is a tragedy/sad, try giving your character what he has been striving for, but in an unexpected way that makes the character wish he had not accomplished his goal. If your story tends to comedy or the lighter side, stick your character with whatever fate she has been trying to avoid, but have it be pleasantly and unexpectedly rewarding.

Sometimes, no matter what you do, you cannot find a satisfying turn or conclusion to your story. This is a sign that you have missed something earlier in the process. Are your characters acting consistently in character? Are there actions, characters, or ideas involved that do not support the theme? If so, it is time to take a step back and begin to rework the story.

- Make sure that characters are consistent. Although complex characters that change gradually throughout the tale are a hallmark of good long-form fiction, you just don't have the time here. Although a character can contain interesting contrasts, she should always act in character.

- If there are elements of the story—actions, characters, or ideas—that do not support the theme, either change them or get rid of them. As I mentioned earlier, have no mercy. They are there to hurt your project.

One last possibility is that you are just telling the wrong part of the story. Most likely, the story is bigger than the part you are telling. If the story of *Snowmen* with all of its relevant information were ordered purely chronologically, it would go like this:

Thousands of years ago, beings from another planet created killer robots and sent them to invade the Earth. Because they like things that are round, and because they like things that are white, they coincidentally designed the robots to look like snowmen. They lay dormant for all that time, waiting for the opportunity to attack. In the present day, a little fellow named Emmit had moved to a new school and was having trouble making friends. Winter came, and he was still left out on the playground. The playground was built near one of the hiding places for the robots that look like snowmen. One day, one of the snowmen received the signal to awaken and begin its rampage. Emmit was its first victim. A great war ensued. Eventually the snowman-like robots were destroyed, but not before humanity had learned a valuable lesson.

Notice that the actual action as presented in the animation only makes up about two of the eight sentences of that summary. The story as presented above is called the **objective storyline**. It is objective because it is the overall, fully encompassing view. It is the story as your Deity of Choice would see it. From the entire time span of that objective storyline, a single incident was chosen to demonstrate the theme. That story as presented in the animation is called the **subjective storyline**.

Your story is most likely a subjective story. Think for a moment about what the objective story is. How does the story you are trying to tell look in the greater context of the character's existence? Could the theme have been better demonstrated by an entirely different situation or incident? Or, more easily, did you choose the best part of the story to tell? What about the two minutes before or after the portion you chose to tell? Sometimes, refocusing on a slightly different portion of the objective storyline can make the difference in finding the right turn and creating a fully satisfying story.

If you can pull together a good character, plot, and image, unify them with a strong theme, grab your viewers with a hook, and satisfy them with a well-crafted turn, then you have a story worth slaving over for the next several months.

Writing It Down

With the story taking shape, your should write it down, if you haven't already. Although actually writing the story down is not completely necessary for such a short, visual production, it can help to give form to your thoughts and provide a good reference for later steps.

Stories that are destined for film or video are usually written in **screenplay format.** To bother with the entire format for this limited production won't really be useful, so we'll borrow some elements from it but strip it down to suit our needs. Here is the final script of *Snowmen* so you can get a look at the format:

SNOWMEN WILL MELT YOUR HEART

EXTERIOR: A BLACKTOP PLAYGROUND AREA. CHILDREN CAN BE SEEN PLAYING IN THE BACKGROUND. IT IS WINTER, OVERCAST, AND LIGHTLY SNOWING.

A LITTLE BOY SITS SADLY BY HIMSELF, ON THE GROUND.

TITLE CARD (script font): This winter...

CLOSE-UP: THE BOY SEES SOMETHING AND STANDS UP TO GET A BETTER LOOK.

CUT TO: A FRIENDLY LOOKING SNOWMAN PEEKS OUT FROM BEHIND A TREE.

TITLE CARD: a very special snowman

THE SNOWMAN APPROACHES THE BOY. THE BOY'S FACE CHANGES FROM SADNESS TO HAPPINESS.

CLOSE-UP ON THE SNOWMAN'S FACE, WHICH ALSO SMILES.

TITLE CARD: will melt your heart.

BACK TO SNOWMAN'S FACE. THE EYES LIGHT UP LIKE HOT COALS.

NEXT, WE HAVE A SLOWLY SPIRALING, INWARD ZOOMING OVERHEAD SHOT OF THE BOY AND THE SNOWMAN, CUT OCCASIONALLY BY BLACKOUTS AND SOUND TRACK THUMPS.

SHOT OF THE SNOWMAN FROM BEHIND THE BOY. WE SEE LASER BEAMS FIRE OUT OF THE SNOWMAN'S EYES, STRIKING THE BOY'S CHEST (ALTHOUGH THE IMPACT POINT IS OBSCURED). IT LASTS FOR SEVERAL SECONDS. WHEN IT ENDS, THE BOY FALLS FACE FORWARD INTO THE SNOW, SMOKE AND STEAM COMING UP AROUND HIM.

TITLE CARD: Literally.

CAMERA IS ON THE GROUND. WE HEAR KIDS SCREAMING. THEY RUN TOWARD THE CAMERA LOCATION AND PAST IT. WE HEAR A CLASSIC "PEW PEW" LASER SOUND. FINALLY, A SNOWMAN CLEARS THE HORIZON, CHASING THE KIDS, LASERS AFLAME.

AS THE SNOWMAN APPROACHES THE CAMERA, ITS GAIT CAUSES THE GROUND AND CAMERA TO SHAKE. FINALLY, THE CAMERA FALLS ON ITS SIDE, AND THE FEED IS CUT BY THE SNOWMAN'S LASERS.

Just for kicks, Figure 2.1 shows the script for *Snowmen*, typed into Blender's text editor.

All you need is a title, stage directions, and dialogue. The division of the stage directions is a bit arbitrary but is analogous to paragraph breaks in standard writing: each little group of stage directions should represent a unit of action. If you are already visualizing how this will look in 3D, those divisions will occur naturally and often represent camera cuts in the final production.

One thing you might notice is the absence of all of the theme elements we discussed previously. Traditionally, a screenplay has been a common reference for the actors and director, and although some writers like to put certain details of set and action that support the theme directly into the script, it is not necessary. The art direction, the actual content of the action, and even the way the actors perform are all managed by the director whose creative vision and sense of theme will make or break the production. As you are the writer, producer, director, and "actors" of your production, communicating such details through the script is unnecessary. Of course, if you have any particularly good ideas that you don't want to forget, you can always include them. The script is a living document that is always available for revision, inclusion, or omission.

Figure 2.1 *If you want to go 100 percent Blender, you can write the script in a text editor window.*

Story Scope, Your Resources, and Reality

You've really sweated over your story so that it works in all the ways we discussed in the previous section. There is another pitfall, though, that could send you back to square one: producibility. Whether or not you can turn that story into a finished animation will be a competition between the combined might of your personal discipline, available time, your skills as an artist, and the unholy alliance of distractions, the desires for sleep and human companionship, and the mountains of work that lay ahead.

So it is a good idea to make sure that you actually have a shot at completing this task. How much time will it really take? Although I cannot tell you that doing *this* or *that* will take exactly *x* or *y* hours, I can say that the work that you face will be a function of several distinct factors: the number and complexity of sets and characters that appear in the animation; the number of special effects like water, hair, and cloth; and the actual amount of time that each character is animated.

If you haven't done so already, watch *Snowmen* on the website. Not counting the credits or the still images at the beginning and end of the animation, the amount of "live" time for which animation was required is around one minute. The story features two characters: Emmit and the snowman. Although there are a number of children in the backgrounds, their animations are built up from libraries of actions. Mostly, though, each shot focuses on a single character. For effects, you see falling snow, laser beams, smoke, and some flying debris.

Think about your resources. Are you working by yourself or with a partner or small team? Remember, you (or your team) will be responsible for every aspect of the production: storyboarding; the modeling and surfacing of all characters, sets, and props; the rigging, skinning, and animation of all characters; rendering and compositing; sound; and final editing. Think about the longest amount of time you've spent on a single project prior to this. Three months? Six?

If you've never worked on a short animation project before, here's a suggested scope. It will give you a nice finished product, provide a little room for narrative structure, but minimize some of the more difficult aspects of the process:

* One character
* One location
* No/minimal dialogue
* No/minimal effects

As everyone works at different speeds and has different amounts of time available for work, it's not really possible to know how long such a project would take you in absolute terms. It is possible, though, to make a guess and to see how the inclusion of additional elements can affect the overall scope.

For example, let's say that a short animation that met the preceding specifications was going to take something like 300 hours of work to complete. That time would roughly break down as follows:

* Story/storyboarding: 20 hours
* Character creation, modeling: 20 hours
* Rigging, skinning, and animation testing: 20 hours
* Rough set creation: 10 hours
* Main animation: 100 hours
* Final sets and props: 40 hours

- Final surfacing and lighting: 40 hours
- Compositing/editing/sound effects: 50 hours

Those estimates don't include render time, because we're just counting the time you actively have to spend in front of the computer.

Now, we're going to do some math. If you're coming at short animation production from the artistic side, you may want to grab your uncle the accountant to help you.

Scope Example: Adding a Second Character

Adding a second character to the suggested scope will cause the following change: both character creation and rigging/skinning/testing times will double. Time spent on final surfacing will only go up a bit, say, by 10 hours, because only a quarter of the original time was going to be spent on the single original character. Main animation time, however, will only go up based on the percentage of time that both characters appear in a shot at the same time. If the running time remains the same and the scenes constantly cut between separate shots of the two characters, you will only be animating each character for half the time. On the other hand, if the characters spend 80 percent of the time in a shot together, you will be doing 80 percent more animation work. For this example, let's say that through judicious storyboarding and editing, the additional character will only appear with the original during 30 percent of the running time. This means that the main animation phase goes from 100 hours to roughly 130 hours.

The result of adding a second character to our story of limited scope is to create an extra 80 hours of work, a little more than a 25 percent increase. If you estimated that the project would take six months to begin with, it will now take closer to seven and a half.

Scope Example: Adding a Second Location

A second location or scene means the creation of an additional set and props. Although careful planning can let you reuse some of the elements from the first set, the odds are that you are creating a separate location to provide contrast, and therefore you will be creating most of its assets from scratch. In that case, double both the rough set and final set and prop creation times. Also, non-character-related surfacing and lighting will also double.

A fully realized second scene or location will add another 80 hours onto the project.

Scope Example: Adding Length

For one last example, assume that you will not be able to adequately tell your story within one minute. Your storyboards and rough sound track work much better at the 90-second mark—a 50 percent increase. With all other factors staying the same, how does that affect the workload? Main animation, storyboarding, compositing, and editing times will all increase in direct proportion to the running length. Based on the preceding estimates, this equates to an increase of 85 hours of working time.

Of course, all of these changes reinforce one another. Using the original estimate, adding a second character, another location, and 30 more seconds of animation would result in an additional 285 hours of work—almost doubling the original scope of the project! Obviously, it is important to maintain command of the scope of your story before it gets out of control. It is equally important to realize that removing unnecessary elements can significantly reduce the amount of work you will have to do.

How Long Is My Story?

It's easy to count characters, sets, and effects ahead of time, but it can be harder to guess the actual length of the final animation. The simplest way to do this is to act out the story in real time.

To get the best estimate, outfit yourself as closely as you can to match the characters and events of the story. If your story is about intelligent alien space probes squabbling over who gets to keep the moon, then grab a couple of spaceship toys and a ball. If you're doing a simple man-versus-nature story about someone who gets attacked by a mountain lion while walking in the forest, get a pair of boots and a stuffed animal. If you're doing a story about a killer snowman, *do not* dress up like one and threaten the neighborhood children. I'm just saying.

With that done, find a clock with a second hand and act the thing out. Say everything that is said. Do any sound effects with your mouth. Adding the sound will help you to keep the timing real. It's easy to make things go too quickly or slowly in your head, but actually doing the things and hearing them will exert a normalizing force. Try it through three or four times and see what the clock says. As long as you are getting fairly consistent results, you can use this time as a good guess at the length of your animation.

> **Note**
> As you act out the story, you might realize that something about it that seemed good on paper or in your head just doesn't work. That's okay. Of course, it means that you have to go back to the story stage again. Hopefully, it will be a simple fix that you can work out as you act, but if you need to take the buzz saw to the story, don't be afraid. Any time you spend now getting things right will be given back to you later when you successfully finish the project. You will thank the Lords of Animation that you followed the correct procedure and didn't discover these problems after 200 hours of animation.

Summary

Creating a satisfying story that is appropriate for a short animation can be difficult. The best stories have a memorable character and plot and iconic imagery. From the perspective of storytelling mechanics, you need to have a unified theme, as well as a hook and a turn. The choices your characters make will create the plot, and the theme watches over everything, which adds depth to actions and details.

The story must also be within your capabilities to translate into the short animation format. Overly ambitious stories with many characters, sets, and effects can easily overwhelm a lone or small group of animators. Keeping a handle on the length and scope of the story and whether or not it is producible is just as important as having an engaging story to begin with.

It cannot be emphasized enough that it is far better to show the world a rough-around-the-edges animation with a great story than a short full of amazing effects and a subpar storyline—or worse still, a great looking project that never gets finished.

Chapter 3

Organization

Objectives in This Chapter
* Identifying your digital assets.
* Understanding the way that Blender handles assets.
* Reviewing a suggested organizational structure.

Your Digital Assets

By the time you are finished with your short animation, you could have dozens of production files and thousands of rendered frames to keep track of. If you don't approach file management with a plan, you will almost certainly end up rendering the wrong version of some file or, worse yet, accidentally saving bad files over good ones, which can potentially ruin weeks of work.

The digital assets of your project will consist of storyboards, sounds, models and rigs, sets and props, materials, textures, animation, and renders. Although we will be extending the way that those assets are organized with each chapter, it's important to begin with a good baseline and an understanding of how Blender locates and deals with them.

The Way That Blender Handles Assets

Blender sees any asset, whether it is a texture, a set, or a sound clip, in one of three ways:

* *Local.* Local assets are contained directly within a particular BLEND file. If you've only worked with still images or very small projects so far, the odds are that you've been working entirely with local assets. Blender does not need to go looking on the disk for them. If you have the BLEND file loaded in Blender, the assets are self-contained. You would use very few local assets in a typical short movie project.
* *Absolute.* Absolute assets are not contained in the BLEND file itself but are assets that Blender references by way of an absolute disk path. An absolute path is one that contains, for example, the entire drive and directory structure, including the filename of the asset. If you are using a Windows-based computer and you have a texture image file in your **My Pictures** folder, the absolute disk path would look something like this:

C:\Document and Settings\User\My Documents\My Pictures\texture.png

As you will learn later, assets from one BLEND file on disk can be linked to another, just like a texture or sound file.

• *Relative.* Relative assets are treated in the same way as *absolute* assets, except that the disk reference is a little more complex. Instead of referring to the asset by an absolute disk path, the *relative* method creates a path based on how to get to the referenced file from the active BLEND file. In Figure 3.1, you see a directory structure with a BLEND file called "cliff.blend" finding a path to a texture image file. There is a standard code for writing relative paths: a move to the left is represented by two periods (".."), whereas a move to the right is shown with a forward slash and a directory name ("/dir"). In Figure 3.1, the relative path of the texture image from the BLEND file is "../../textures/rock/granite. png"—as you have to go two steps to the left, then right through both the "textures" and "rock" directories.

> **Note**
> I am using Windows-style path notation in the book, but you should be familiar with your operating system's method of writing paths and use it accordingly.

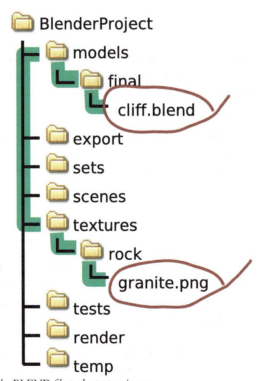

Figure 3.1 *A relative path from the BLEND file to the texture image.*

Almost all of the assets in your project will be created in individual files, which will be brought together by relative linking. It's not important that you know how to do this yet or that you know the specifics of path construction, but it is important for you to understand the value of organizing things properly from the beginning.

If you were going to model, texture, and animate the entire production in a single BLEND file, it would not only be huge—because of production issues, it may turn out to be impossible. For that reason, using local assets will not work. To streamline production and render times on anything but the simplest of projects, you will have many scene files, and they will need a way to efficiently reference the same set of assets.

Using absolute disk paths will work if you plan to never move the project from the hard drive on your own computer. However, if there is a possibility that you may want to work on the project in more than one location or that you may someday archive the production files to disk and want to resurrect them in the future, you must use relative paths. Fortunately, Blender defaults all file links you create to use relative paths. Relative paths make your project much more flexible and less likely to suffer a failure at some point in the production's future.

A Suggested Organizational Structure

Figure 3.2 shows a good way to organize your work.

- *Export.* You will probably want to send out test renders to friends or post animation clips and other in-production materials to the Internet or your local network. Having an export folder is a good idea, because you will always know where to look when you need to send an asset out.
- *Models.* All of your model files go here. Each main object, like a character or a major set piece, will have its own separate model file. If you are going to have large numbers of characters, sets, and props (but you're not, right?), you can create subfolders for each of them. What you want to avoid is a list of model files that you have to scroll through several times to find what you need.
- *Renders.* This folder is for rendered images and animations. Within the render folder are subfolders for the files associated with each individual shot. Within those, you will have additional subfolders for **raw** renders and **composite** frames. Also in the **renders** folder will be a folder called **quick**, which contains low-resolution animation files for each shot, good for intermediate use in your story reel.

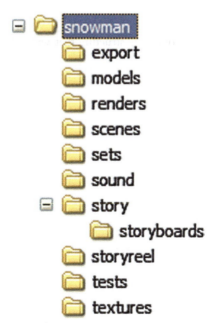

Figure 3.2 *A directory structure for organizing a short animation.*

- *Scenes or Shots*. The actual scene files go here. These files bring together all of the assets you have created and are where you will do the actual animation. There will be a separate scene file for each shot in your project.
- *Story*. Any files pertaining to the screenplay, including the script itself, will go here. You probably won't refer to this folder too often once you've entered the production phase, but you need a place to keep it for posterity when you win all those awards.
- *Sets*. Although sets might consist of either full BLEND files with the props stored locally or files that simply contain links to files in the **models** directory, different sets will be linked as a single asset, so they should have their own organizational niche.
- *Sound*. This folder will contain sound files, including the rough sound track, dialogue, and final sound effects and music.
- *Storyboards*. Your storyboards files will go in this folder. If you are using a program that has a "working file format," like Photoshop (PSD), you may want to make a subfolder for working files and leave the main **storyboards** folder for the actual storyboard images. In the figure, and in my own work, I usually place this one within the **Story** folder.
- *Story reel*. You'll learn about the story reel in the next chapter. The BLEND file that represents the current state of the story reel goes here, along with any previous versions you might have saved.
- *Tests*. You might need to do render tests or create small BLEND files to try a new technique or feature. Those files can be put here.
- *Textures*. This will be the location of all of your image texture files. If you have many characters or sets, you can create a subfolder for each one.

Summary

Before you begin to create files, it is important to create a directory structure on your hard drive to hold them. Using a good directory structure along with relative file paths for your Blender assets will make your project more flexible and portable.

OUTBOX

You will come out of this chapter with a directory structure that will help to organize your project in later chapters.

Chapter 4

Storyboarding and the Story Reel

Objectives in This Chapter
- Understanding storyboarding basics.
- Identifying the suggested tools.
- Creating the storyboards.
- Telling the story.
- Recording a temporary sound track for timing.
- Assembling a story reel in Blender's Sequence Editor.

INBOX

Coming into this chapter, you need the following:

- A finished story

Storyboarding Basics

Before you take your story into 3D, you need to visualize it in a less time consuming medium. Storyboards provide an efficient way to move the ideas and words of your story into a visual format. At their most basic level, storyboards are a series of drawings, either real (on sheets of paper) or virtual (drawn directly into a digital painting program), that show the sequential action of your story. They can become incredibly detailed for shots that feature complicated action, showing every character pose. Depending on your speed and ability at sketching, you may opt for a more simplified workflow, making sure that all of the major actions are shown.

Each storyboard represents an actual shot from the animation, framed as it would appear in its final form on the screen.

Notice how closely the final shots follow the composition of the corresponding storyboards (Figure 4.1–4.6). Without the mechanics of animation and 3D to worry about, you can concentrate on quickly developing the compositional strength and organization of the story. If you make a bad drawing, it only costs you a few minutes to draw it again. If you compose a scene poorly in 3D, it may cost you weeks.

In addition to static images, storyboards can also contain notes, arrows, or lines to indicate motion, camera directions, and even "dialogue" (Figures 4.7 and 4.8).

Let's take a look at a portion of the script from *Snowmen* and follow the process of storyboarding. Here's the excerpt:

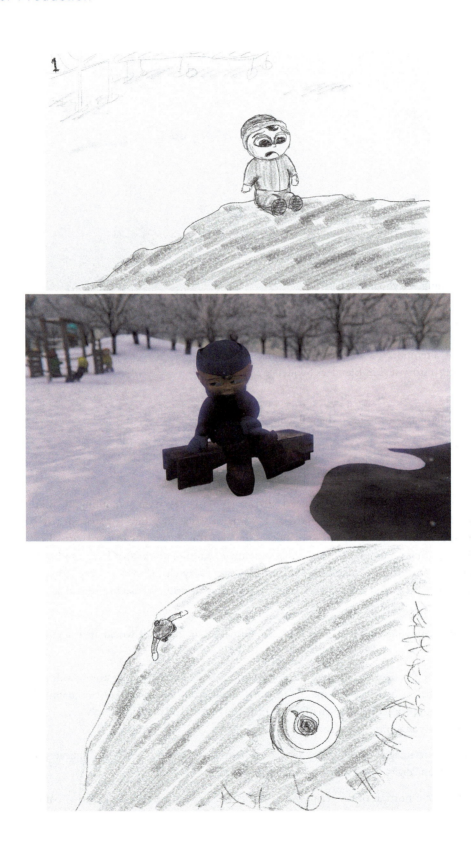

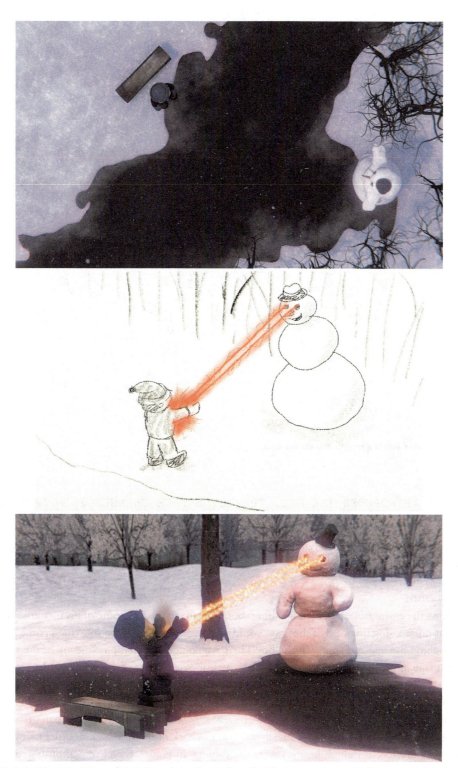

Figures 4.1, 4.2, 4.3, 4.4, 4.5, and 4.6 *Several storyboards from* The Snowmen *along with the accompanying production shot.*

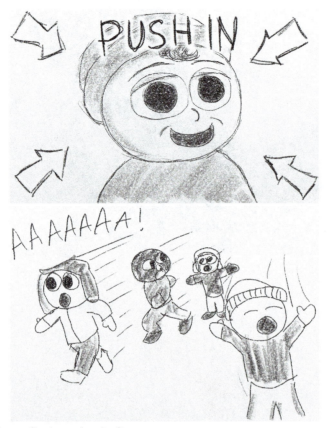

Figures 4.7 and 4.8 *Camera directions and motion lines.*

THE SNOWMEN APPROACHES THE BOY. THE BOY'S FACE CHANGES FROM SADNESS TO HAPPINESS.

Immediately, you are hit with a directorial decision: How will I frame this shot? It seems pretty straightforward, but there are several ways to do it.

Use a Long Shot

Figure 4.9 shows the entire tableau framed in a long shot. We can see the boy, some of his surroundings, and the snowmen all at once. Using this kind of shot, we would just linger and watch the snowmen come out from his hiding place behind the tree and approach the boy. Then, we could draw in for a close-up of the boy's smiling face. The advantage of this kind of shot is that provides a clear explanation of the action to the viewer.

Use a Point-of-View Shot

Another technique that we could use is the point-of-view shot. We can show the snowman's reveal from the perspective of the boy, either shooting over his shoulder so the back of his head and shoulder frames the image, or as a true point-of-view, as though his eyes were the camera. In Figure 4.10, I've demonstrated the former. Point-of-view shots offer immediacy, and if used consistently they provide a distinct tone to your work. An over-the-shoulder shot is often used for dialogue and probably wouldn't be appropriate for this situation.

Figure 4.9 *Framing the scene in a long shot.*

Figure 4.10 *Point of view, over the shoulder.*

My Solution: Montage Close-ups and Implied Action

Take a look at the eventual sequence that I used, presented in Figures 4.11 through 4.16. The first (Figure 4.11) is an establishing shot of the boy. Figure 4.12 shows a close-up of the snowmen, peeking from behind a tree. Because there weren't any trees in the establishing shot of the boy, the viewer already knows that the snowmen and the boy are separated (i.e., different settings), and we can enhance that perception when we move to lighting design by providing a distinctly different lighting scheme to this close-up shot.

Note also that the establishing shot is almost from the point of view of the snowmen. If we were to make the camera move a bit in that shot (which we may or may not do—we can decide later), it immediately implies to the viewer that *someone in the scene* is watching the boy, as opposed to the impression we would convey to the viewer if we used just a static camera that represents ourselves. Therefore, when we switch to the close-up of the snowmen it is almost a mini-reveal.

Figure 4.11 *The establishing shot.*

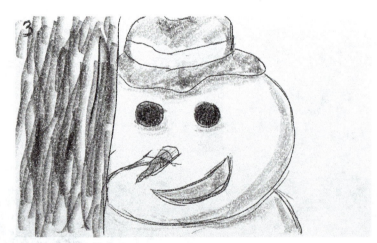

Figure 4.12 *The snowmen peeks from behind a tree.*

In Figure 4.13, we cut back to a close-up of the boy. In the next figure (Figure 4.14), the camera pushes in (note the arrows and camera direction built right into the storyboard) and his expression changes. As we've only seen the boy and the snowmen so far, it's reasonable for the viewer to assume that the boy is smiling *because* he has seen the snowmen. This makes the viewer do a tiny bit of mental work, but hopefully it is more engaging than the long shot.

That guess on the part of the viewer is confirmed in the next shot, shown in Figure 4.15, in which we see the boy happily regarding the snowmen. Note that we've used a slight variation of the over-the-shoulder shot so that we can see both of the characters and still get a good look at the boy's face. I mentioned earlier that the over-the-shoulder shot is often used in dialogue, and that's what we're actually presenting here. As there is no spoken dialogue in this animation, the conversation takes place with the boy's facial features.

When you are creating your storyboards, you are really making your first decisions as the director of the animation. Part of that process is thinking about the viewers, what they know, what they assume, and how you can use that. That's what we've tried to do here. Of course, this is a very subjective process.

Figures 4.13 and 4.14 *The boy sees the snowmen and smiles.*

Figure 4.15 *The viewer's assumptions are confirmed.*

To get better at it, you must do at least three things. First, go back and watch some of the filmed entertainment (either live action or animation) that affected you the most. Pick out a key scene or two that made an impression on you, and rewatch it (several times) with an eye toward what shots were chosen and how that affected you as the viewer. Second, talk about those decisions with other people of similar interests. They'll notice things that you hadn't, and vice versa. Bounce ideas off of one another. Finally, you have to practice. Whether it's by drawing storyboards or grabbing a video camera and making some short movies, try your hand at the things you noted in the works of others, then watch and analyze with your friends just like you did with the source material. Sometimes even copying a series of shots from something you like can teach you a lot as well.

The storyboards for the rest of the animation are available in the production files portion of the project archive in the "story" folder.

Suggested Tools

Many artists prefer to prepare storyboards in "real life," as opposed to digitally. The advantage of doing so is that small cards with sketches are extremely easy to arrange and rearrange to test different orders of action and scenes. It is also simple to swap variations on a particular storyboard to see how it changes the flow of the shot.

If you will be creating your storyboards using traditional tools, you will need the following:

- *Paper.* Unlined 3"× 5" index cards will work well.
- *Pencil.* Any drawing implement will work, but if you have a favorite artist's pencil, feel free to use it.
- *A board.* You can use a cork-backed bulletin board and pins, or a blank wall or artist's table and masking tape.

Finished drawings will be arranged in sequence on the board (or wall or desk), like this:

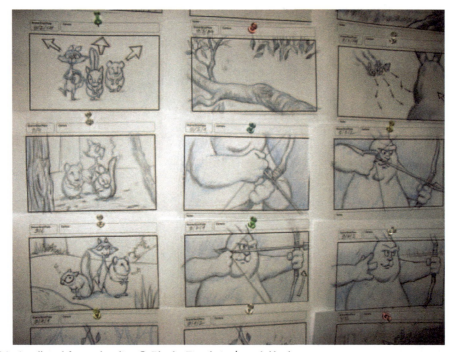

Figure 4.16 *A wall used for storyboarding.* © *Blender Foundation | peach.blender.org.*

Other artists, like myself, prefer to create their storyboards digitally. To accomplish this, you will need a pen tablet, some kind of painting program, and a program that can help you to organize the storyboards.

Pen Tablets

Although you could just paint using your mouse, you'd be silly to try. Using a pen tablet, which is significantly more responsive, is the generally accepted way of digital painting. If you've never used one before, a pen tablet is a USB device that consists of a hard drawing surface and a pen. As you move the pen across the surface, it controls the cursor on screen. Most pen tablets include **pressure sensitivity**, which means that the harder you press with the pen, the more "force" is applied digitally when painting or drawing, mimicking the response of real artist's media. Some better tablets are also sensitive to the angle of the pen, thereby providing an even more realistic experience.

The industry standard product is sold by Wacom, and the company's excellent reviews in a variety of publications and online boards, as well as personal experience, show the reason why. In the context of a larger production, the expense of a pen tablet is negligible, but those producing their own short animations may consider the price to be high. Wacom currently makes a series of tablets called "Bamboo," though, which are fairly inexpensive (the smallest is under $100) and still receive great reviews on both quality and responsiveness. Of course, depending on your skills as a sketch artist, even this may be more than you need. A simple product search on the Internet will turn up a number of off-brand or generic pen tablets that cost significantly less and that, as long as they have pressure sensitivity, will work just fine for creating simple storyboards.

Paint Software

In addition to the commercial-grade, relatively expensive image-editing and paint programs like Adobe Photoshop and Corel Painter, there are a number of free or low cost alternatives that have suitable functionality for drawing your storyboards.

Although the GIMP (GNU Image Manipulation Program, www.gimp.org) is the current open source option for image editing, my personal favorite is a program called ArtRage (Figures 4.18 and 4.19), a natural media painting application from Ambient Design, a New Zealand–based graphics software company. The full edition of the software is available for Windows and Macintosh computers from www.ambientdesign.com for only $20.

Figure 4.17 *My workstation setup.*

Figure 4.18 *ArtRage Studio Pro.*

Figure 4.19 *A faux oil painting created with ArtRage.*

If you have ever worked with real media (pastels, oil paints, etc.), you will find that ArtRage mimics the experience very well. Many of the techniques you use in traditional art have a great digital counterpart, allowing you to make illustrations and paintings that appear as though they were done with the traditional tools.

All of the storyboards for *Snowmen* were drawn in ArtRage Studio Pro.

At http://mypaint.intilinux.com, you can get an open source traditional media painting program called MyPaint that is available for Windows, Mac, and Linux machines.

There are also a few online image editors that are functional enough for storyboarding. One that I have used in a pinch is called Sumo Paint, which can be used for free at www.sumopaint.com. Obviously, you need an active Internet connection and a Flash-compatible browser to make use of it.

Blender's Image Editor

If you have Blender and are not the finicky type, you already have an image editor sufficient for the needs of storyboard creation. To find it, run Blender and configure a screen so that a single window dominates. Change that window to the **UV/Image Editor** type (Figure 4.20).

Before you can use this window for painting, you need to create a new image. Do this by selecting **New Image** from the **Image** menu on the window header (Figure 4.21). The dialog that pops up gives you options for naming the new image and choosing a size. For now, set the **Width** to **800** and the **Height** to **600**. Using the color picker between the **Width** and **Alpha** controls, select a pure white (RGB 0,0,0) for the background.

Figure 4.20 *Blender, featuring a UV/Image Editor window.*

Figure 4.21 *The New Image dialog.*

Aspect Ratio

It is a good idea to choose your finished format and size before your begin to create your story-boards so that the framing you work out will translate properly into 3D. There are some small technical considerations, but the real questions are, how do you want your finished animation to look, and where will it most likely be viewed?

The main choices are film, high-definition (HD) TV, and standard video.

Although you almost certainly won't be rendering your animation at film resolution (2,048 × 1,108), the aspect ratio (1.85:1) can be attractive if you want your project to look like a movie.

If your target is to show on widescreen TVs or DVDs, then a widescreen HD size (1,920 × 1,080; 1,280 × 720; or 852 × 480) and aspect ratio (16:9) will make sense.

Finally, standard video resolution (648 × 486 in the United States or 720 × 486 in Europe) and aspect ratio (4:3) are still hanging around and fit well for full-screen playback on many existing and new computer monitors and televisions.

When you click **OK**, the **UV/Image Editor** is filled with your new, blank image. Press the **1** key on the number pad to have Blender zoom the image to 100 percent. Before painting, choose **Save As Image (F3)** from the **Image** menu on the header, then assign the image a filename. You can choose the image format right from the save dialogue, shown in Figure 4.22. I recommend using PNG for storyboards.

To enable the paint tools for this particular image, either click the pencil icon on the window header or choose **Image Painting** from the **Image** menu (Figure 4.23).

Figure 4.22 *Choosing PNG format.*

Figure 4.23 *Enabling Image Painting.*

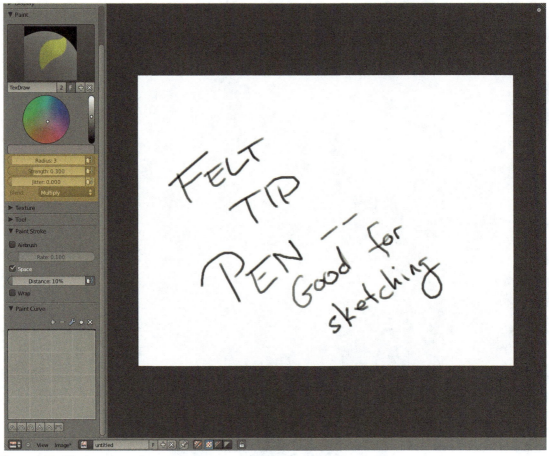

Figure 4.24 *Felt-tip marker settings.*

Finally, press the **N** key to bring up a panel with the image painting brush tools. This panel allows you to choose paint colors and textures, brush type and settings, and a variety of other options. While Blender's image editor isn't the most advanced paint application in the world, it does have enough complexity to make settings appropriate to sketching a little hard to come by. Figure 4.24 shows the panel configured for a decent approximation of a sharp-pointed felt-tip marker.

The settings in Figure 4.25 show a configuration appropriate for washing some color into a storyboard after the sketch, if you choose to do that. The brush size can be adjusted depending on the overall size of the image and the area you are coloring.

Remember that if you choose to sketch your storyboards directly within Blender's image editor, your image will not automatically be saved if you accidentally close the program. Unlike other image-editing programs, there are no selections or masking available, and there is no easy way to actually erase mistakes.

Figure 4.25 *A good setup for applying some color.*

Creating the Storyboards

At this point, your artistic sense must begin to take over a bit. Read through your script, close your eyes, and try to visualize the first shot. Using your storyboarding tools of choice, draw it. Line characters or whatever is appropriate to your skill level in sketching are fine, as long as you will be able to tell one character or item from another.

When you have the first shot drawn, pin it in the upper left corner of the board if you are using physical tools (a pencil and index cards). If you are creating your storyboards digitally, save the image into your **storyboards** directory using the following convention:

<div align="center">Board Number + Description . Extension</div>

Board numbers should start at "010" and go up by tens ("010," "002," etc.). You do this so that if you decide to enhance a sequence of storyboards with a few extra drawings, you can keep them numbered sequentially without renaming all of your files. If you're really nervous about it, you can number by hundreds.

The description is a very short description of what the storyboard depicts.

Figure 4.26 *A listing of the storyboard files from* Snowmen.

Of course, the extension is dictated by the format in which you choose to save the illustrations. The PNG format is usually a good choice for storyboards, because it keeps a good balance between file size and image quality, although you are free to use your favorite format, as long as it is one that Blender will be able to import later.

A segment of the **storyboards** folder from *Snowmen* can be seen in Figure 4.26. Notice how several storyboards have been inserted into the "by tens" numbering sequence.

As you proceed to draw your storyboards, make sure that you include one for each action or significant moment that takes place. It can be useful to create before-and-after storyboards of quickly occurring actions, such as the first laser blast. Add arrows to show motion. Scribble notes on camera movement, sound effects, or anything else that you think is important. Include bits of dialogue where applicable. Relevant set elements and props should be drawn, but don't become bogged down drawing every detail of every shot.

If you are working with index cards and a board, you will see your story develop with each sketch that you add. If you are drawing directly on the computer, you will need an additional tool to see the storyboards as you would in real life.

On a Windows PC, one such program is IrfanView, a free image viewer and browser available from www.irfanview.com. Figure 4.27 shows IrfanView's **Thumbnails** view, found by clicking on **Thumbnails** in

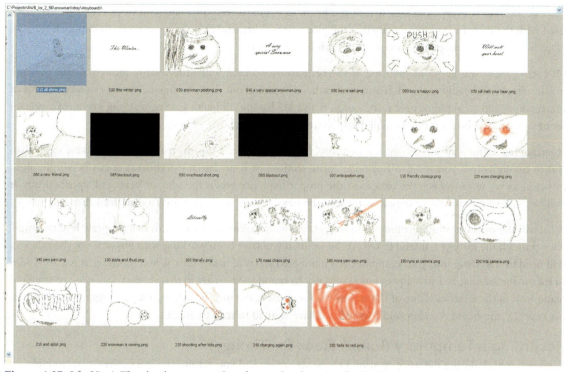

Figure 4.27 *IrfanView's Thumbnails screen provides a fast storyboard overview for Windows users.*

the program's **File** menu. Through the **Thumbnails** view's **Options** menu, you can increase or decrease the size of the thumbnail images. Pressing the **F5** key will refresh the thumbnail display each time new storyboards are added.

Macintosh users can use the bundled **iPhoto** application to achieve a similar effect. Adobe Photoshop users can use the Contact Sheet utility (under the File > Automate menus) to create a single sheet with all storyboard images laid out. This can be printed out for a small but easy reference.

Telling the Story

One thing that animation directors do after storyboarding is to use their storyboards to actually show and tell the story to an audience. Even though your production is short, this is still a good idea. Find yourself an audience, most likely friends and family, and walk them through your storyboards.

If you have a physical wall full of storyboards, grab a yardstick, tell the story, and begin to direct your audience's attention to the relevant boards. If you are doing it digitally, you can show each image full screen with the slideshow feature of any number of applications like IrfanView, iPhoto, or Google's Picasa. In either case, the point is to show someone *who doesn't already know the story* the storyboards, while you narrate. This last point is critical, because what you are looking for here is feedback on what the viewers misunderstood (or completely failed to understand), what they thought went on too long, whether your jokes worked, and if anything just plain didn't make sense. Sometimes when you've lived with a story for several weeks or months, certain things become so obvious to you that you completely forget to mention them to your audience. Doing this, while potentially cringe inducing, is a valuable part of the short animation creation process. It's a chance to get the

bugs worked out of everything long before you begin to put in the real time and hard work. Also, you may have lived with the story for so long already that the plot points, jokes, and twists may have lost their punch for you. A fresh audience can, hopefully, restore your faith in the project.

Of course, there will be problems. One of the benefits of working with storyboards, though, is that they are quick to make and easily replaced. If your test audience pointed out that you missed giving out a crucial bit of information, add a couple of new storyboards. If you are having difficulty getting a strong vision of a certain set of actions, storyboard it from several perspectives and see which works best.

Rearranging sections of your story can help too, but that is easier to do in real life with physical cards than it is to do digitally. If you want to rearrange entire sections of your digital storyboards, it can be a little more involved, as we want to keep the images in the proper sequence when the files are arranged alphabetically. It will become easy to rearrange digital sections in the next step, so you may want to wait until then.

Whatever the case, you should come out of the process with a series of storyboards that properly lead the audience through the story you intend to tell. At this point, if you have been working with physical storyboards, you will need to scan them into your computer as a numbered series of image files. When scanning, it is a good idea to follow the naming and size/aspect ratio conventions mentioned earlier in this chapter. The need to scan and name each of the sketches is one of the arguments for creating the storyboards digitally to begin with. *Snowmen* has only 21 storyboard sketches, and I would not have wanted to scan them all.

Recording a Temporary Sound Track for Timing

Remember back during the story creation process where we had you act out the story in real time to make an estimate of the running length? Well, it is time to finalize that process. In the next step, you will be compiling your storyboards into an animated, timed slideshow, set to a temporary sound track.

Grab a cheap PC microphone, fire up whichever bundled sound recording application came with your system (see Chapter 8 for more information on recording sound), and get ready to act again. What fun! You had no idea you'd be up to these kinds of shenanigans when you started this project!

Your vision of the story has no doubt solidified as you worked through storyboard creation. You should have an excellent idea at this point how the story will actually function on screen.

Press **Record** in your sound application and act the story directly into the microphone, visualizing the storyboards while you do so. If more than one person talks at a time in your production, get a friend to help you. The actual timing of individual words or hard dialogue isn't as important right now as getting the overall timing correct. Make sounds to signal the start and end of actions (grunts, smashing noises, screams) so that you will be able to place their storyboards properly in time.

Place this recording in your project's **sound** folder under a name like "dirt track" or "temp sound." If the recording program gives you options and formats to choose from, choose the 16-bit WAV format, at 44,100 kHz. If not, don't worry about it. Those are the most common settings. Now, open up the slideshow viewer you used when you narrated the story for your test audience, play the audio you just recorded, and try to follow the sound track by advancing the slideshow manually at the right times. Give it a few tries to make sure that there are no parts of the action you missed when creating the temporary sound track. If you did miss something, just go back and make a new recording. It will only take a couple of minutes.

Just like when you were estimating the length of the animation in the story phase, building a sound track adds a real-world time scale to your project.

Assembling a Story Reel in Blender's Sequence Editor

With the storyboards and a rough sound track created, you will assemble them into an animated **story reel**. When you paged through your storyboards as a slideshow with the sound track playing, you were actually making a temporary story reel on the fly.

The story reel is a self-playing animation that marries your storyboards to your rough sound track. If done well, it will give an excellent sense of the look and feel of the action in the finished animation. In fact, as you proceed with your work later in the project, you will be replacing the storyboards in the story reel with previews and with final, rendered animation clips as you complete them. In this way, the story reel evolves over time, until it becomes the final edit of your finished, rendered animation!

For this reason, the story reel is vital to your project. All of your work in the story, planning, animation, and rendering phases come together there. It will be your guide.

You can create your story reel directly within Blender's Video Sequence Editor. The initial story reel file for *Snowmen* is called **beginning_story_reel.blend** and is available in the included project's **storyreel** directory. Let's examine the way that you build a story reel in the Sequence Editor.

> **Note**
>
> The Video Sequence Editor screen is often referred to in online and printed documentation as either the **Sequencer** or the **VSE**. You should become familiar with both terms so that you can make use of other tutorials without confusion.

In Figure 4.29, you can see that the larger part of the screen has been split horizontally, and both halves have been set to **Video Sequence Editor** windows. The bottom one is the default visualization of the Sequencer.

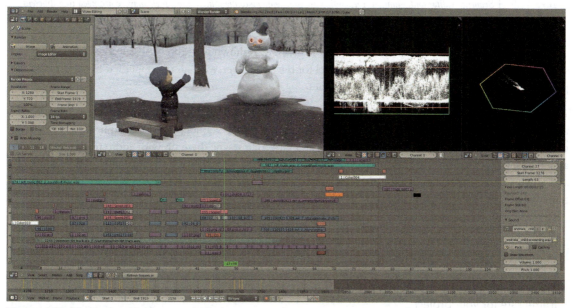

Figure 4.28 *The Sequencer is where your production comes together.*

Figure 4.29 *A Sequence Editor configuration. Depending on your window configuration, the panels may be arranged in a different order than presented here.*

The top has been switched to display the Sequencer preview, as shown in Figure 4.30. On the right side of the screen at the bottom is the **N-key** properties panel for the Sequencer, whereas the upper left holds a traditional properties window showing the **Render** properties.

The Video Sequence Editor is one of the "black holes" of Blender. If you've never done any video work, you may have known it was there but considered it advanced Blender voodoo. Its primary purpose is to string together sequences (that's its name!) of still images and video clips, sync them up with audio tracks, and output a single, long piece of video or animation. Sounds like it's exactly what we need to create the story reel. Images and video will be added and manipulated in the bottom half of the screen, while the preview of the current frame will be shown in the top. The VSE obeys most of Blender's interface conventions, as you will see.

> **Note**
> Before you continue, save this file with a name like **storyreel_master.blend** in the **storyreel** direc-
> tory for your project. We are about to use assets with relative links, which will not work unless the
> file is saved. Also, confirm in the **Render** properties that the file is using the proper pixel size and
> frame rate for your project.

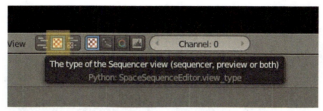

Figure 4.30 *Choosing the Preview visualization.*

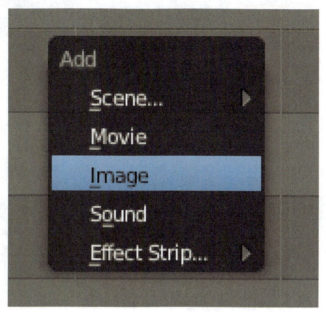

Figure 4.31 *Adding an Image Sequence.*

With the mouse over the timeline in the VSE workspace, press **Shift–A** to pop up the **Add** menu for sequencer elements, just like you would press **Shift–A** to add an object in Blender's 3D view. From the menu, choose **Image**, as in Figure 4.31.

This brings up the file chooser screen. You need to find the image directory that houses your storyboards and select all of them. A cool fact about Blender that not many people realize is that its regular selection tools also apply in the file selector view. That's right—you can use the **A** key to select all files or even the **B** key to border select! Selected images will be highlighted in orange, as shown in Figure 4.32. Of course, you can carefully select images if you like with **Shift–LMB.** The selected images will be brought into Blender in alphanumeric order, not necessarily the order in which you select them, so it is important that you've named them as specified earlier in the chapter. With all of the image files highlighted for selection, make sure that **Relative Path** is enabled at the bottom left of the screen (it should be) and click **Add Image Strip.**

When the VSE workspace returns, a Sequence strip will be added to the workspace at the location of the current frame indicator. The strip is automatically selected when it was created (just like an object in the 3D view). Figure 4.33 shows the strip for *Snowmen,* added at frame 1. Notice how the full path name to the first storyboard is displayed within the strip? The Sequencer can get rather full of strips, and it is feedback like this that can help you to maintain your bearings.

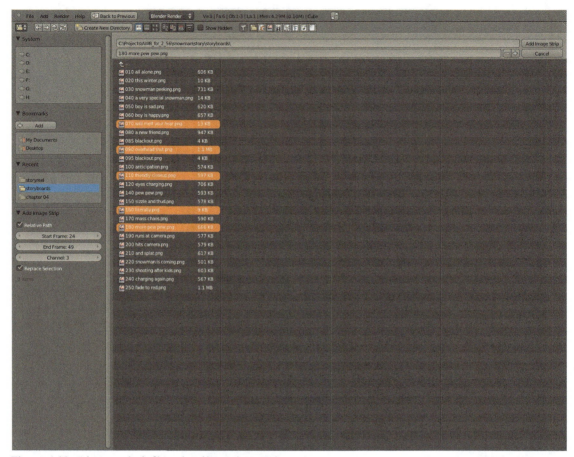

Figure 4.32 *Selecting multiple files and enabling Relative Paths.*

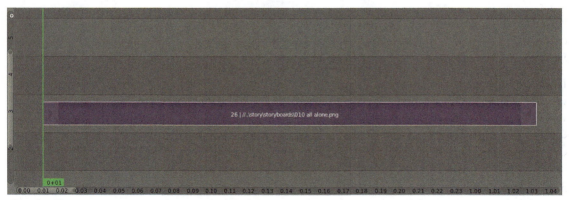

Figure 4.33 *A strip, added to the workspace.*

You might also have noticed the strange numbering scheme along the bottom of the timeline. In the figure, it counts upward seemingly by hundredths (0.01, 0.02, 0.03), but jumps straight from 0.23 to 1.00. This is because the decimals actually represent frame numbers in this view, whereas the whole number portion counts the seconds. Because there are 24 frames in one second, the "frame" part of the number counts to 23, then turns over. Zoom out a little more, like shown in Figure 4.34, and things get even weirder. Now the display only shows

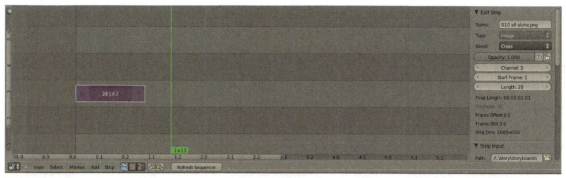

Figure 4.34 *Several numbering schemes at once.*

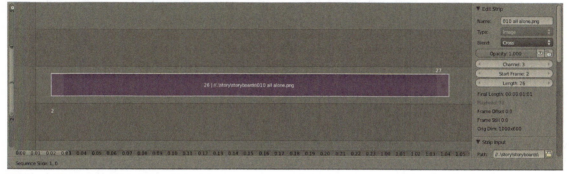

Figure 4.35 *An Image Strip in transform mode.*

the "tens" digit of the frame number, so the marks on the timeline actually mean "second 1, frame 0; second 1, frame 10; and second 1, frame 20." To make matters worse, notice the completely different notation of the current frame marker: 1 + 13, which means "second 1, frame 13." It's all very confusing. Fortunately, when you go to work with the strips themselves, you get some more useful feedback.

With the new strip already selected—and if is not, a simple **right mouse button (RMB)** click on it will do so—press the **G** key to move it. This is just like moving objects in 3D in Blender: clicking the **right mouse button** will cancel, whereas clicking the **left mouse button** will drop the strip at the cursor's current location. Be careful if using the **right mouse button** to cancel the transformation, as the import will still have taken place, dropping the images in sometimes very hard-to-find places in the workspace. In Figure 4.35, notice the different elements of the Sequencer **Image Strip** while it is being moved:

- The numbers on either end of the strip indicate the start and end frames the strip would have if you accepted the current transformation. You're back in the familiar territory of actual frame numbers. Hooray!
- The first number inside the body of the strip indicates how many images (i.e., your storyboards) are contained in the strip.
- Once again, note the full disk path and filename of the first image file in the strip.

Move the strip until the indicator for the start frame is **1**, meaning that the sequence of images will begin on Frame 1 of the animation. Which particular horizontal channel the strip is in is not important right now. Press the **left mouse button** to accept the position. If something went wrong, and the strip ended up somewhere other than Frame 1, just follow the Blender convention to move something: select the strip with the **right mouse button** and press the **G** key to begin a movement transform.

Once the image strip is in proper position, try scrubbing through the VSE's timeline by holding down the **left mouse button** and dragging in the workspace. As you scrub across the area occupied by the image strip, you should see the images display and change in the preview window in the upper portion of the screen. If the preview image is very small, or you are only seeing an extremely magnified version, position your mouse over the preview window and use the mouse's scroll wheel to adjust the zoom.

If you watch carefully, you'll see that each image occupies only a single frame in time. Hardly the effect we're looking for. In a moment, we'll see how to change that, but first we need to get Blender ready for our animation.

Warning

If you forget to set frame rate, resolution, or aspect ratio at this step, it can lead to mismatched render sizes, audio/video sync problems, and timing issues that could spell disaster for your project. If you've saved your project's animation settings as a Blender default as suggested in the previous chapter, you should be fine. In the actual **Timeline** window at the bottom of the whole view, change the syncing method from **No Sync** to **AV-sync** (Figure 4.36). **Av-sync** forces Blender to maintain accurate time during sequence playback, causing it to skip the display of frames if things are taking too long to process.

With the animation settings prepared and confirmed, you add your rough sound track. Press **Shift-A** over the VSE workspace again and this time choose **Sound**. Select the audio file you created as a rough sound track (which you *very cleverly* placed in your **Sounds** directory in your production tree) and place it in the VSE beginning on frame 1, just like the image strip. With the audio in place, pressing **Alt-A** (the standard Blender command to **Play Animation)** should cause the sound to play while the storyboard images flash past in the preview window.

With the audio strip selected—it will appear in teal, while the image strip is purple—note the controls in the **N-key Properties** panel, shown in Figure 4.37. The **Edit Strip** section shows that the Start Frame of the strip is frame 1, and it is 1,245 frames in length. In the **Sound** section, enabling the **Draw Waveform** option shows the amplitude of the sound in the strip. This will be useful in just a bit when we attempt to coordinate sounds with storyboards.

In Figure 4.38, you can see the small size of the purple image strip (26 frames), compared to the much larger green audio strip (1,245 frames). When you have the audio strip positioned, make sure that it is selected (**right mouse button**) and **Lock** it by pressing **Shift-L** or choosing **Lock Strips** from the **Strip** menu on the VSE header. Locking prevents a strip from being accidentally moved within the timeline. As this sound strip will be our reference for the rest of the animation, we want to make sure that it stays put.

Figure 4.36 *Enabling Audio-Visual Sync.*

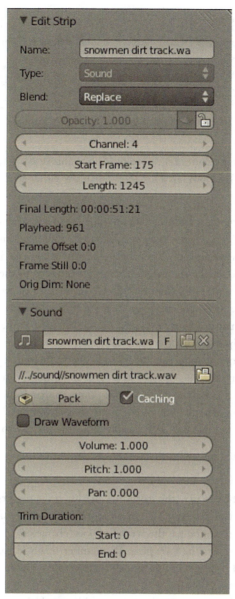

Figure 4.37 *The N-key properties for a sound strip.*

Figure 4.38 *Showing strip amplitude with Caching enabled.*

Figure 4.39 Snowmen*'s image strip separated into its components.*

Using a little bit of math, let's set the entire frame range for our animation. The sound begins on frame 1 and is 1,245 frames long. So set the **End** property for the animation–either in the Render properties or in the Timeline view—to 1246.

Our next task is to break the single image strip into individual images so that we can adjust their lengths and positions along the timeline, producing a true story reel. Blender's tool for doing this lets you specify an initial length in frames for each of the single images. A good place to start is to make it use almost the entire running length of the animation. To do so, divide the total number of frames from the audio (1,245) by the number of images in the image strip (26) and round the result down. In the case of *Snowmen*, this yielded 47 (1,245 / 26 = 47.88). This number represents how many frames each storyboard image will need to be in order to fill the available time. Use the **right mouse button** to select the image strip and either press the **Y** key or choose **Separate Images** from the **Strip** menu on the VSE workspace's header. Blender separates the images into a bunch of single strips, each only one frame long. Hit F6 to bring up the tweak panel and enter the length that you just calculated. We are breaking the single image strip with all of the storyboards in it into individual strips, fitted end to end, so that we can adjust their start and end points to match the audio track. The image's strips are resized, with the last one falling near the end of the audio strip if you did the math correctly (Figure 4.39). If not, just keep playing with the tweak panel and possibly ask someone else to do the arithmetic.

And now begins the somewhat tedious task of adjusting the timing of the storyboard images. The workflow proceeds like this:

- *Identify a sound cue.* Press **Alt-A** to play the story reel and listen for the first definitive audio cue that you can sync to. It might be a bit of dialogue, a crash or some other sound effect, or the fake trumpet sound you made with your mouth to announce the arrival of your character.
- *Note where in the timeline the sound cue takes place.* Remember that you can use the **left mouse button** to scrub in the timeline and hear specific portions of audio to narrow it down. The amplitude (volume) preview on the audio strip can also help.
- *Locate the storyboard that matches that cue.* You've been working with the storyboards for long enough now that you should know which image you are looking for. Also, if you are working sequentially, the next storyboard in line will almost certainly be the one that you need. This is where any notations or dialogue that you've drawn directly into the storyboards can be very helpful.
- *Position the storyboard to match the location of the sound cue on the timeline.*

The first real sync of sound in *Snowmen* is the sound track *thump* found at around the 20-second point and storyboard number 85. Figure 4.40 shows this storyboard matched to that location on the sound track.

There are several techniques for moving the image strips around, and we will discuss them next, but this is the basic procedure. As you match storyboards to sound cues, press **Alt-A** to preview your work, tweaking things a frame at a time if necessary.

Figure 4.40 *Sound synced to the proper storyboard in* Snowmen.

Sequencer Tools for Working with Image Strips

Although the Video Sequence Editor shares some of the rest of Blender's commands and workflow, it has its own quirks and hidden secrets. Actually, by bringing in a series of images and a sound clip and splitting them into their components, you have already acquired significantly more Sequencer knowledge than a great many Blender users.

First, a little more Sequence strip anatomy. Notice the inward pointing arrows on either end of each image strip. Image strips can be selected with the **right mouse button** and moved with the **G** key, just like any other Blender object. The handles, though, can be individually selected and **G** key moved, allowing you to extend the length of time that the strip covers. In Figure 4.41, you can see that the top strip has had its right handle moved to the right and the bottom one has had its right handle moved to the left, making them, respectively, longer and shorter than the one in the middle. The bottom strip is in the middle of its transformation, with the right-most handle selected.

Sequence strips may also be selected and moved in groups. The standard **right mouse button** and **B** key selection methods apply. Selected strips can be deleted with the **X** key, or duplicated with **Shift-D.**

When moving a sequence strip (or several at once), Blender will allow you to move it into a space already occupied by another strip. If this happens, the outline of the moving strip will turn red as a warning. If you accept the transform by pressing the **left mouse button** while the strips are overlapping, the moved strip will automatically be placed adjacent to the blocking strip (Figure 4.42).

The main tool you will use when working with a list of image strips laid out end to end like this is the **Extend from Frame** command, which is triggered by the **E** key. If you are familiar with Blender's

Figure 4.41 *Adjusting the handles to lengthen and shorten sequence strips.*

Figures 4.42 and 4.43 *A strip transforming to overlap will be outlined in red.*

Figure 4.44 *Using Extend from Frame causes all handles and strips on the right of the current frame marker to transform together.*

modeling workflow, you can think of it as an **Extrude** tool for sequence strips. **Extend from Frame** looks at three factors: which strips are selected, where the current frame marker lies, and where the mouse is when the **E** key is pressed. It then enters a grab/move/transform mode that lets you move all handles on the mouse side of the frame marker together. That sounds odd, but Figures 4.43 and 4.44 show its practical use. If you have all image strips selected and place the frame marker in the middle of one of the strips, using **Extend from Frame** will cause that strip to grow and shrink, while all others attached to it move along with it, maintaining their original boundaries.

So if you have used the **A** key to select all of the strips in the sequencer and moved them so that the beginning of a particular strip matches a sound cue, you now have an easy way of making that strip shrink or grow so that the next strip begins at the next sound cue. With all of the strips selected (this is why we locked the sound strip earlier), position the current frame marker with the **left mouse button** in the middle of the strip whose position you are sure of. If you need to move to the right side of the strip, put your mouse to the right of the

current frame marker; if you need to move the left handle of the strip, position the cursor to the left. Press the **E** key and move the mouse back and forth to see how the transform functions. All other strips on the side of the cursor that are adjacent to the central strip will move along with it, allowing you to grow and shrink the central strip without introducing gaps or causing overlap.

The great advantage to using this method of adjusting the image strips over simply grabbing the handles individually and pulling them around is that you never have to worry about gaps or overlaps between images occurring. Everything stays neatly together. Although the description of the functionality is complex, after using it a few times, its value will become apparent.

If, however, you do need to break things up and start really shuffling strips around, here are some tools that can make your life easier:

- *Alt right mouse button on handle.* Using **Alt** while **right mouse button** selecting either of a strip's handles selects both that handle and the one from the neighboring strip. Using the **G** key on this selection allows you to adjust the boundary between the two strips without moving either strip.
- *Alt right mouse button × 2 on handle.* Adding a second click to the previous command will select all strips to the right or left of the directly selected one. This allows you to quickly and easily select and move entire blocks of strips at once, say, to make room for an additional strip.
- *Alt right mouse button on strip.* Holding down the **Alt** key while selecting a strip selects the strip plus any strips that border it immediately on the left and right. The interior handles are directly selected, allowing you to move the center strip back and forth while the outermost handles remain in place.

Each of these methods seems a little odd when described in words, but they are easy to understand when actually doing them in Blender. Spend two minutes in the Sequence Editor to try out these capabilities, and their usefulness will immediately become apparent.

Watching and Exporting the Story Reel

As you've been working, you have no doubt been using **Alt-A** to watch the evolving story reel in the preview window of the Sequence Editor. As long as you are using fairly modern hardware, Blender will easily be able to show it in real time.

Before exporting the story reel as an animation, there is one more thing to do. The **Render properties** contain a **stamp,** located near the bottom in the default configuration. By enabling the controls on the panel, you can have Blender burn various informational notes into the animation for later reference. Set the panel up as in Figure 4.45 to include both the frame number and the timestamp into the animation. This will make it very easy later on to use the story reel as a reference for timing.

If you would like to show the animation outside of Blender, the render controls that you use for making and saving still images all apply, with a few additions. First, you must enable the **Sequencer** button in the **Post Processing** panel of the **Render Properties** (Figure 4.46). It is usually enabled by default, but you should check anyway. Then, you choose one of the animation formats from the **Output** panel: AVI Codec, H.264, MPEG, Ogg Theora, or Xvid, depending on your personal preferences (Figure 4.47). If in doubt, choose H.264, which should enjoy wide playback acceptance on a variety of systems.

To export the rough sound track along with the storyboards, check the **Encoding** panel and make sure that an **Audio Codec** is chosen at the bottom. You can try MP3, MP2, AAC, and AC3. If none of those will play back on your system, fall back to PCM, which should work anywhere.

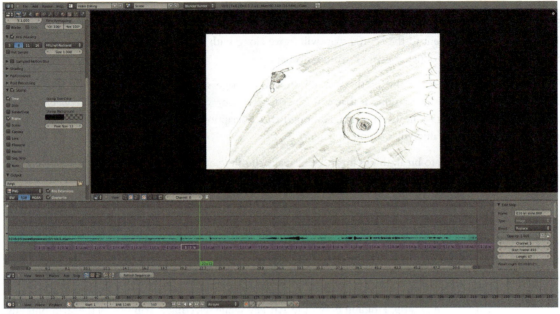

Figure 4.45 *The Stamp panel.*

Figure 4.46 *Making sure that the renderer will use the Sequence Editor.*

> **Note**
> If your storyboards were created (or scanned) at exactly 1280 × 720 pixels, which corresponds to the 720p render settings we will be using, you can turn off anti-aliasing in the **Render** properties. If you are using storyboards of a different pixel size, anti-aliasing will do a nice job of resizing them for you. However if you don't need to have it enabled, it will just cost you precious time when rendering. Also, you can turn it off if you don't mind your storyboards being resampled into the story reel with a little bit of digital blockiness.

Finally, you enter a path and filename on the **Output** panel so that Blender knows where to store the animation. Clicking the folder icon to the right of the path field will open the file picker so that you can interactively choose the save path. A good suggestion at this point would be to use the **Export** folder you created in the previous chapter. The **Output** panel is shown in Figure 4.48. When you are ready to generate the

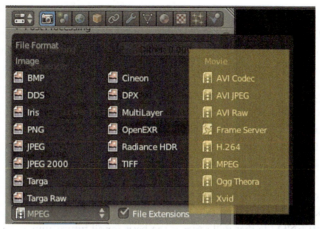

Figure 4.47 *The different export formats available.*

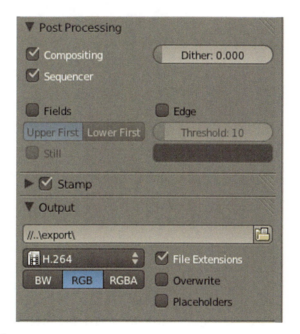

Figure 4.48 *Set up for export.*

animation of your story reel, press the **Animation** button on the **Render** panel (Ctrl–F12), as opposed to the **Image** button.

These days, so many different codecs are available for encoding both sound and video that it might take you several tries to find a combination that will reliably play back on your system. If the H.264 preset does not work, you'll have to delve into the finer points of the **MPEG** setting, which doesn't necessarily have to produce MPEG video files. Blender's MPEG setting in the **Output** panel actually chooses a free video encoder called **FFMPEG**, which can export a wide variety of formats. In fact, the combination of options here is kind of mind boggling. Your best chances of getting good output will come from choosing either **AVI** or **MPEG4** for the wrapper, found in the **Format** control. The codec will be **MPEG–4(divx), MPEG–2,** or **H.264**.

Summary

Storyboarding involves the creation of a comic-like series of images that describe the action in your story. Storyboards help to organize your thoughts on the way that action and staging will take place in 3D, and it can point out problems in the way the story was constructed.

Although storyboards can be drawn with either traditional or digital tools, at some point they must be brought into the computer and organized. Once there, the storyboards are synced with a temporary sound track to create a story reel. The story reel becomes the core of your animation production and provides you with your first chance to get a feel for timing and action.

OUTBOX

- A series of storyboards that effectively tell your story
- A rough sound track to assist with timing
- A master story reel BLEND file that will serve as the basis for all future animation work

Chapter 5

Character Design and Creation

Objectives

- Designing in line with your theme and reality.
- Modeling based on storyboard requirements.
- Exploring mesh animation issues.

INBOX

Coming into this chapter, you need the following:

- A story with a well-considered theme
- A strong idea about who your characters are
- An ability to use Blender's mesh modeling tools

Designing in Line with Your Theme and Reality

If you have already drawn your storyboards and assembled your story reel, then you have a number of sketches of your characters. If not, that is okay. The character design process can take place at the same time as storyboard creation. Depending on staffing (is it just you or a whole team?) and deadlines (at your leisure or imminently looming), you might even have different people working on the two tasks. If you are by yourself, it is often useful when working on a project of this size to have several tasks going at once, so that when you are not feeling particularly inspired by one aspect of the production, you can switch to another for a while.

Your instinct might be to sit down with a pencil and pad of paper and start sketching away, and, in fact, that is what you will do soon enough. First, though, there are some things to think about.

The design of a character should reflect and support the theme of your story. For example, let's say that your story is about a lonely monster who wanders the hills in search of the last mossy patch in the land on which to rest its aching bottom, and the theme is something like "the things we need (i.e., a place to rest, companionship) are often closer to home than we expect." There are a number of ways you could design such a monster, but before beginning any artwork, you can use that story and theme to narrow your creative search. The monster is lonely, so he must have a bit of sadness to him. He also has a sore backside, which can be reflected in a hunched, awkward-looking back configuration, or lopsided legs, and so on, so that he walks painfully. Because the theme is "looking for home," he would probably carry more than just the standard monster gear (club, goat hides, sacks for lost children). The theme suggests that he might carry trinkets and mementos of his home with him. If you wanted to go funny, he could carry little monster-style tchotchkes around, tied to his backpack, like

Figure 5.1 *A monster with his world on his back, thinking of home.*

Precious Moments figurines but brown and scaly. If you wanted to go sad, you could have him carry shards of rock or wood from his forest home that had burned to the ground.

When you have the theme foremost in your thoughts, you will find it much easier to create telling and interesting character details.

In addition to theme, you must also decide what level of reality you want to represent. Character design can produce anything from extreme abstraction and stylization to photorealistic digital actors. How you choose to position your characters along that continuum will depend on the action required in your story, your available resources, and, once again, the theme.

The more realistic you make your characters, the more work you will be making for yourself. After a certain point, characters that are very realistic but not quite perfect feel creepy to the viewer. This effect is called "the uncanny valley" and represents a serious problem that you need to avoid. A character that has perfect physical modeling and photorealistic textures will have to move just like a real person. The human brain interprets it visually as "real," and when the motion is off, it looks bizarre. As you approach the stylized side of the scale, you have more artistic freedom, both in character creation and in the eventual range of motions and actions when you animate.

If you think of things in terms of a 3D interface like Blender, there are four "sliders" that control the realism/ stylization level of your characters.

You can control the following axes:

- *Modeled detail.* Is your character simply modeled, with very few small details, or can you see every muscle striation and skin crease?
- *Proportion.* Standard human proportions, and those for other animals, are well documented. The further you move from the standards (giant head, tiny legs, etc.), the less realistic your character will be.

Figure 5.2 *A pretend set of sliders for controlling character realism.*

- *Materials*. This feature runs the gamut from a completely untextured, default shaded character to one with photographic skin and accompanying normal, specular, and reflectance maps.
- *Motion*. Can the character squash and stretch beyond the boundaries of what a real skeletal structure would allow? How much? Must it obey the laws of motion of a physical character?

You can mix things up to achieve the appropriate level of realism and stylization for your project. If you look at a promotional shot for *Snowmen* (Figure 5.3), you will see that although there is a fair amount of detail in the models, the proportions have been altered from the human ideal, and the materials are very simple. The boy's clothes are simple but realistically textured, whereas his face is reminiscent of the current visual style in feature animation. This is because one of the things we are doing with this animation (i.e., the theme) is to play off the viewer's expectations of such fare.

Whichever level of realism versus stylization you choose, you should try to keep it relatively the same for all of your characters. Even if things end up rather abstract, you want to give your viewer the illusion of a believable world with actual characters. It doesn't have to be like our world, but it should at least be internally consistent, which means that the character style should be as well.

> Remember that your character design, with respect to manners of stylization, will need to influence your set and prop design in turn. Notice how the sets in *Snowmen* are simple, but textured realistically, as we try to evoke the feeling of the current trends in feature animation.

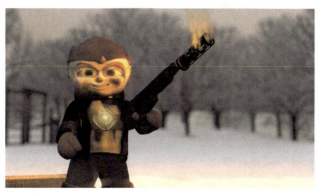

Figure 5.3 *A promotional shot for* Snowmen.

The Boy

In *Snowmen*, the theme directly informs the look of the characters. While initial sketching was done on pencil and paper, I eventually turned to ArtRage to do the final reference sketches that I would model from. The first sketch that I did was too realistic. It clearly isn't a humanly proportioned face, but it was not stylized enough for what I had planned. You can see this first sketch in Figure 5.4. What it came down to was that I looked at that sketch and thought, *I can't blast a hole in this kid's chest.*

Beyond my own squeamishness, remember that during storyboarding we avoided showing the contact point of the lasers, which could turn it from darkly amusing to just nasty. The shot as presented already skirts the line of good taste. Even though the proportions are still slightly cartoonish in this first sketch, I felt that it was realistic enough to push it over the line. The final design, in Figure 5.5, pushes the stylization even further. You still say "Awwww" when you see him but don't weep for his humanity (hopefully) when he bites the dust. In Figure 5.6, you can see how closely the final model followed the sketch.

From a practical standpoint, I had to decide how to clothe him. He is supposed to elicit immediate sympathy in the viewer, so I gave his clothing a raggedy look. Also, any other children seen in the background are going to be variations of this model to save time. To provide additional contrast with the main character, I will make the color palette for their clothing bright and cheery.

The Snowman

The only real decision that I faced when designing the snowman was whether to give him bendable snow arms or sticks. You can see the difference in Figures 5.7 and 5.8. The stick arms looked a little creepy, and the thick snowy ones made him seem more cartoonish and appealing. He ends up going on a rampage in the end, but we want to keep the viewer thinking that everything is nice and happy until that point.

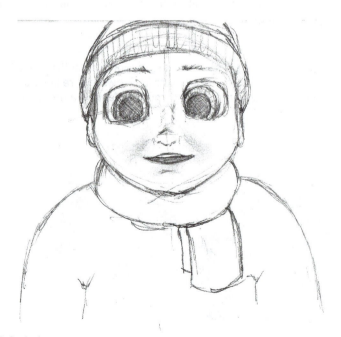

Figure 5.4 *Initial sketch for the boy.*

Figure 5.5 *The final sketch of the boy.*

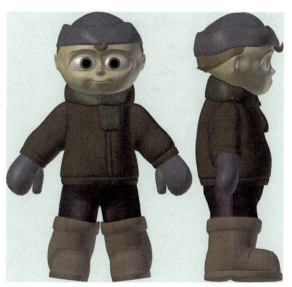

Figure 5.6 *The final production model of the boy.*

To complete the look, he has a tiny, crumpled top hat and the all-important coal eyes. Figure 5.9 shows the final production model of the snowman.

Modeling Based on Storyboard Requirements

A careful examination of your storyboards and the story reel can save you time when designing and modeling your characters.

Figure 5.7 *Snowman with sticks for arms*

Figure 5.8 *Snowman with snowy, friendly arms.*

Faces, Hands, and Clothes

For each of your characters, follow their progress through the story reel to see if complicated modeling items like faces and hands actually appear on screen, and if so, for how long. It is possible that certain characters would never have a full frame face shot or that their hands would never appear in the frame without being in motion.

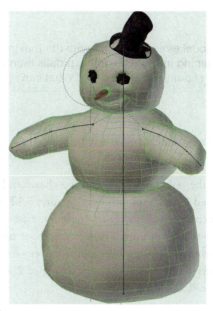

Figure 5.9 *Snowman production model.*

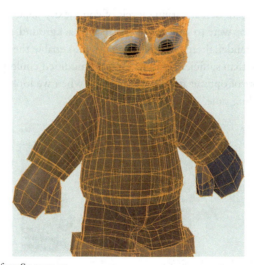

Figure 5.10 *The mesh of the boy from* Snowmen.

If that's the case, you may be able to save modeling time by only using simplified versions of those portions of the model.

Remember that anything that moves quickly will be obscured to a certain degree by motion blur, which can be very forgiving.

Also, I have seen many people model an entire body with great muscle definition and detail, only to cover it with clothing in the end. All of the time spent modeling the body itself was wasted. In Figure 5.10, you can see that there is no body under the boy's jacket and pants.

Level of Detail

The ideal level of mesh detail in your character models will be whatever it takes to not show polygonal edges on curves in your render.

In Figure 5.11, you can clearly see the polygonal nature of the character. However, the same model with a subsurfacing modifier properly applied shows a smooth edge (Figures 5.12 and 5.13). When working with an animation then, it is often better to create models with relatively low base polygon counts and use subsurfacing to smooth them. Figure 5.14 shows the boy's mesh structure without subsurfacing. It has only 3,014 faces, which makes the mesh deformations that happen while animating very responsive. Of course, rendering this sort of model will produce ugly, boxy results. With a subsurf setting of 2, the curves and surface of the boy's face are appropriate for even extreme close-ups (Figure 5.15).

So unless you need to build fine details directly into the mesh, using a simpler basic model that is smoothed with a subsurface modifier works to your advantage in animation. In fact, it is a built-in **level of detail** system.

Level of detail refers to rendering models at varying levels of complexity depending on how much of the rendered frame they occupy. If the boy were to appear only far in the background, taking up less than, say, 20 pixels from top to bottom in the final render, there would be no reason to enable the subsurface modifier. The 3,014 face base model would be more than sufficient, and to use it unmodified could potentially save a great deal of render time. We'll revisit this sort of optimization in Chapter 14 when we look at rendering and compositing, but the strategy begins at modeling time.

Figure 5.11 *The boy model rendered without subsurfacing.*

Figure 5.12 *Rendered with subsurfacing.*

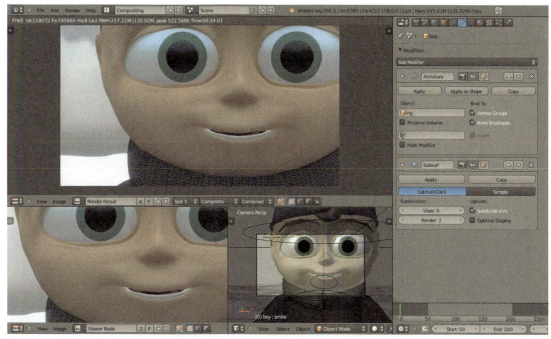

Figure 5.13 *The subsurface modifier in the Modifier Properties.*

Figure 5.14 *The raw model.*

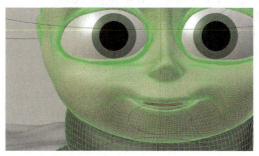

Figure 5.15 *A close-up of the boy with two levels of subsurfacing.*

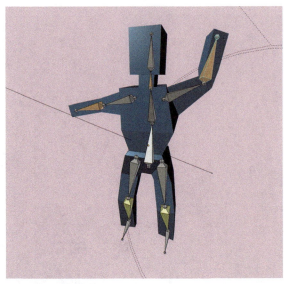

Figure 5.16 *The animation responsiveness test blend.*

Polygon Count

The maximum number of polygons that your particular system will be able to work with while animating is impossible to predict. To help you figure it out, we have included a file called **animation_poly_testing.blend** on the book's website. When you open the file in Blender, you will see the screen shown in Figure 5.16. The file includes a simple mesh and a control armature. In its raw state, the mesh only has 92 vertices, and no computer made in recent years should have trouble deforming it in real time.

Right mouse button select either of the foot bones or the orange arm or neck bones and move them around. This is as responsive as the animation system gets. What we're going to try to do is to find the upper limit of your system's responsiveness.

Select the mesh again, go into **Edit Mode** with the **Tab** key, and select all of the vertices with the **A** key. From the **W key** specials menu, choose **Subdivide**, as in Figure 5.17, and using either the **T key** toolbar panel or the **F6** tweak panel, set it to use **3** cuts (Figure 5.18). This will bring the mesh's vertex count to 1,442. Leave edit mode and play with the armature again. You should still be fine.

Do another **Subdivide** on the mesh, this time choosing **2** cuts, to bring the vertex count to 12,962. At this point, depending on how powerful your system is, you might experience something a little different when you move the armature. It will still be very responsive but will not be the same as previous rounds of the test. If it still feels the same to you, then feel free to keep going until you can really notice a slowdown in the way Blender responds to moving the armature and deforming the mesh.

Your goal is to find a level of polygonal detail that will allow you to model with relative accuracy but still give you a good feel while you are animating. On *Snowmen*, which was mainly animated on an AMD X6 with 8 GB RAM, an nVidia FX550 card, and Xubuntu Linux, I decided to keep the basic meshes below 10,000 vertices.

Figure 5.17 *Subdivide Multi on the W key specials menu.*

Figure 5.18 *Three cuts.*

When you actually get to animating, there will be things that frustrate you: complicated rigging situations you hadn't considered, character/prop interplay, glitches. Don't let a vertex count that is too high for a quick working animation response compound those problems.

So in line with the advice given previously in the section about level of detail, you will want your character models to remain under the vertex level where your system begins to slow when animating, and use a **Subsurf** modifier and possibly normal mapping to provide the additional smoothness and detail you need for great final renders.

Proxy Characters

Of course, if a very high polygon count ends up as essential to your character model, you can use a proxy character.

A proxy character is a lower-resolution stand-in for your final model. We'll learn more about proxy models in Chapter 7 when we discuss the rough set. Suffice it to say that a low-resolution character model shares an identical control rig with your final, high-resolution character. Animation work and previews are done on the low-resolution model. When it is time for the final render, you can use any of several methods that we will learn about later to swap the full-resolution version into the scene.

Preparing the Model for Future Work

Before we leave the world of character design and modeling, there is one more crucial thing you must do. The next time we visit the character models, we will be rigging, skinning, and performing test animations. For that to work without surprises and for your characters to be successfully integrated into your scenes, the following rules should be obeyed:

- Place the 3D cursor along the centerline of your character from left to right, and at the bottom of their heels. Then, use **Ctrl-Alt-Shift-C** (or the Spacebar toolbox) and choose **Origin to 3D Cursor.** The goal is to have the character object's origin between the feet, on the floor. If your character is built from multiple objects, individually select and set each of the different objects' origins to this same point.
- Use **Alt-G** to reset your character model at the origin of the scene. If you've adjusted the object origins of each part of your object, clearing the positioning like this will not hurt the relative positioning of the parts.
- Make sure that your character is in scale with any other characters already created. If you need to, use **Shift-F1** to append another character model you've already created into the file (we'll learn all about this kind of "importing" functionality in the next chapter). If this is your first character, then it becomes the reference for all others that come after it. Many Blender users (and developers) adopt the convention of having 1 Blender Unit equal 1 meter. So a fully grown human character would generally be just under 2 Blender units high. Feel free to use your own system, but make sure to keep it consistent.
- Use **Ctrl-A** to apply any object-level scaling or rotation that has been done to your model.

> **Warning**
> If you do not do these simple things, you could literally waste weeks of work. The rigging, skinning, and animation tools work best with a model whose scale, rotation, and origin are all at the defaults, like the **N** key popup panel in Figure 5.19.

Summary

The design of your characters is constrained by the theme, how the characters are used in the storyboards, and by the needs of maintaining responsiveness during animation and good deformations in the final render. Character design will both be informed by and strengthen the theme. The realism of characters will depend on your resources and the goals of your animation.

Figure 5.19 *The scale, translation, and rotation values for a properly prepared character model.*

While modeling characters, you need to make sure they have a high enough resolution to look good when rendered, but small enough in face count to provide a good experience when working with the animation tools. Often, a subsurface modifier and normal mapping can provide an excellent solution to this dilemma. The requirements of animation must also be respected, with quads and edge loops playing a major role in achieving good deformations later.

71

Chapter 6

Libraries and Linking

Objectives in This Chapter

- Understanding libraries, and why you should bother.
- Linking assets that do not animate.
- Linking assets for object-level animation.
- Linking assets for character animation.
- Managing your links and libraries.

Libraries, and Why You Should Bother

Imagine for a moment that you are working on a large-scale animation project that includes many scene files, each representing a different camera view and portion of the overall timeline. Of course, because this will eventually be edited into one continuous animation, the different scene files all need to contain the same models of the characters and sets, the same materials, and the same lighting. The most obvious solution is to create one master scene file that contains all of your characters, sets, lamps, and cameras. Then, you create a bunch of duplicate files, and rename and use each duplicate for a separate shot.

Perfect, right?

Well, what if after you begin working, you realize that the way you weight painted the main character's mesh just isn't giving good enough deformations? And, let's say you've already animated five out of twenty shots. Or, more simply but significantly worse, what if you want to tweak a material setting? Do your characters share materials, or do they contain duplicates? Will you have to edit every duplicate of that material in every shot file to get it all to match? Immediately, you see the shortcoming of the simple duplication method: any change you make to any element must be made in the same way on every copy of the file.

That could be… cumbersome.

In a hidden hole of functionality even darker than the one where the Video Sequence Editor hides, Blender has an entire workflow devised to solve this very problem: the **library** and **linking** system. Using this system, every BLEND file you have created or will create can be treated as a *library* of assets: models, armatures, materials, lamps, cameras, and even entire scenes.

You can import those assets into your current BLEND file, making them local assets, as discussed in Chapter 3, or you can choose to import them as links. When an asset is brought into another BLEND file as a link, it appears but is for the most part "untouchable." You cannot edit or change the linked version of the asset in the current BLEND file. However, if you go back to the original file that holds the local version of the asset and

make changes, those changes will show up in each and every BLEND file that has linked to it. This is the magic you're going to need for a project that will span dozens of files and months of time!

Unfortunately, not every part of a BLEND file is a linkable asset. Things like node networks and groups of render settings are not linkable. User Interface configurations are not linkable. However, almost all of the assets you will use to produce your animation—mesh models, armatures, materials, lamps, and entire scenes—are linkable. Basically, if you can assign a name to it in Blender, you can link to it as a library.

Before you learn how to actually link to assets, let's take a look at the way that one of the final shot files from *Snowmen* is constructed, so you know where we're headed. If you want to examine this file in Blender for yourself, it is called **snowman/scenes/shot04.blend** in the project archive.

Although it is full of everything you need to successfully render a scene, this file (Figure 6.1) has very few local assets. The characters (Figure 6.2), including their materials, are all linked to (you may also see the term "linked from" used sometimes) their respective files in the **/snowman/models/** directory. The set and almost all of the lamps (Figure 6.3) are linked as an entire scene to the appropriate set in the **/snowman/sets/** directory. The lighting rig and World settings that contain Global Illumination and sky settings are stored in a separate file in **/snowman/sets/worldlibrary.blend**. The few assets that are local to the **shot04.blend** file are the actual animation data for the characters and the spot lamp that follows the boy.

If that BLEND file is moved out of the organized directory structure and opened, it will not know where to find all of its linked assets and will appear as it does in Figure 6.4. All that is left are the local assets of the spot lamp, particle-based snow, some cameras, and a couple Empties that acted as animation stand-ins for the boy and snowman.

Each "shot" file in the **scenes** directory is constructed this way, meaning that any changes made to assets in the **sets** or **models** directories will automatically carry through when that shot's file is opened for work or rendering.

In fact, most individual assets have their own master BLEND file, either in the **models** or the **sets** directory. Figure 6.5 shows the file **jungle_gym.blend** from the **models** directory. This file contains the teeter-totter from the playground that appears behind the boy in the opening shot. The file has mesh objects and an armature, which is necessary to animate the structure. These objects are all named appropriately so they are easy

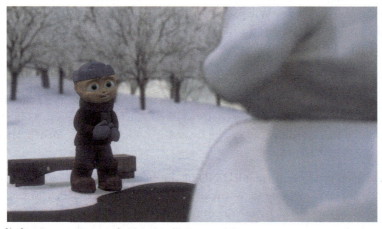

Figure 6.1 *A shot file from* Snowmen, *in production.*

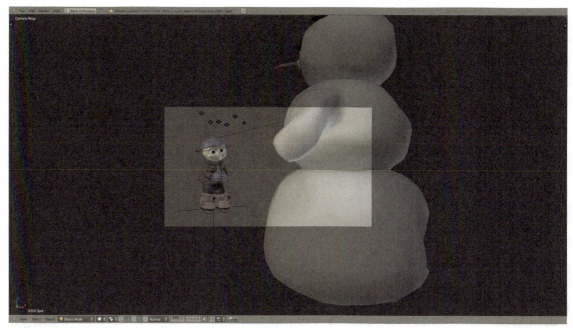

Figure 6.2 *The characters.*

Figure 6.3 *Lighting rigs.*

Figure 6.4 *Shot04.blend opened without its library linked assets.*

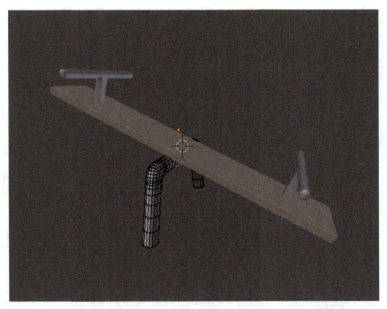

Figure 6.5 *The teeter-totter.*

to keep track of when part of a crowded scene, and they are easy to identify when creating the asset links. In addition to the assets that we want to link to, the file also contains a camera and some lamps, which were used for test renders while building the model. These objects can be left in the file for later testing and tweaking, as they can simply be ignored during the linking process.

As a "best practice," both the main mesh object and the controlling armature have no transformations applied to them within the library file. Remember what we did with the character model in the previous chapter? The same rules apply to set objects. Looked at through the **N key Transform Properties** panel, they show Locations of 0, Rotations of 0, and Scales of 1 (Figure 6.6). The **DimensionX/Y/Z** fields show the actual dimensions of the object, so you don't need to worry about forcing them to any specific values.

If you have opened the jungle gym file for yourself, you'll see that there are actually two sets of objects within it: the teeter-totter and the larger jungle gym. For organizational purposes, you might choose to put objects of a similar category (like playground equipment) into a single BLEND file and link the objects into your production files separately. The choice is yours, and it is purely based on how you feel you can best organize and locate your assets. You can see the directory listing from *Snowmen's* **models** directory in Figure 6.7.

Let's examine each of the pieces in the shot from Figure 6.2 to learn the different ways to link and use your assets.

Figure 6.6 *A "zeroed" transformation panel.*

Figure 6.7 *The models directory of* Snowmen.

Linking Assets That Do Not Animate

In an animation production, assets that do not move are called the **set**. Linking set assets is the simplest form of library use, and a good place to start.

To begin a new set, create a new BLEND file and save it.

Press **Ctrl-Alt-O**, or choose **Link** from the main **File** menu, which will bring up the file picker/browser as shown in Figure 6.7. Just like in Chapter 3, you navigate to the BLEND file that contains the assets you would like to link and click on it as though the file itself were just another directory that you would like to browse. In fact, it is just that. Blender presents the contents of the file in a directory-like format, showing all of the categories of assets that are available. For now, we will only be diving into the **Object** "directory." This example, shown in Figure 6.8, will link the model of the jungle gym from the **junglegym.blend** file.

Figure 6.8 *The contents of the Object directory within junglegym. blend.*

Before selecting the jungle gym objects, both the **Link** and **Relative Path** buttons in the **Link/Append From Library** panel of the picker are enabled. They should be, by default, when using the **Link** command or **Ctrl-Alt-O.** If you use **Append** instead of **Link**, a full local copy of the jungle gym would be created in the current BLEND file. It would be the equivalent of "importing" the object. If **Relative Path** is disabled, then Blender will always look for the jungle gym asset in the same place in the computer's directory structure as it is now. That may seem like a good thing until you realize that you may be working with these files on different computers and sending them to a render farm at some point. When that happens, unless the drive names and directory structures of all other systems you will use are identical to the original machine, the link will fail.

So with **Link** and **Relative Path** enabled, you can click on the various objects whose names begin with **junglegym** in the list with the **left mouse button,** holding down the **Shift** key to build the selection. The jungle gym actually consists of several different objects. Then, click the **Link/Append from Library** button in the upper right to link them into the current file.

If you are following along on your computer, you may have to enable all layers (` key) and zoom out a bit to find the jungle gym object. The first thing you will notice is that the jungle gym appears in the scene in the same location it held in the original library file.

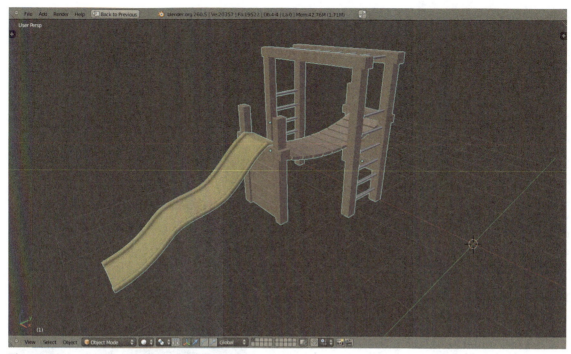

Figure 6.9 *A solid view of the linked in jungle gym.*

Figure 6.10 *The same object in wireframe.*

Although it is not easily seen in a solid view (Figure 6.9), the equipment's outline and wireframe representation are a light blue (Figure 6.10). An object that is linked in from a library file has a dark blue wireframe when not selected, and it has a light blue one in its selected state. The normal colors for a local object are black and orange, respectively. This color coding lets you tell at a glance which of the assets in a given scene are local, and which are links.

Remember how we said that this was the linking method to use for objects that did not move? If you select the jungle gym object and attempt to transform it in any way, nothing will happen. It is anchored in place. This is because everything about the object, including transform data like location, rotation, and scale, is merely being referenced from the original library file.

There are a couple of things you can do to such an object, though, to help organize your scene:

- You can move linked library objects to different layers. Pressing the **M** key to pop up the layers panel lets you send the jungle gym to a different layer.
- Linked objects can be added to and removed from groups. Groups are used for both organizational purposes and for restricting certain lighting and simulation effects.

Let's take a look at the current project tree in the **Outliner** view (Figure 6.11). Notice the little page icon with the arrow in it beside the object name for the jungle gym entry? It indicates that the designated object is, in fact, linked in from a library. Additionally, by switching the Outliner to **Libraries** view on the header (Figure 6.12), you can see a listing of the different source files that the current BLEND file is linked to. Note that this view is one way only. For example, you could not use it with the **junglegym.blend** source file open to tell which other BLEND files were making use of it.

Of course, there may come a time when all of the indicators that an object is linked and not local escape you, and you try to do something to the object that is not allowed, such entering **Edit Mode** with the **Tab** key. At some point it will dawn on you that you cannot edit a linked object. You must return to its source file to make any changes.

With the jungle gym object selected, examine its **Material** properties. You will see, as in Figure 6.13, that the object's

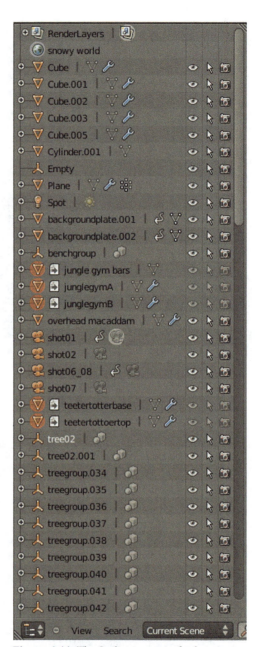

Figure 6.11 *The Outliner properties for the scene.*

Figure 6.12 *The Libraries Outliner view.*

materials have also been brought in as links automatically. Although its settings are visible, they are grayed out and disabled. Just like with the object's mesh data, attempting to alter this linked material here will produce no results. You simply cannot do it.

Make Local

You will not want to use this technique during a production like this one, but it's good to know anyway. If you are in a situation where you have a linked object and you would like to make it a local object, it can be done. Why would you want to do this? Perhaps you've realized that this instance of the object and this one alone needs to be different from the others, or you no longer care if modifications to the object's master file update this one. In those cases, select the object in the 3D view and press the **L** key. From there, you can choose to make only the object local, leaving things like mesh structure and materials linked, or to make both object and its data local as well.

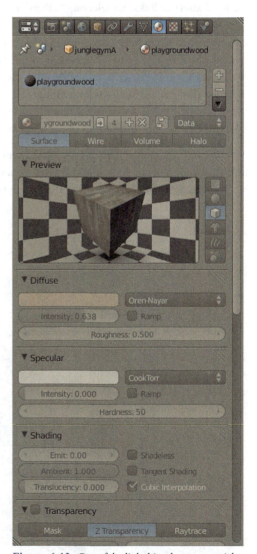

Of course, your set will probably consist of more than a single object, and to link the different set objects into each of your shots piece by piece would grow tedious.

Let's back up a step to find the solution. Within a single BLEND file, you can have several **scenes**. If you've only worked with still imagery, you may not have encountered anything other than the default scene. Now is the time. Located on the main header is the drop-down menu for choosing and adding scenes (Figure 6.14). A scene itself is a single library asset that you can link into another file.

Delete the jungle gym object from the current scene, and reopen the **Link** file picker with Ctrl-Alt-O. Blender returns you to the same place in the file that you were before, the **Object** directory. Click the "**..**" or the up arrow on the header (Figure 6.15) in the file list to go up to the listing of asset types. From there, choose **Scene**, and select the scene called **fullset**.

Now, the Scenes drop-down on the header presents you with a second scene to choose from. Select **fullset** from the menu, and you will see Figure 6.16 (you may have to enable all layers and adjust your 3D view to see it exactly like this).

That would have been a lot of stuff to bring in had it been done object by object! Notice the "arrow page" icon to the right of the scene's name, indicating that it is a linked asset. Many of the settings in the interface are now disabled as well.

Every object that is in the scene called "fullset" in the library file is here, including the cameras. Selecting any of these objects that were brought in as part of the linked scene shows the same color scheme of blue outlines. There is one difference, though, from the linked jungle gym object we brought

Figure 6.13 *One of the linked jungle gym materials.*

Blender Production

in before. Notice, in Figure 6.17, that the "arrow page" icon beside their object names in the Outliner appears darker than the one beside the Scene object itself. This is because the Scene object is the directly linked object, whereas any items brought along with it are only there through that first link. Thus, they are referred to as **indirectly linked**.

As these objects are indirect links, you cannot even move them to other layers as you could with a directly linked object. If your sets are well constructed, though, this is not a problem.

Back in the original blank scene (not the one called "fullset"), check out the **Scene** properties. Here's one more Blender secret: the **Background** control on the **Scene** panel lets you use another scene as a ghosted, unselectable set. Clicking the selector highlighted in Figure 6.18 brings up a list of all other scenes in the BLEND file. It doesn't care whether the scenes are local assets or links. So selecting "fullset" from the menu that comes up uses the linked "fullset" scene as a set for the default scene. Figure 6.19 shows how the set appears grayed out, or ghosted. The great advantage of using this function is that nothing in this set is selectable from the main scene, meaning that you are free to work without the large number of objects that make up the set getting in your way as you select and work with your characters and interactive props.

Now, witness the power of this fully armed and operational linking system: you can link in as many set scenes as you care to. If you have half a dozen set files that are optimized with

Figure 6.14 *The Scene selector on the main header.*

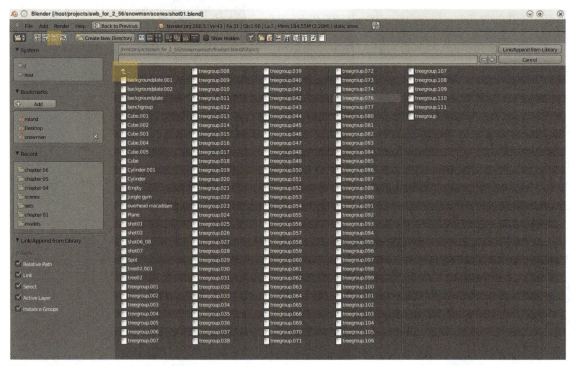

Figure 6.15 *Moving up a level in a file's asset structure.*

82

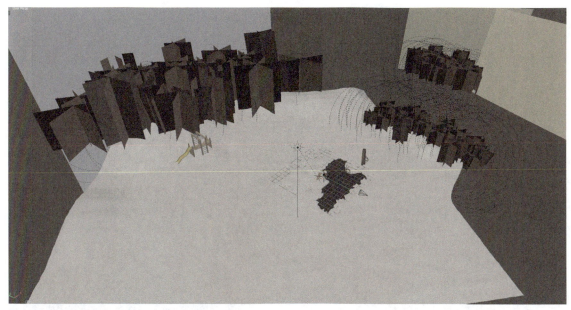

Figure 6.16 *The linked set.*

Figure 6.17 *The icon that designates an indirectly linked asset.*

Figure 6.18 *The Sets popup menu on the Output panel of the Scene buttons.*

Figure 6.19 *"Fullset" brought in as a set for the main scene.*

lighting schemes and levels of detail for different camera angles, you can link every one into your shot files with almost no overhead. It costs next to nothing to do so from Blender's standpoint, and you can easily switch between sets by choosing different ones from the popup in the Scene buttons. And since the set scenes are all linked in from your master files, any changes that you make to the original models, lighting, or anything else in your sets automatically propogate to every shot file in your production. Your files are always up to date. Problem solved!

In the chapter on set creation, we will look at exactly how to build and structure your set file (or files) to make the best use of this system.

Linking Assets for Object-Level Animation

Obviously, if you are producing an animation, certain things are going to have to be, well, animated. Before we get to character animation, we'll take a look at dealing with the animation of objects that don't contain control structures like armatures and that don't require deformation. This type of object is called a **prop**. It is something that the characters in your story will interact with. It can change over time and will often have to be synced with the actions of the characters. Therefore, it cannot be a part of the **set**.

Creating and Linking a Dupligroup

If you are following along with the provided project, open the **stick.blend** file from the **models** directory. Figure 6.20 shows the file contents. Notice that the stick's mesh outlines are green. Green object lines in Blender indicate that the object is a part of a **group**. In the actual production of *Snowmen*, there aren't any props like this, so although we will use this stick as an example, you will not find it used anywhere in the files.

In Blender, **groups** are simply groups of objects that have been assigned a unique name. You add objects to a group by selecting them in the 3D view and pressing **Ctrl-G.** Doing so creates a new group and adds all currently selected

Figure 6.20 *A wireframe view of the **stick.blend** file.*

objects to it. The name of the new group (which defaults to "Group," "Group.001," "Group.002," etc.) can be changed in the **T key** toolbar or the **F6** tweak panel. There are other ways to do it, which you will see in a moment.

Groups are handy for a number of things, most of which deal with object management. Materials can restrict their lighting to lamps from certain groups. For example, you could have a lighting rig with 14 different lamps and use grouping and material settings to cause one object to only be affected by a smaller set of those lamps, regardless of where it is. Also, rendering, force fields, and particle systems can make use of groups to restrict their effects.

The reason that the stick has been added to a group (called, incidentally, "stickGroup") is that groups are library assets themselves, which means they can be linked into other files, and groups can be used with Blender's **Group Instance** functionality. **Group Instancing** is the ability for a Blender object to act as a stand-in for an entire group. Figure 6.21 shows two Empties. The one on the left is a traditional Empty. The one on the right is an Empty that has been enabled to act as a Group Instance and has been set to use the "stick" group.

Here's how to prepare the objects in your library files for linking as a group:

* Select all objects that will be a part of the prop in the original library file.
* Create a new group for these objects with **Ctrl-G**, and name it something sensible (Figure 6.22).
* Save the library BLEND file.

Figure 6.21 *An Empty set to use Group Instancing.*

Once you do this even a few times, adding an object to a group and assigning it a name will turn into a reflex operation that you can accomplish in a few seconds.

On the other side of the process, let's link a group into the working scene file. Figure 6.23 shows the shot file from the previous example with the full set linked in as a separate scene and enabled as a **background**.

Next, use **Ctrl-Alt-O** and browse to the **Group** section of the **stick.blend** file, as in Figure 6.24, and select the "stick" group. Make sure that the **Instance Groups** option is enabled on the leftmost side of the picker.

Note on the Properties header in Figure 6.25 that the **Empty** properties are available. This is because Group

Figure 6.22 *Naming a group in the tool shelf.*

Instances live on the back of Empty objects. The linked group you see in the scene is really just an Empty, with Group data displayed in the 3D view. If you switch to the **Object** properties (the settings with the cube icon), you will see on the **Duplication** panel that the radio control has been set to **Group** and the **stickGroup** group has been chosen in the selector below it. This means that if you wanted to, you could add a plain old Empty to your scene and configure it to be a Group Instance "by hand" with these controls.

Of course, as the Empty itself is a local asset, you are free to animate it as you wish!

When you use Group Instances, the Scene origin from the master object file becomes the location of the Empty when the Group Instance is created. So if you want the objects that make up the Group Instance to appear centered on the Empty, you would place them at the Scene origin in the original file. Figures 6.26 and 6.27 demonstrate this behavior.

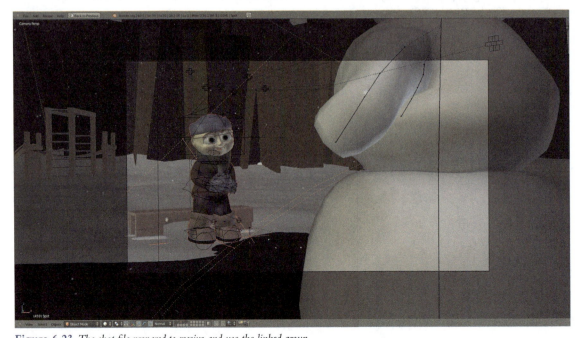

Figure 6.23 *The shot file prepared to receive and use the linked group.*

Figure 6.24 *Selecting "Group" from the asset list.*

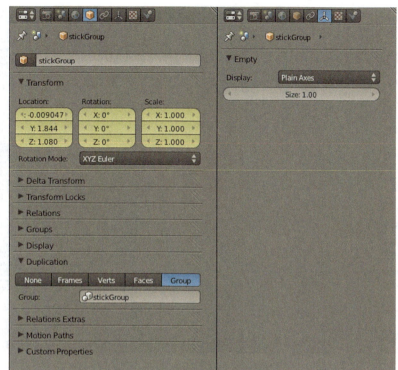

Figure 6.25 *The Empty and Object properties for the linked stick.*

Figure 6.26 *A group whose object's center is on the origin and its Group Instance visualization.*

Figure 6.27 *A group whose objects are away from the origin. Note how the stick is now offset from the Empty.*

If you are organizing your assets within a single file as mentioned earlier in the chapter, you don't want to end up with all of your groups at the origin. Things could get messy. When using this organizational method, you can leave your groups wherever they are and apply an offset to them by using the **From Cursor** button on the **Groups** panel of the **Object** properties. Just place the 3D cursor wherever you want the origin of the group to be and hit the button.

Linking Assets for Character Animation

Properly bringing characters into your shot files with links requires a little more preparation but builds on the techniques already used. In the next chapter, we'll look at rigging and skinning your characters, but some of the object preparation advice given there mirrors what was said in the previous chapter: make sure that all rotations and scaling are applied to your character components in their master files before you attempt to do any animation.

Just like working with a single prop, you navigate to the **Object** section of your library file. In Figure 6.28, you can see the listing for all objects in the **boy_rigged.blend** file. When building this library file, I made sure to begin the name of all of the components of the character with "boy" so that they could be easily identified when looking at long lists of object names in places like the file picker or the Outliner. All of the pieces of the character, including the control armature and any deformation helpers like lattices or deform cages, are then placed in a single **Group**. It is crucial that the different parts of the character all have their origins centered on the origin of the scene so that the Group Instance that we'll bring into the working set file appears in the proper place. This group is linked into your main scene file, bringing all the parts of the character with it.

You already know that you can move the Group Instance as a whole, by transforming the Empty object to which it is attached. But how do you get access to the armature "inside" the group? Blender allows the creation

Figure 6.28 *All of the objects that make up the boy model.*

of an **animation proxy**. An animation proxy is a local instance of a portion of the group that, while it remains linked to the original and the other members of the group, is freed to undergo certain changes. In the case of an armature, it is freed for animation work.

To create an animation proxy of the armature, select the Group Instance of the character and press **Ctrl–Alt–P**. A menu pops up that lists all of the component objects that make up the group, like the one in Figure 6.29. This is where a clear naming scheme will help you to avoid rework. Choose the armature from the list, and Blender automatically retargets the rest of the linked objects toward the new proxy armature. You can now animate the Group Instance character locally by working with the armature, which is now fully accessible. Notice in Figure 6.30 that the outlines of the mesh objects for the character are still blue, indicating that they are linked assets, even though the local proxy of the armature controls them.

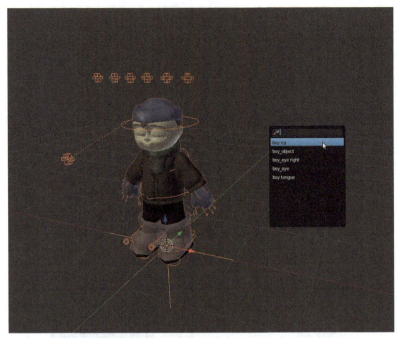

Figure 6.29 *Choosing the armature during the Make Proxy process.*

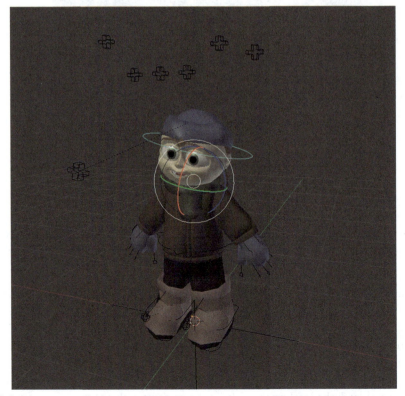

Figure 6.30 *A linked character controlled by a proxy armature.*

Managing Your Links and Libraries

Blender gives you several tools to examine and manage your linked libraries. Figure 6.31 shows an Outliner view set to show library assets, which we mentioned earlier in the chapter.

This view shows all of the libraries that are linked into the current BLEND file. Relative links will begin with a "//" symbol, the double forward slash. If you see these in front of all of your library path names, then you've done things correctly. If, however, you see ones that begin with either a single "/" followed immediately by path information or a drive letter like "C:\", you have absolute links to a library.

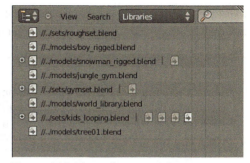

Figure 6.31 *The Outliner set to Libraries.*

Remember that using relative links will preserve your ability to access your shot files and their libraries if you move or copy the production onto another computer or if you are trying to use them over a networked drive.

Finding and Fixing Broken Links

There may come a time in your production when you open a shot file only to see that some, or maybe all, of your linked objects are missing. To make sure that is what's going on, check the Blender console. If you see something like Figure 6.32, then your links are broken.

> **Note**
> You can find the console in the Blender 2.6 series by pulling the top header bar downward.

Figure 6.32 *The Blender console reporting failed links.*

Don't panic. This can almost certainly be fixed. There are a number of reasons that your links might be broken, and each has its own remedy. The following hints only apply to libraries that are linked with relative paths.

> **Warning**
> When attempting to fix broken links, do not save any of the shot files you have opened. Saving a file with a broken link can result in losing the link, and possibly other local data, entirely, making it unrepairable. Of course, if you are fixing the original library files themselves, any changes you make will have to be saved. But as a general rule, avoid saving any file that reports broken links.

- If only a single link out of many in your file is broken, then the culprit lies with the original library file. First, examine the supposed path in the Outliner. Look on your disk for the file. It is possible that either the library file has been moved to another directory or the filename has been changed. In either case, simply move the file back to its original location, or restore its original filename, both of which can be obtained from the Outliner in **Library** view. If the path and filename are correct, you will need to look inside the Library file. Most likely, the name of the original object has been changed. You need to change it back to its original name to restore the link.
- If some but not all of your links are broken, then files have been moved or renamed. If all of the links were to the same file, check to make sure that file's name and path appear as they do in the Outliner.
- If all of the links in a file are broken, there could be a number of reasons. First, has the shot file been moved from its original directory? If it is not in the same position in the directory structure relative to the libraries as it was when the links were made, it will fail. To fix this, simply move the file back to its original directory. If that is not the case, then it is almost certain that somewhere along the way a directory has been renamed or moved. This will cause all links to fail. You must restore the original directory structure for the links to function again.

In addition to the information available in the Outliner and the console, you can also have Blender generate a report on any missing links. In the main **File** menu, there is an entry for **External Data** that has a number of options. From that menu, choose **Report Missing Files**. With this command, Blender generates a text file with a list of any missing links that can be viewed directly in a Text Editor window.

It's pretty obvious from the troubleshooting advice given here that maintaining file and directory names, as well as their locations, is of primary importance when dealing with libraries and linking, and that changing them, either accidentally or on purpose, will result in problems. The organized directory structure suggested in Chapter 3 is an attempt to minimize your need to move things around once you've begun to work. Of course, you might run into a situation where you need to move a file. If it's a shot file that contains lots of links, it turns out that this is not so hard to do.

Moving a Shot File and Maintaining Its Links

If you want to move a shot file to another part of the overall directory structure of your project, use the **External Data** menu again and select **Make All Paths Absolute**. Then, save the file and quit Blender. It's true that so far all we have talked about is how splendid relative paths are for your project, and now we're saying to change all paths in your shot file to absolute ones. Don't worry. They'll only be that way for a moment.

Move the shot file to its new location, restart Blender and open the file. Because you used absolute disk paths, Blender still knows exactly where to look to find the links, keeping them alive. Now, use the other path

command from the menu, **Make All Paths Relative**, which will rebuild all the paths as relative and make your whole project portable once again. You've just moved your shot file into a different directory and maintained your relative links.

Moving an Asset File

Don't do this. Seriously. Just don't.

Obviously, if you've not linked any of the library file's assets into scenes in other files, this isn't a problem. However, when you move or rename the file, there is no way to determine for sure which scenes have linked to assets from it. You will only be able to tell when you open those files and find the links broken. Unfortunately, the process of opening a file with links, especially proxy objects, can cause irreparable damage to the links, meaning that even the **Find Missing Files** tool in the **External Data** menu item may not fix things. The files will be relinked, but the damage to the proxy will already be done. If you do have to move or rename an asset file, though, here are some suggestions to help you out:

Situation. You've moved the original asset file, then linked those assets into other scenes from the new location.

Solution. Create a duplicate of the file and return the duplicate to the original location using the technique described earlier if the asset file itself contains any live links. If you are going to do this, though, make sure that you do not save the file with broken links when you discover it. Once again, doing so can ruin the file.

Situation. You've moved or renamed the original asset file and for some reason cannot or will not duplicate the file into the original path.

Solution. You will have to locate any assets in the shot file that are linked to the missing file and delete them (the Outliner can be helpful for this). Then, you will need to relink them from the **Ctrl-Alt-O** dialogue, as though they were brand new links. If you used proxies before, you will need to create new ones. After you have all of the assets linked back in, you use the Action Editor to reattach animation actions to the appropriate objects. If you were rigorous about naming Actions as they were created, this will be easy. However, it's more likely that you will need to go through a trial-and-error process to find the correct actions for each linked object.

Or, to put it more simply, don't move or rename your asset files once you've linked to them.

Summary

Libraries and links are the technical bedrock of a consistent large-scale animation project. Each asset in the project (characters, sets, props) is created in its own BLEND file, which acts as a library to which other files can link.

Depending on your needs, there are different ways to link and use these library assets. For an animation's sets and other static objects, it is sufficient to link them in as an entire scene, then use that scene as a background set in the Scene properties. Assets that require only object-level animation can be linked by adding them to a group, and linking that group into the scene as a Group Instance. For character animation work, all of the elements of the character including the rig and controls are placed in a group. That group is linked into your production file as a Group Instance, and an animation proxy is created for its control armature.

Library and link information can be viewed in the Outliner, in the console when the file loads, or with the Report Missing Files tool in the External Data submenu of the File menu. It is important to maintain your original filenames and relative paths once you begin linking to your library assets.

Chapter 7

Rough Sets, Blocking, and an Animatic

Objectives in This Chapter
- Creating rough sets.
- Building your template scene file.
- Matching camera angles and character blocking to the storyboards.
- Considering additional detail: reusing cameras, moving cameras, moving characters.
- Creating an animatic.

INBOX

Coming into this chapter, you need the following:

- Character models—these do not have to be rigged or completed
- Completed storyboards (Chapter 4)
- The ability to create models in Blender
- A knowledge of linking assets (Chapter 6)

Creating Rough Sets

At this point, you have character models, a story reel, and not much else. It is time to start bringing the pieces together. Your characters need a meeting place, and that place is going to be a rough set. Now, if your final set will be very simple, there is no need to create a rough version at this early stage. Just build your final set and skip this section. If you're wondering why you would want to create a rough set, well, it comes back to time. Sets, like any other aspect of an animation project, could occupy an infinite amount of your time. If it came to choosing between having crummy, half-baked animation appearing on a beautifully detailed set or wonderfully crafted animation taking place on a minimalist set, which would it be?

Hopefully, it won't come down to that, but you never know. It might. Our goal is to get to the animation phase as quickly as is practically possible so that it occupies the majority of your time. Later on, you can spend any time you have left enhancing your sets or getting outside help with them.

During the story development and storyboarding process, you probably developed a decent sense of the physical space in which the story takes place. Actually, this is one of the reasons for acting out the story and creating the storyboards in the first place.

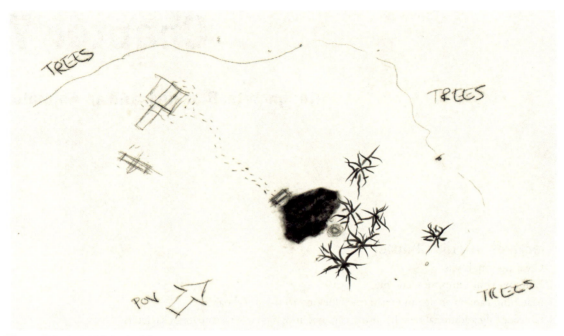

Figure 7.1 *An initial sketch of the set.*

It will probably help before you begin working in 3D to sketch an overhead map of the set, either on paper or in a digital painting program. Figure 7.1 shows an initial sketch of the set for *Snowmen*. Notice the cameras on the sketch. Even though we haven't placed cameras in a 3D scene yet, we can use our storyboards to make a guess as to where they will be placed. This also lets us know which areas of our set will actually be observed and which ones won't. Shooting a live-action film like this, you would most likely find a playground, which automatically includes things like backdrops (the sky, hills, etc.). When working toward a 3D set, we only want to include the bare minimum—things that will appear on camera.

The point is that a set for an animation is more like a set for a television show or movie than it is an analog of real life. If you've ever seen a shooting set for the interior of a building, it is radically different from a house or apartment in the real world. The requirements for living in a place are completely different from the requirements of staging and filming a production in one. Of course, as our sets are digital, we can easily do things like remove a ceiling, make a wall or piece of furniture transparent, or put up a picture for the sky in order to get the shot we are after, so the stylization of the set does not have to be as extreme as that of a physical production.

Preparing the File for the Rough Set

To begin your rough set, create a new BLEND file. Just like working with multiple characters, it is important to maintain the same physical scale across all of your files. So use a **Shift F1 Append** command to import one of your characters into the file (Figure 7.2). There's no need to bother with linking, as you'll be removing this character once you have established the scale.

If you are working with an exterior, the obvious starting point is to add a plane for the ground and scale it past the bounds of where the set objects will sit. The easiest way to begin an interior set is to trace the floor plan. Even though the terrain in the final animation will show some variation in the background, the areas where the action will take place will be flat, so a simple plane will work nicely.

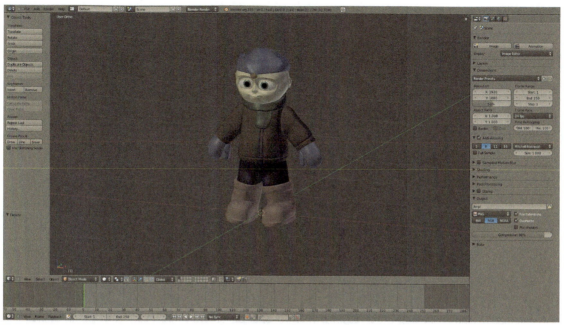

Figure 7.2 *An empty BLEND file with a character mesh appended.*

If you are working with an interior space, you don't even need walls or a ceiling at this point unless your characters will be making contact with them. The rough set is all about boundaries. The ground/floor is necessary because your characters and props will (probably) be making constant contact with it, and you need it for a reference. Any other items you add will be there for that same purpose: as a reference for contact or position. No final frames are going to be rendered with this rough set, so the shading of any of its objects and their exact contours and construction are mostly irrelevant. All that matters is that when you put the final high-resolution sets in place, your characters and props are already set to react to any surfaces they coincide with.

As Figure 7.3 shows, the rough set for *Snowmen* consists of a ground plane, a cube, and a cylinder. The cube stands in for the bench the boy sits on, and the cylinder is the trunk of the tree around which the snowman will peek. As we will be animating our characters within the rough set, it is important that the height and positioning of the bench cube match the model of the actual bench in the final set. How do you accomplish this? Well, when you build your final set, you simply make sure that it matches. If you have already finished your bench object or have obtained one from somewhere else, add it to the rough set scene and size the stand-in cube to match its dimensions.

For a little additional visual feedback while you animate, you can assign simple materials to your set pieces. Only the main and specular colors, and the amount of specularity will make a difference in the regular solid view, so you can ignore any other settings (Figure 7.4). Figure 7.5 shows things with basic materials so that the rough set has some color. I've actually gone one step further here and used vertex painting to give a rough idea of where the blacktop surface is compared to the snow. To get it to show in the 3D view, I've used the **Textured** view option, set to **Multitexture** shading, in the **N-key** properties. When I do that, it turns out that the textures on the boy and other items display incorrectly. At this point, you have to decide how complex you want to get with a rough set. I went the extra few steps and set the other objects' maximum drawing style to **Solid** in their object properties, producing the final image shown in Figure 7.5. I've also added a few extra cubes in the background to represent playground equipment.

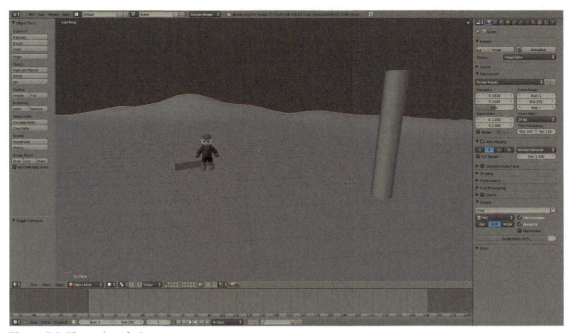

Figure 7.3 *The rough set for* Snowmen.

Unlike other elements of the production, it's not even necessary to apply your rotation and scaling to any of these set objects. This entire construction will be replaced throughout the course of the coming chapters. Speaking of placeholders, if you added a character to confirm your scale, you should remove it now.

The only thing that you should do after the rough set is finished is to name the scene something appropriate like "roughset," as in Figure 7.6. Then, save it as "roughset.blend" in your **sets** folder.

If you have several sets, then your scene and filenames should reflect that with proper descriptions. Your goal is to be able to link these rough sets into your working files as entire scenes, and use them as **backgrounds** in the Scene properties, as shown in Chapter 6. In *Snowmen*, there will only be a single set. However, even with a single set, you may want to have different scenes. Although you won't need to truly worry about it until you build your final sets, it is good to understand the technique right away.

Figure 7.7 shows a shot of the complete final, single set for *Snowmen*. You already know how to link this scene (called *finalset*) into another file. But what if you have a series of shots that only feature one part of the set? For example, storyboard #3 shows the snowman peeking out from behind a tree. Do you really want Blender to have to deal with all of the playground equipment just because you linked in the full set? Of course not.

If you click on the New Scene button (the "+" symbol) beside the scene name on the header, you are presented with the dialog shown in Figure 7.8. The option that you want is Link Objects. This creates a new scene that automatically contains links to all of the objects in the current scene. These objects are brought in individually though, not as a group, so you can delete them individually. In this case, I am going to remove all playground equipment, the boy's bench, and any background objects that won't appear in woods shots. Figure 7.9 shows the result.

I give this new scene a descriptive name like "finalset forest." All of the objects are linked in from the first scene, so if I decide to rearrange things or even edit the objects later, any scenes created in this fashion will

Figure 7.4 *A basic material for coloring the set in the OpenGL 3D view.*

automatically update. Furthermore, I can individually link all of these scenes into my later animation files and choose between them with the **Background** control at will. It's very flexible.

The Template (or Master) Scene File

Each camera angle in your animation is considered a "shot." Each shot will eventually have its own BLEND file. Although each of those files will have an optimized population of characters, sets, and props, they will all be traceable back to a master file for the scene.

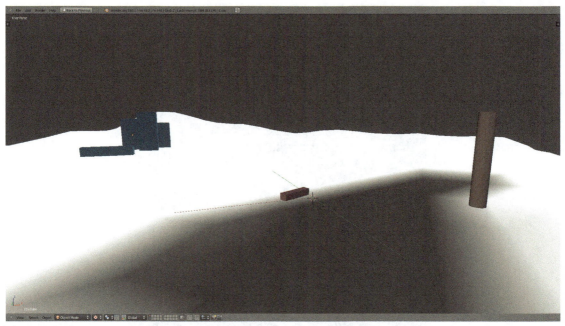

Figure 7.5 *The* Snowmen *rough set, colorized.*

Figure 7.6 *Naming the scene for later use.*

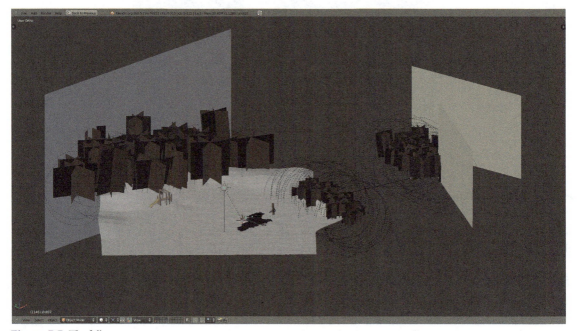

Figure 7.7 *The full set.*

Figure 7.8 *Creating a new scene.*

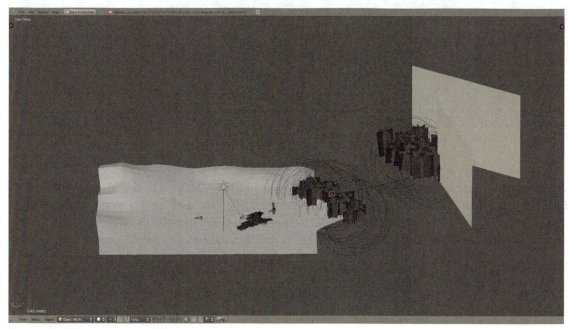

Figure 7.9 *Many objects removed that won't appear in woods shots.*

The **template scene file** (sometimes called the master scene file, master shot file, etc.) is a BLEND file that contains links to all of the sets, props, and characters that are in a scene, as well as all of the different cameras and lighting rigs that will be used throughout. It will act as a baseline for most of the shot-by-shot files that you will create later. Each separate scene will have its own template file.

To create the template scene file, start with an empty BLEND. Save it with an appropriate name so that relative path linking will work. In *Snowmen*, it was called **snowmen_scene_template.blend** and placed in the **Scenes** folder.

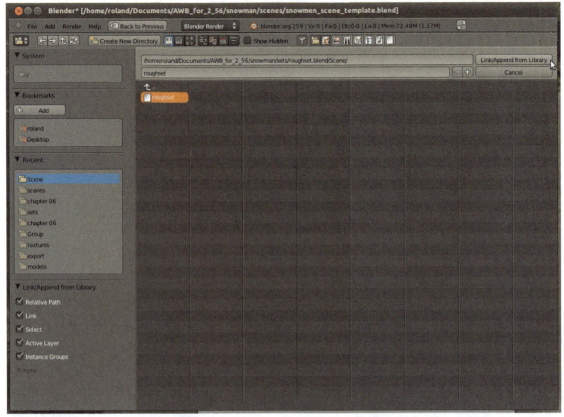

Figure 7.10 *Choosing the rough set scene for linking.*

Use **Ctrl-Alt-O** and navigate to the file containing your rough set. Make sure that **Relative Path** and **Link** are enabled in the file chooser screen, and find the scene (not the objects!) that contains the set. Figure 7.10 shows the rough set selected from the **Scene** section of the BLEND file. When you link the set scene, Blender will not show any noticeable difference in the 3D view, but rest assured, your scene is there.

In the **Scene** properties, choose the "roughset" scene as a background, using the control in Figure 7.11.

If you have any props you want to bring in at this point, link them in as Group Instances as explained in the previous chapter. Position any props at their starting points.

At this point, you are ready to add your characters to the template. Unless you have worked ahead, your characters are not yet ready for animation. They are basic meshes, possibly untextured. You will not be animating the characters now, just moving them around like statues, so this is okay. The fully animatable versions of the characters will replace them later.

Because adding characters to your scene for animation involves bringing them in as Group Instances then creating animation proxies of the control armature, we can just skip the last step and use them as single objects. If you haven't already done so, open your character files and place your character models into groups. Link those groups into your template scene file just like a prop. In Figure 7.12, I've brought both the boy and snowman into the template file as Group Instances. I then duplicate the boy several times to stand in for the children on the playground.

Figure 7.11 *Choosing the background set.*

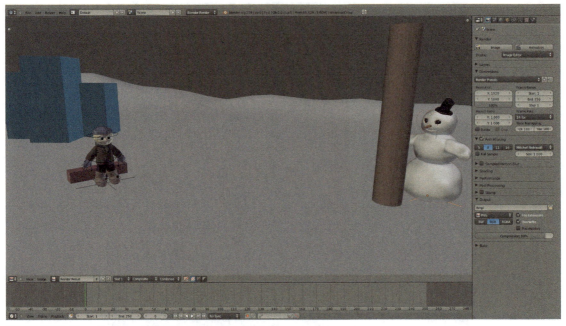

Figure 7.12 *Group Instances of the characters in the template file.*

When all of your characters are linked into the template file, it's time to find out how good your visualization skills have been.

Why Use a Different File for Each Camera Angle?

It may seem like needless complication to create a new BLEND file for each camera angle in your animation. During the course of the production, though, you will see that it grants you significantly more freedom in both animation and direction. Consider the following problems you can run into when working with a single, monolithic BLEND file for your animation:

Composition. When switching between two camera angles, the framing may not be exactly what you want. A configuration that looks great from one angle may not be ideal from another. The solution is to tweak the positioning of the characters for each angle. When edited together, such a shift will not be noticeable to the viewer but will enhance the composition of both shots. With a single file, you have to perform keyframing sleight of hand to make the characters jump into their positions for each shot, probably causing motion blur problems. If each angle is its own file, you simply adjust the characters as needed for each shot.

Bad animation. There is a bit of animation you are displeased with or for some other reason would like to replace. If your character has a two-minute-long stream of animation in your single file production, you have to make sure that removing or replacing the bad animation doesn't mess with the good animation and maintains proper transitions. If your animation is broken up into smaller portions, each with its own file, this once again becomes an easy problem to solve. Replacing the animation for a discreet shot does not endanger any of the work done on other shots.

Render management. You are ready to render your animation. Whether you are using a render farm or just your home workstation, having to baby-sit your single BLEND file along the way can

be a pain. For each camera angle, you have to make sure that the proper camera is selected, the right frame range is designated, and the right combination of sets, props, characters, lighting, and render options is used. Each time you want to render a different angle, you have to reevaluate and possibly reset all of these. If you need to go back and rerender a particular shot, you have to make sure you set things up just like the first time. When each shot is its own file, all of the optimizations and render settings for that shot are permanently saved in the file. All you have to do is open it and render, or, send that file as is to the render farm.

Division of labor. If you are working with a team, a file-per-shot approach allows the easy division and assignment of the animation work.

Matching Camera Angles to Storyboards

You're about to start adding cameras to this template file and matching real 3D camera framing to your storyboards. If you have a dual monitor system available, this is a great time to start using it. The procedure is to add a camera to the scene, bring up a storyboard and try to match the framing of the actual shot to the storyboard illustration. With a two monitor setup, it's easy to bring up the story reel in the secondary monitor and work with your 3D scene in full frame on the primary monitor. If that's not an option, you can configure Blender on a single monitor like Figure 7.13.

Another option is to display the story reel directly within the 3D view. This is just like adding a background image when you are modeling, except that you choose **Camera** in the **Axis** control and select your exported story reel movie file for the image, as detailed in Figure 7.14.

Advance the current frame to reach the first storyboard in the story reel. Add a camera to the scene, and change its name to "shot01." You will be naming both your cameras and your Blender scenes this way so that it will be easy to tell at a glance later if you are working with the intended camera and scene. In a single scene production,

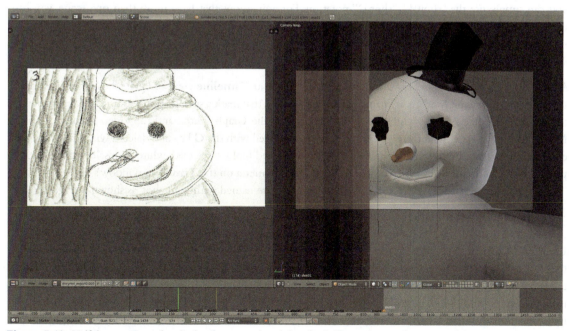

Figure 7.13 *Half the screen is used to display the story reel, and the other half is used to match camera and character positioning.*

Figure 7.14 *Settings for using a movie as the camera view background.*

you can simply use the "shot01," "shot02" notation. For animations that have more than one scene, you can expand that to "shot01.01," "shot01.02," with the first number designating the scene and the second designating the shot. Of course, you are free to use any naming scheme you care to, as long as it will be clear what is what if you revisit the project a year from now.

Along with naming the camera, hover your mouse over the main **Timeline** view and press the **M** key. This adds a **marker** to the timeline. Markers are nameable, movable items that mark a specific point in time. Adding a marker to the main timeline makes it visible in the Action Editor, the Graph Editor, and the Video Sequence Editor. Markers can be selected with the **right mouse button**, moved with the **G** key and deleted with the **X** key. You can also name them. To do so, make sure the marker is selected (gold = selected, white = unselected) and either press **Ctrl-M** or choose **Rename Marker** from the **Frame** menu on the **Timeline** window's header. Name it "shot01." Now, you have a camera and a point in time that are named with your shot, as shown in Figure 7.15.

Select the camera and adjust its position to your first best guess of where it will show the shot that you see in the first storyboard. If you drew cameras on an overhead plan of your set, you can use that as a starting point. Use **Ctrl-Numpad-0** to enter camera view and use the translation and rotation tools to do your best to match the shot to your illustration. One rotation method you may not be familiar with is the "trackball" style that is triggered by pressing the **R** key twice. Try it from the camera view with the camera selected. I've found that this is a much more intuitive "true to life" way of aiming the camera than the standard rotation tools. Also, don't ignore the **Lens** value on the **Camera** panel of the **Edit** buttons. It defaults to 35, which is almost certainly a wider angle than what you drew in your storyboards.

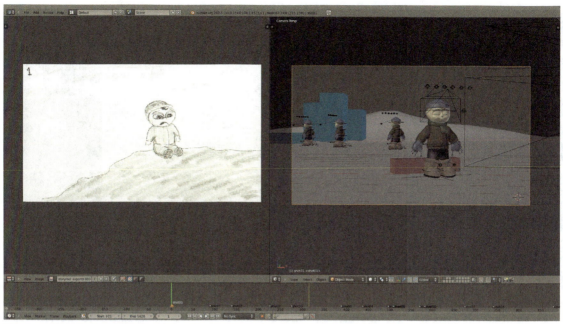

Figure 7.15 *Adding a marker for the shot.*

If you have not used this control on your cameras before, a higher value equates to a greater zoom in a physical camera and lessens the effects of perspective. Lower values are the equivalent of zooming out, with very low values (around 20 and below) giving a wide-angle lens, almost fish-eye effect. Take a look at the cameras as positioned in the master template file. You will notice that I only have three different lens values, even though there are many more cameras. Instead of always adjusting the lens length, I decided on three different settings that roughly correspond to close-ups, medium shots, and long shots. That way, there is one less thing that I have to deal with when trying to match shots.

This is when you will find out how well you visualized the 3D space in which your animation takes place. You may find that no matter what you do, you just can't match in 3D space what you drew in your storyboards. Figures 7.16 through 7.21 show several storyboards from *Snowmen* and their corresponding framing in actual 3D. Some obviously worked out better than others.

When you have a discrepancy between the two, you need to ask yourself if the difference will cause a material change in the staging or action that needs to take place in the shot. If not, adjust the camera to compose that shot as well as you can and move on. If the difference really will affect the way the shot plays out, you need to consider if it is, in fact, the right camera angle to use. It is possible that you may need to rethink the action in the shot. If you do, you may have to go back to the storyboards and rework them a bit, armed with your greater knowledge of the physical aspects of the scene.

As I am interspersing title cards between my shots in several places, I've also indicated their location along the timeline with markers that use the naming convention **title01, title02,** and so on. The point is not to conform to any kind of rigid formula for doing this, but to provide yourself and any others with whom you are working a clear guide to the road map of the work.

Blender Production

Figure 7.16 *Storyboards and their corresponding 3D framing.*

Figure 7.17 *Storyboards and their corresponding 3D framing.*

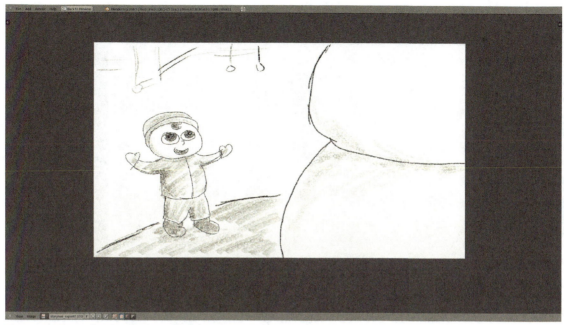

Figure 7.18 *Storyboards and their corresponding 3D framing.*

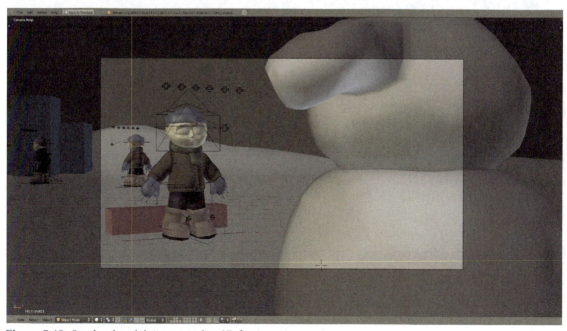

Figure 7.19 *Storyboards and their corresponding 3D framing.*

Figure 7.20 *Storyboards and their corresponding 3D framing.*

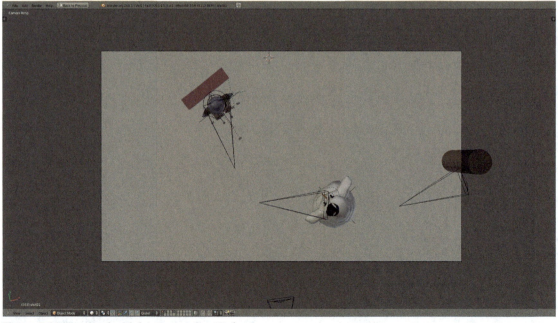

Figure 7.21 *Storyboards and their corresponding 3D framing.*

Even though the chapter on storyboarding is behind you, that does not mean that the storyboards, or any other part other of the production that has been worked on up to this point, is really finished. Many phases of animation production are iterative, meaning that what you do at a later stage may cause you to go back and rework something you thought you had set in stone before. Don't be afraid to do this. Although we go through this process to try to minimize such things, it's perfectly normal.

Placing Your Characters

With a camera in place, you can move your characters into frame. Of course, without the ability to pose them, you won't be able to match your storyboards exactly, but you will at least be able to tell if the general positioning will work. Select and transform your characters until they work with the framing presented in your storyboards. As you will potentially be changing these with each different camera angle, you should set rotation and location keyframes for the characters.

Automatic Keyframing

In this chapter, you are beginning to add animation to your files, albeit in a primitive fashion. Although you could use the I-key method every time you wanted to insert a keyframe, there is an easier way. Located in the **Editing** section of the user preferences (Figure 7.22) is a button labeled **Auto Keyframing.** With this option engaged, Blender will automatically set keyframes whenever you transform an object or a bone. Although this method has its advantages (you don't have to press the I key constantly while animating, and you won't accidentally lose a careful placement because you forget to set a key), it can lead to a surprise or two if you forget that it's on.

From time to time, there will be objects that are not supposed to move, like a camera or a lamp. The problem arises when you adjust the positioning of otherwise static objects while automatic keyframing is enabled, then readjust them on a different frame. Although you didn't intend it to, you've just animated the object. You can easily prevent this by also enabling **Only Insert Available** in the preferences. This will only insert keyframes for channels that are already animated. So if you have never inserted a keyframe for the camera object, auto keyframing using the "only available" option will not give it keys when you move it.

Of course, this means that that first time you position an object that you want to record keyframes for, you need to set one manually with the **I** key.

Automatic keying can also be enabled by pressing the "record" button in any **Timeline** window, as in Figure 7.23.

Press the **I** key and choose **LocRot** from the popup menu as shown in Figure 7.24. This sets a key for the character's location and rotation on the current frame. Before you proceed to other storyboards, camera angles, and character positions, you need to make an adjustment to the way that Blender interpolates keyframes. If you were to proceed through your story reel setting positions and keys for your placeholder characters, they would slide from key to key, producing an ugly animation. At this stage, we are just interested in matching the static shots of the storyboards, so it would be beneficial to have the characters just snap into position at the beginning of each different storyboard.

Figure 7.22 *Auto Keyframing Enabled in the user preferences window.*

Figure 7.23 *The record button on a Timeline window.*

With a character Group Instance selected, head to the Graph Editor, as shown in Figure 7.25. Using the **A** key, select all of the animation curves in the window. Then, from the **Key** menu on the window header, select **Interpolation Mode** and choose **Constant**. You can also choose this option by simply pressing the **T** key in the window's workspace and selecting **Constant** from the popup menu.

In case you are not familiar with animation curves—and you really should be if you're attempting to make a short animation—the Graph Editor is a visual representation of the changing values of an object's attributes, including (but not limited to) location, rotation, and scale. Each curved line in the window tracks a different attribute and is color coded to match its description on the left side of the window. The curves can be selected and edited just like a mesh in the 3D view, with the **Tab** key, in order to fine-tune animation timing. How your objects move between the keyframes you have set is decided here.

Figure 7.24 *The Insert Keyframe popup menu.*

The **Interpolation** type you choose determines how the object acts between the keyframes. The default, called **Bezier**, produces smooth transitions between keyframes, beginning and ending slowly with a more constant rate of change in the middle. The **Linear** interpolation type changes the value at a uniform rate, producing abrupt stops and starts in motion. The **Constant** type that we are using here signals that there will be no interpolation between the keyframes at all. The value of the previous keyframe is held intact until another keyframe is encountered, at which point its value is used.

Binding the Camera to the Marker

You have the first shot set up, a timeline marker created, and camera and characters placed. The last step is to **bind** the camera to the marker. This tells Blender to use that particular camera starting on the frame of the marker and continuing until it hits another marker with a bound camera. To do this, select the "shot01" camera and use **Ctrl-Numpad 0** to enter camera view in the 3D window. **Right mouse button (RMB)** select the "shot01" marker in the timeline. Now, with the mouse still over the **Timeline** window, press **Ctrl-B.** You can also find this command with the Spacebar toolbox under **Bind Camera to Marker**.

Figure 7.25 *Setting Interpolation to Constant.*

Figure 7.26 *A camera is now bound to this marker.*

When you activate the command, a faint dashed line appears above the marker, shown in Figure 7.26. Now regardless of what camera is selected as active in Blender, setting the current frame marker to somewhere within this shot as designated by the Timeline markers will set the camera labeled "shot01" to be current. In this way, as you add cameras, shots, and markers for the rest of your animation, you tell Blender the correct camera to shoot from, based simply by the current frame. Note that contrast has been enhanced in the figure to show this effect.

Proceeding through the Story Reel

With the camera bound to the marker, you can move on through the story reel. Find the next frame on which the camera angle changes. It won't necessarily be the next storyboard, as you may have many consecutive boards shot from the same angle. When you find it though, add a new camera, name it, and begin the process again:

- Add your camera.
- Name it per shot.
- Add and name a marker on the timeline.
- Adjust camera positioning to match storyboard.
- Move characters into the frame.
- From camera view, bind the camera to the marker.

As you work through the rest of the story reel, you will develop a series of named cameras that correspond to timeline markers, and you will develop character positions that will allow you to visualize your storyboards in 3D for the first time. Depending on how many camera angles there are in your animation, you may end up with something that looks like Figure 7.27.

Special Case: Reusing Cameras

You may find that a certain camera is used more than once in your animation. In fact, it's possible that you could have only one or two cameras for the entire production. When that is the case, you need a way to keep track of which bit of action is shot from which camera, as creating a series of identical cameras with different names every time the perspective changes would be pointless. Note that even if you have such a camera setup, it is still a good idea to break your shots into separate files for all of the reasons mentioned before.

For a situation in which you have significantly fewer cameras than shots, it can be useful to label the cameras with letters like "CameraA," "CameraB," or descriptions like "Long" or "TreeCloseup." When you create

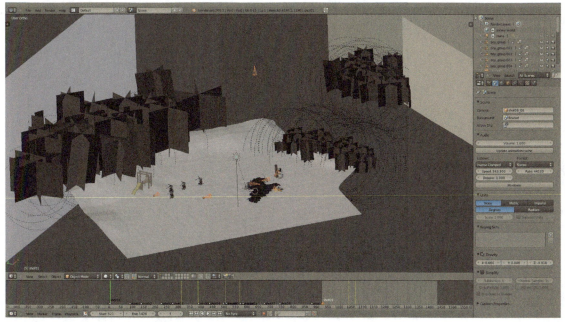

Figure 7.27 *The template scene file for* Snowmen.

your timeline markers, you simply expand the name to include the shot number and the camera name, as seen in Figure 7.28.

Additional Detail: Moving Cameras, Moving Characters

There are many situations in which your camera will move. You may have drawn these into the storyboards with camera directions. Whether or not you did, you can put them into place now.

Once again, it's a matter of following your storyboards as you play through the story reel, and setting keys on your camera instead of your characters.

In the previous section, you only placed the characters once per shot. There is no real reason to restrict yourself like this, though. There may be a number of contiguous storyboards all from the same camera angle in which your characters move about. If that is the case, feel free to adjust the character positioning on a board-by-board basis. You can put even more positions in between, if you feel that it helps to show the action. Don't put too much time into it, though, as these are still just placeholders for the real animation that is yet to come.

Using the Grease Pencil

The grease pencil is Blender's way of allowing you to add completely freeform annotations to your work. What do we mean? Take a look at Figures 7.29 and 7.30. In Figure 7.29, it looks like paths and directions have been sketched onto the rough set's ground. In Figure 7.30, notes have been added to a camera view.

Figure 7.28 *Markers named with shot numbers and their corresponding recurring cameras.*

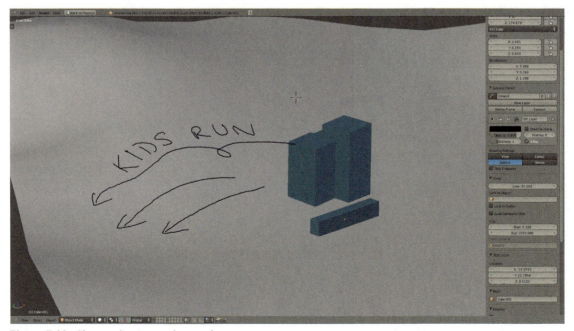

Figure 7.29 *Character directions on the ground.*

Although this ability is nice for reminding yourself of things for later, it can be crucial when working in a collaborative environment. If you are handing a shot off to an animator, how will that person know exactly where the character should walk? Maybe the character needs to grab a handle on a specific frame. You can (and probably will) communicate this information to the animator in other ways, but it is a great asset to be able to write and draw directly into the 3D workspace.

Here is how it works.

In the **N key** panel of the 3D view, find the **Grease Pencil** panel. It will look like Figure 7.31 at first. To start using the tool, click the **New Layer** button. When you do, a bunch of new controls appear, shown in Figure 7.32.

Before we mess with any of those settings, hover your mouse over the 3D view, hold down the **D** key, and **left mouse button** (**LMB**) drag in the workspace. The mouse should draw a fairly thick black line wherever it goes. As long as you hold down the **D** key, **LMB** drag will continue to draw. This is the most basic grease pencil interaction. To erase portions of the line you have drawn, hold down the **D** key and drag with the **RMB.**

Figure 7.30 *Some important notes.*

Figure 7.31 *Starting out with grease pencil.*

Figure 7.32 *Grease pencil controls.*

Back to the panel in Figure 7.32, you see that you can adjust the color, opacity, and thickness of the line. These controls change those parameters for the entire drawn layer at once. Note that everything you draw on this frame, regardless of how many times you press and lift the **D** key, will be a part of this layer.

Let's take a look two of the more useful options under **Drawing Settings**: **Cursor** and **Surface**. When drawing in **Cursor** mode, the default, the drawings that you make appear parallel to the current viewing plane of the 3D window. But how far "back" are they into the view? The drawing resides however far back the 3D cursor is within the view. This mode is good for general annotations when in a camera view, like those in Figure 7.30. Notice in Figure 7.33 how those same annotations are oriented when the view has been rotated away. They are clearly parallel to the plane of the camera and intersect the 3D cursor.

In **Surface** mode, the drawing "sticks" to the 3D surface that is nearest to the viewport. So when I drew the directions on the ground plane from a top view, rotating away from the angle showed that the drawing follows the surface of the ground object (Figure 7.34).

You don't have to constrain yourself to notes and directions though. You could draw a face on a stand-in character, trees on a mountain, or basically anything that you would like to suggest or remember.

Grease Pencil Over Time
If you advance several frames, your grease pencil drawings do not change. However, if you were to do so then press the **D** key and draw some more, you would see that your initial sketch disappears and is replaced by the new one. This is different than before when all of your sketches drew on top of the others. That is because when you change frames, Blender assumes that you want to create a whole new set of notes on the new frame.

Step backward one frame and you will see the previous sketch appear. Step one more forward and the new one replaces it. Basically, this allows you to take notes as you step through the timeline and have them appear at the relevant portions of the animation. When stepping through time, Blender always shows the most recent grease pencil sketch for any particular layer.

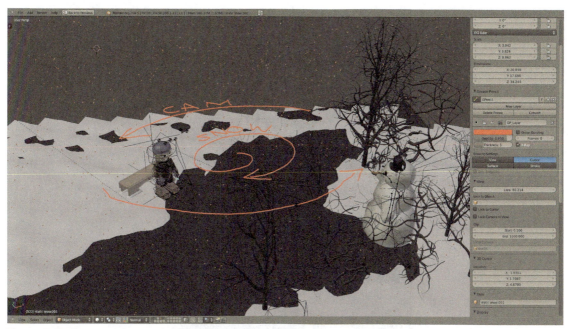

Figure 7.33 *Grease pencil notes taken in Cursor mode from a camera view.*

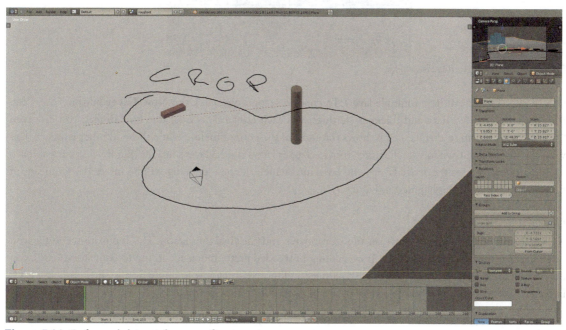

Figure 7.34 *Surface mode lets you draw on surfaces.*

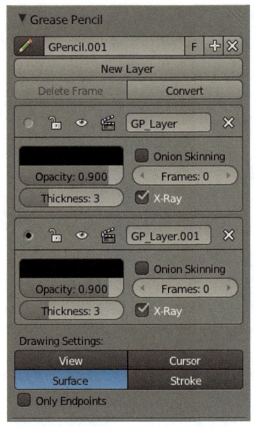

Figure 7.35 *Grease pencil header settings.*

Grease pencil work can have multiple layers. To create a second one, click the **New Layer** button. Layers can have separate color, opacity, and thickness settings, and each layer has its own timeline. In fact, you can even "freeze" one of them so that its sketch shows throughout the entire timeline while those in other layers change with the frame count when you click the "movie clapper" icon on the layer's header (Figure 7.35). If you have multiple layers, you set the active layer—the layer into which the new drawing will be inserted—by means of the left-hand dot, also highlighted in Figure 7.35.

Creating an Animatic

An **animatic** is a bridge step between the storyboards and the final animation. The template scene file you just created is the basis of an animatic. If everything proceeded pretty much according to your storyboards, you don't really have to create one. However, the longer and more complex your animation is, the better an idea it becomes, just to ensure that all of your assets are in place before moving on.

The shot matching for *Snowmen* was close enough to the storyboards and the action was clear enough that I did not create an animatic for the project. If you would like to, though, here is a good way to proceed.

Replacing Storyboards in the Story Reel

Your goal is to replace the storyboards in the story reel with more accurate representations of the final project. To do this, you will be working within the template scene file. For shots in which there is no camera

Figure 7.36 *Sending the contents of the 3D view to the Render window.*

movement and little character action, it is as simple as advancing the frame counter to the appropriate shot and creating an image file from the appropriate camera's perspective. Of course, if you have bound all of the cameras in the scene to timeline markers, camera choice will be automatic.

Locate the shot in the timeline by using the markers you created and set the current frame counter to place yourself at the beginning of the shot. If you have not used it before, there is a quick preview button in all 3D window headers that sends the OpenGL preview of the camera's view to the **Render** window, allowing you to save it like a render. Figure 7.36 shows the button highlighted, with the OpenGL preview in the **Render** window.

You can save these "renders" by pressing **F3**, just like you would do for any regular render. You can save them into a subfolder of your **storyreel** folder called **animatic**.

Back in your main story reel file, import these new images into the Video Sequence Editor and place them above the storyboard image strips that they will replace. Leave the storyboards where they are—you may want them there for reference later, and it costs almost nothing in terms of file size and processing time. Figure 7.37 shows two OpenGL shots superseding their storyboards in the story reel file.

For sections with camera movement, you can either export several still shots that correspond to the storyboard breakdown or, if you're feeling fancier, export the whole range of frames in an animation.

Once again, the preview render header button comes into play. First, though, choose an animation codec that is appropriate to your system (see Chapter 14) and set a filename as you did when creating the animation file for the story reel. If you have a large hard drive with plenty of space, you can simply choose **AVI JPEG**, which is

121

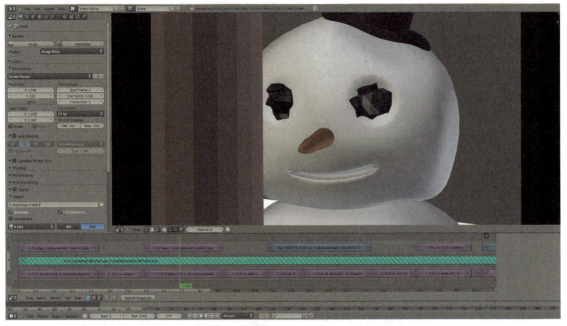

Figure 7.37 *Animatic images replacing storyboards in the Sequencer.*

one of Blender's internally supported animation formats. It does not produce the smallest files and other animation or video programs may have trouble reading it, but any version of Blender on any platform will happily see and read the file, and the quality is more than good enough for an animatic.

In the **Dimensions** panel of the **Scene** properties, set the frame range for the preview render to match the range designated by the shot markers in the timeline (Figure 7.38). Hold down the **Control** key and click the header **Preview Render** button. Blender will pipe the OpenGL 3D view to the **Render** window as an animation and save it with the format and filename you specified.

In the story reel file, you can add this new bit of animation above the storyboards.

At this point, you can regenerate your story reel animation if you like. If you are going to do so, it's a good idea to give it a different name (like "storyreel_animatic") than the original storyboards-only animation, so that when your project is done, you will have a progression of files to look back on. It's not a necessity, but it's nice when you're finished to see how far you've come. Of course, you don't have to export the animation at all. Pressing **Alt-A** directly within Blender will play the animation for you live from the Sequencer.

Summary

Using your storyboards and a physical sketch as guides, you create rough sets with primitive objects to give your characters references for their actions during animation. A template file is created that will serve as the basis for all the shots in the scene. The template scene file contains the rough sets linked in as whole scenes and any props and characters that are available linked in as Group Instances.

Cameras are added and synchronized with the story reel, whereas markers are placed in the timeline to help with future organization. The character models are moved around to roughly follow the storyboarded action.

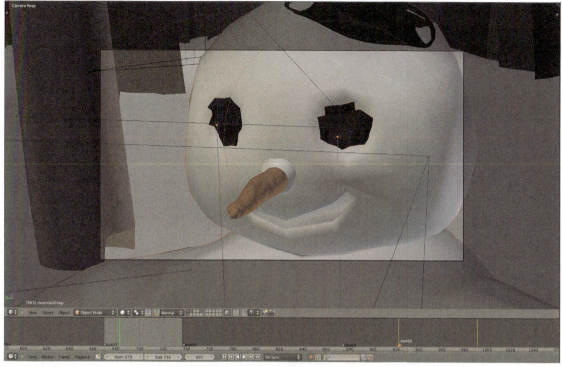

Figure 7.38 *Preparing to export a bit of preview animation.*

Finally, preview images are made from the new cameras that correspond to the original storyboards. These images and any animated camera movements are put in place in the master story reel file to create an animatic.

OUTBOX

- A rough set file for each set in your production
- A template scene file that contains a link to both the rough sets and character meshes, as well as local assets for each camera in the production
- An animatic-enhanced version of the story reel

Chapter 8

Good Sound

Objectives in This Chapter
- Finding decent equipment and environments.
- Making the recording.
- Understanding sound-processing basics.
- Previewing the recorded sound.

INBOX

Coming into this chapter, you need the following:

- A script
- People to perform the lines

Finding Decent Equipment and Environments

Although you won't be adding ambient sounds like footsteps, crashes, and background noise until after animation is finished, you need to have any dialogue recorded before you begin. Although those other types of sounds are fairly easy to synchronize to your animation, the reverse is true for the spoken word. The viewer will easily discern any variance from the rhythms of natural speech, so you are constrained to using speech in a mostly unaltered format. It is much simpler, then, to animate to already recorded dialogue than to try to have your voice actors match what they say to characters whose mouth movements and facial expressions were done without guidelines. In fact, doing the latter would be nearly impossible!

Neither you nor I are professional sound engineers, though, so we're not going to be able to get beautifully reproduced studio-quality dialogue. Fortunately, it is possible to get "good enough" sound for your production with only a little effort and investment.

What to Use

There are four levels of equipment quality and configuration to choose from. You should obviously choose the highest level of quality that your production and resources will comfortably support.

The lowest level of quality will be a simple PC microphone connected to the microphone input of your computer. Depending on how picky you are, prepared to be (or not), the sound gathered from this setup might be good enough. Although I have heard some surprisingly "not bad" recordings done with a simple PC mic, most likely it will produce a fairly noisy, low-quality recording.

The next step up would be to purchase or borrow some lower-end "phantom power" microphone equipment. These microphones are significantly better in sensitivity and quality than the ones that plug directly into your PC, but they require an external power source. Usually, a powered mic will plug first into the power source (often a powered mixer), then into the line input source on your computer's sound card. Because of other projects I have worked on, I already owned a powered microphone and power source, which you can see in Figure 8.1. The microphone is an MXL brand condenser mic, and the power source and mixing board combination is the Behringer Eurorack UB1002. Both were obtained for less than $150 total—not truly professional quality, but not entirely out of bounds regarding cost. You can also obtain a good-quality USB microphone, which allows you to skip some of the hardships of analog recording.

The next level of quality would be obtained by not recording directly into the computer. Depending on the sensitivity of the microphone you use, the sounds of the computer's fan and electrical interference from the power supply can introduce additional noise into the recorded signal. Using a quiet laptop can counter the sound problem, and obtaining a USB-based external sound "card" can eliminate electrical interference. Once again, because of other projects, I already owned a direct digital recorder that can be used without a computer. Figure 8.1 shows the device, called the I-Key. It is a "retired" product, but more modern (and much better) equivalents are available below the $150 mark. Devices like this take analog audio inputs and save them in WAV or MP3 formats directly to an attached USB device like a USB memory stick or hard drive, or an SD card. There are certainly more expensive digital recorders that perform the same job, and, much like computer equipment, you could divert nearly infinite amounts of money to this task if you were so inclined. If you have an iPad or Android tablet, you can use them (along with appropriate apps) for recording as well.

The highest level of quality, and one in which you are not likely to invest, is the true top-of-the-line recording equipment: Sennheiser and Shure microphones, Allen & Heath mixers, and Sony and Yamaha digital recorders. This equipment costs thousands of dollars and will almost certainly outstrip your meager recording skills in its ability to produce great-sounding dialogue.

Here's a hint for finding a great resource for audio knowledge and equipment without spending a cent. Do you know someone in a band? You almost certainly do. Band members traditionally spend ridiculous amounts of

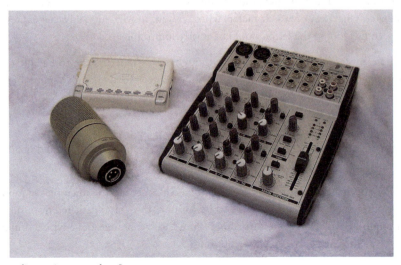

Figure 8.1 *The recording equipment used on* Snowmen.

money on audio equipment and equally ridiculous amounts of time learning the arcane ins and outs of high-end recording and sound reproduction. Ask the band what they recommend and if you can have an hour with their recording equipment. If you can appeal to their audio geek sensibilities, they will not rest until you have the cleanest, best recording possible.

Another resource to consider is that of local churches. Many churches have invested tens of thousands of dollars in audio and recording equipment. If you are a member of that church, they might let you use for the asking. Churches of which you are not a member or don't attend could be persuaded to let you use their facilities for a small donation.

Where to Record

The location and portability of the recording equipment at your disposal may determine your recording environment. If you'll be using your desktop computer and a direct microphone, then you'll be recording in your computer room. As the point of your project is to produce a short animation and not learn every aspect of audio engineering, you should try to make your dialogue recording as "live" as possible. This means that if a bit of dialogue takes place in a kitchen in your animation, you should try to actually record in a kitchen. Nothing you and your amateur audio skills can do to a pristine studio sound will make it sound as realistic as actually recording on location.

Of course, you will need to minimize nondialogue sounds when recording. Put the dog outside. Ask the neighbors to save their very vocal fight for another day. If you live near a busy street or highway, you'll have to wait until a low traffic time. If the people you live with and your voice talent can stand it, the early morning hours (3 to 5 a.m.) are a great time to do this sort of thing, as the ambient sounds of daily life will be at a minimum. One last thing to do before recording is to unplug (not just turn off) any electrical equipment in the area. Refrigerators, televisions, and all sorts of appliances make noise that we generally filter out as we go about our daily lives but that will emerge as annoying background noise when put through a sensitive microphone. One last source of unintentional noise is fluorescent lighting. Turn it off if there is another source of light.

Making the Recording

To make proper use of them, your sound files are going to have to be as organized as the other assets in your production. The easiest way to keep track of what dialogue is in what file is to take notes with paper and pencil. Here are some guidelines for recording your dialogue:

- Do several readings of any piece of dialogue.
- Multiple readings can be recorded into the same sound file, with a small bit of silence before and after each one. This will make it easy to listen to the different readings when you are trying to decide which to use.
- In a single reading, group any phrases or lines that naturally occur together in speech. You don't want your voice actor to have to break what would normally be several sentences delivered together into several separate takes. The lines will lack the transitions that are found in natural speech.
- If you have portions of dialogue where characters are speaking simultaneously, try recording them both at once and individually. You can decide later which sounds better. Of course, if you are using high-end equipment with multiple microphones in a studio setting, they'll rig something snazzy up so each actor can hear the other on their high-end headphones, allowing them to act "together" but be recorded separately. If you have the resources, good sound isolation, a multitrack recorder, and long enough cables, you can do the same thing at home, but it's really a step above what most home setups will be able to accomplish.

- Consider the physical situation of the character when the lines are delivered. If the character is crouching or hunched over, make your actor do the same. Record the actor a few times in a natural pose, while trying to make the voice sound like the actor is hunched, and a few times in under the actual circumstances. If your character is being eaten by a bear, it is advisable not to have your actor actually eaten by a bear, regardless of the level of realism you might attain.
- In addition to reading the different lines of dialogue into separate files, try using one overall take in which all the actors cluster around the mic (or mics) and do their interactions "live." What you could lose in sound quality by not having everyone speaking directly into a mic might be made up for with the group dynamic and better interplay between the actors.

> **Note**
> When we use the term "actors," we really mean whomever you have decided to record for your dialogue. You don't need to inquire at the Screen Actor's Guild or, even worse, your local community theater group. Most likely you will be able to find "actors" of sufficient talent from among your friends and family. Who knows—your own voice might be appropriate for any number of your characters. Of course, if you really want to be nice, you can advertise in your local craigslist "GIGS: Talent" section and throw some starving actor or actress a bone.

The Goal of the Recording Session

The goal of the recording session is to walk away with a set of sound files that represent several different readings of each spoken line of your script. The sound signal that is recorded on the files should include minimal background noise and be as strong as possible without clipping. Clipping is when the sound source (in this case, the actor) is so loud that it overloads some portion of the recording equipment, making that particular portion of the recording useless.

To get a strong signal without clipping, you need to make sure that your actors are the optimum distance from the microphone. This will vary from mic to mic, and this information will possibly be included as part of the instructions that came with your microphone, if it had any at all.

One source of clipping is the introduction of "plosives" in the dialogue. Plosives refer to the small blast of air that is produced when you make a "p" sound or, to a lesser degree, "t" and "b" sounds. The air hits the microphone and is the equivalent of someone smacking the thing, producing a pop in the recording and, often, a clip. The simplest way to mitigate plosives is with a screen, as shown in Figure 8.2. Screens are cheap, but you don't even have to purchase one. A simple one can be constructed from a 5- to 6-inch loop of metal coat hanger covered with two layers of nylon stocking and clamped to the microphone stand between the mic and the actor.

With your actor the proper distance from the mic and plosives taken care of, you just need to set the proper recording levels. If you are using a noncomputer recording device, it will almost certainly have a "clipping" indicator. If you are recording to directly to your computer, the recording software that you are using, which we'll examine in a moment, should also have a clipping indicator. Basically, you want to have your actors speak into the microphone just as they will when recording, while you keep turning up the recording volume. Turn up the input volume until the clipping indicator begins to trip. When that happens, it means that you've gone a little too far. Back off on the input volume. Have your actor read through the lines again (just the louder ones if there are a lot) and pull the input volume back until you no longer see the clipping indicator.

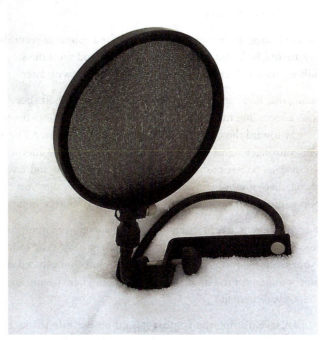

Figure 8.2 *A screen for avoiding plosive clipping.*

Some Sound-Processing Basics

If you have and already know how to use a sound-processing program, you can skip this section. However, those of you that do not are welcome to download and install Audacity, an open source, completely free sound-processing program that runs on Windows, OS X, and Linux-based computers. Audacity is available at http://audacity.sourceforge.net and is included on the disk that came with this book.

Recording with Audacity is as simple as running the program and pressing the large "record" button that is shown in Figure 8.3. It uses the familiar icons for play, pause, stop, and record, as shown in the illustration. One of Audacity's features that is immediately useful is a live input level indicator. By clicking once in the meter area designated in Figure 8.4, you can see how much sound is coming through your microphones. If the bar

Figure 8.3 *Audacity's main controls.*

Figure 8.4 *The input meter and microphone level controls.*

reaches the end of the meter, you're clipping. The level for your chosen input (microphone, line in) can be conveniently set to the right of the input meter.

To record a take, press the record button, have everyone stay silent for a couple of seconds, then have your actors speak their lines. When they are finished, wait a second or two again and press the stop button. The pauses are there to give Audacity's built-in noise reduction filter something to work with later.

You are looking for a recording that looks something like image in Figure 8.5. It shows a solid input level with no clipping. Figure 8.6 shows a recording made with too little input. Notice how the waveform is smaller and barely reaches a third of the way toward the outer edges of available volume space. The audio tools can amplify it, but it's better to start with a stronger signal. Turn up the input level and try another take. Figure 8.6 shows clipping in the indicated areas. This take is trash. Turn down the input levels and try it again. Depending on what equipment you are using, there might be several places along the way that you can adjust the levels: mic inputs, mixing board outputs and mix controls, and computer or digital capture inputs.

The clipping on the left side of Figure 8.7 is probably due to the computer's input level being too high. The clipping on the right is more likely to have occurred in the equipment before the sound even got to the computer. The more complex your setup, the more places that clipping can be introduced and the more you'll need to know about your equipment to prevent it. This is another situation where having an experienced audio geek on your side will really work to your benefit.

When you have recorded a take, save it using the **Export** item from the **File** menu. Put the sound into your **sound** folder, giving it an appropriate name like "terrified_scream_05.wav." The default uncompressed format

Figure 8.5 *A good audio take.*

Figure 8.6 *Input levels are set too low.*

Figure 8.7 *Input levels are too high and clipping results.*

is the WAV format, which is the one you should use. After the take is saved, click on the **X** in the upper left corner of the audio track to close it, as in Figure 8.8.

If you leave the track up when you record your next sound clip, it will play in the background, causing problems. Of course, you can always use the **Play** button before you save and close the track to make sure that you got what you wanted from the actor. If you like, you can monitor the performance through a set of headphones.

Figure 8.8 *Closing an audio track.*

Whether or not you use direct-to-computer recording with Audacity, at some point you will have the raw files of several takes and different readings of your dialogue. Make a backup copy of each these files before proceeding.

Removing Noise and Adjusting Levels

Open one of your recorded sound files in Audacity. Using the **left mouse button**, click and drag in the flat area at the beginning of the sound, as in Figure 8.9. This is the area of quiet that you hopefully left at the beginning of each of your recordings. With this area selected, choose **Noise Removal** from the **Effect** menu. The **Noise Removal** dialog appears, with two steps, shown in Figure 8.10. Choose **Get Noise Profile**. This option examines the area of "quiet" that you selected previously. The dialog disappears, returning you to the sound file.

Left mouse button click in the sound file to cancel the selection. Reselect **Noise Removal** from the **Effect** menu. This time, simply click **OK** to start the removal process. Depending on the length of the sound file, it may take a few seconds.

Figure 8.9 *Selecting the quiet area at the beginning of the sound file.*

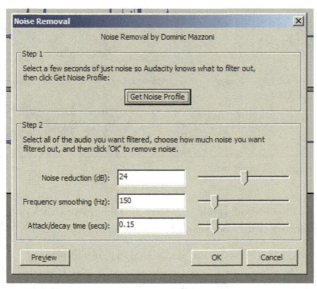

Figure 8.10 *The Noise Removal dialog.*

The other simple trick you can do to your sound file is to run it through a **compression** filter. Compression amplifies softer parts of the sound and reduces the volume of louder portions, giving a more even dynamic range. You may or may not prefer the effects of compression, so be sure to play your sound a couple of times both before and after you use the filter for comparison.

Then run the sound through the compression filter, double-click the sound to select the entire thing, and choose **Compressor** from the **Effect** menu. Although a number of options and settings are available, accept the default by pressing **OK**. When the file sounds good to you, choose the **Export** command again to resave the WAV file. (Choosing **Save** in Audacity creates an Audacity project file, not a playable sound file.)

With background noise removed and the dynamic range compressed, your audio tracks are ready to use.

Previewing the Recorded Sound

The odds are that you don't have the professional equipment available to properly preview your sound files before using them. If you do, well, lucky you. For the rest of us, here is a low-tech way of getting an idea of whether or not your recording session has you at least in the right ballpark.

- Using the CD burning software that came with your computer, burn an audio CD of both the raw and noise-reduced/compressed sound files. It might be a good time to take notes, as it will be helpful to know which is which when you are listening.
- Play the burned audio CD in a DVD player that is attached to a television set. Most DVD and Blu-ray players are capable of using standard audio CDs.
- Listen to the CD through whatever speakers you normally use to watch television. Whether it is just your television's built-in speakers or a full-scale digital receiver system doesn't matter. The point of doing this is that you are used to hearing dialogue played through this system. It provides a good reference for what your own recorded dialogue sounds like when piped through the same equipment.

Does it sound like what you are used to hearing? Worse? Better? You may notice things when listening to the recording in this way that you didn't notice when playing it through your computer's speakers or headphones. Depending on how it sounds, you may want to go back, rerecord, and process the dialogue again. In fact, it would probably be a good idea to do a few tests with your recording pipeline before you bring in the voice talent. Actors can be touchy, and you don't want a strike on your hands.

Summary

When recording the final dialogue for your animation, you should try to get the best equipment your resources will allow. Sound should be recorded in as "clean" of an audio environment as you can find. Dialogue is recorded in different ways, and with different readings of each line so that you can choose the take that works best in the final production. Once the recordings have been made, basic digital processing can enhance the raw sound files.

OUTBOX

- A series of sound files, one for each line or naturally grouped series of lines in the script

Chapter 9

Managing Animation at the Project Level

At this point, you should have a master scene file that contains links to all of your rough sets, props, and characters. It will also hold properly named cameras and markers for all of your shots. It's time to get organized (again).

Figure 9.1 shows a spreadsheet with rows representing each shot in the production and columns that show different production milestones and various bits of information.

As much as the story reel is your bible when it comes to timing and shot construction, this document will become your ever-present guide during the long and arduous animation and rendering phases of the project. Let's take a look at the different elements that can be useful for tracking your progress. Items like "shot name" and "start frame/end frame" are pretty much self-explanatory.

- *Blocking.* Poses blocked in constant interpolation mode.
- *Smooth.* Main animation phase, after poses are confirmed.
- *Polish.* Tweaking phase of animation.
- *OpenGL.* An OpenGL animation file has been produced.
- *Render prep.* A technical checklist on the file before rendering.

	A	B	C	D	E	F	G	H	I	J	K	L	M	N
1	**Snowmen Will Melt Your Heart**													
2	**Production Tracking**													
3														
4	Shot Name	Start Frame	End Frame	Camera Name	Set Name	Characters	Blocking	Smooth	Polish	OpenGL	Render Prep	LoQ Motion	Prod Still	Final Render
5	Shot01	1	91	shot01	finalset	a,c	x	x	o	x	x	x		
6	Shot02	137	225	shot02	finalset forest	b	x	x	o	x	x	x		
7	Shot03	273	387	shot03	finalset	a	x	x	o	x	x	x		
8	Shot04	433	493	shot04	finalset	a,b	x	x	x	x	x	x		
9	Shot05	505	564	shot05	overhead set	a,b	x	x	o	x	x	x		
10	Shot06	578	669	Shot06_08	Finalset 0608	a,b	x	x	o	x		x		
11	Shot07	670	737	shot07	n/a	b	x	x	x	x		x		
12	Shot08	737	872	Shot06_08	Finalset 0608	a,b	x	x	o	x		x		
13	Shot09	921	1426	shot09	finalset	b,c	o							
14														
15														
16														
17														
18														

Figure 9.1 *A shot breakdown spreadsheet.*

Render

We'll go through the first four items in this chapter and the last one in later chapters. However, before we take a closer look at each of these, there is some housekeeping to perform. In Chapter 7, we noted that each shot will have its own file. It is time to make those files. It is also a good idea to take a last look at your master template file to make sure everything is there that should be there and everything is set as it should be. Go through this checklist:

- Render dimensions (720p? 1080p? Something else?)
- Frame rate (24 fps for film, 29.97 for video)
- All rough set scenes are linked in
- All characters are linked into the main scene, and animation proxies have been created for their armatures.
- All props are linked into the main scene

This is your last chance to square this stuff up before things become much harder. After you create all of your shots files, making changes to individual assets will still be easy because of the library and linking system. If you edit a character model later, those changes will automatically propagate through everything else the next time you open any file that links to the character. However, if you get any of the items wrong in the preceding checklist, you will have to go into each shot file to fix it. Although that is not a big deal for the links to specific sets or props, getting the frame rate wrong on one file could cause a bunch of rework.

With all of those items confirmed, head into your **scenes** directory and create as many duplicates of the master template file as you have shots in your production. Rename each file with the appropriate shot name. You should end up with a series of files called **shot01.blend, shot02.blend,** and so on. Next, go into your **Render** directory and create a corresponding folder for each shot file. Renders for shots will be placed into individual folders to help to keep things sane.

Open each of these shot files, and do the following:

1. In the Timeline window, note the first and last frames of the shot, using the markers. Set the Start Frame and End Frame controls (either on a Render properties window or in the Timeline window) to these values.
2. If you have more than one linked set scene, confirm that the correct one is chosen in the Scene properties. If you have not already created your final sets, you can build and link them in later.
3. Change the Scene name to the name of your shot.
4. In the Output control on the Render properties, browse to your Render directory and find the appropriate subfolder for this shot. Enter the shot name after the directory. This will cause the renders for the shot to not only show up in the correct folder but to be named with the shot number as well, just in case renders are accidentally co-mingled.
5. Note the start and end frames and the name of the linked background scene in your shot tracking spreadsheet.
6. Save the file.

The shot files are now ready for either you or someone else to work on. If you're working by yourself, then… go! Animate!

However, if you are working with a team of animators, here are some tips on how to proceed.

Working with a Team

When working with a team of animators, the two keys are **communication** and **organization**. Your ultimate goal is have them return to you shot files that contain beautiful animation that matches what you had imagined. How can you make that happen? By spelling things out initially and reviewing work at key stages.

Make yourself clear. To get a good result from your animators (assuming that they are competent), you need to make sure that you communicate to them exactly what you want to see. This should consist of a written description, relevant storyboards, references, cues, and in-file notes.

Let's pretend for a moment that I had a team of animators working on *Snowmen*, instead of just myself. I want to assign an animator to work on one of the children playing in the background. What I want is a loopable animation of the child climbing up one side of the jungle gym, down the other, then running around to the start. If the animation is done well, I should be able to use it in the Non-Linear Animation screen to animate several kids doing this at once. How do I properly assign this task? Here is what I would give to the animator:

1. A written description of the action, including frame-level specifics:
 "The child begins at the bottom of the jungle gym ladder. The child climbs the ladder, goes to the other side, and climbs down the ladder on the opposite side. The child runs around the base of the jungle gym until it is back in the same pose and positioning as the beginning. The entire sequence should take between 240 and 260 frames. This action will only be seen from the perspective of the provided storyboard."
 Notice the kinds of specifics that I provided, including frame counts and where one pose needs to match another.

2. The storyboard shown in Figure 9.2.

3. Links to references. In this case, I include links to two YouTube videos. One is of actual children climbing a jungle gym and other playground equipment. As our child characters aren't close to human proportions, I also provide a link to a bit of animation that shows similar stubbular kids climbing in a fashion that I wouldn't mind emulating. Also, if I were having them animate a hero character instead of a background character, I would provide a couple of examples of reference animation for the character that have already been finished. This will give them a chance see how the character is actually supposed to look when it moves.

Figure 9.2 *The first storyboard of the animation.*

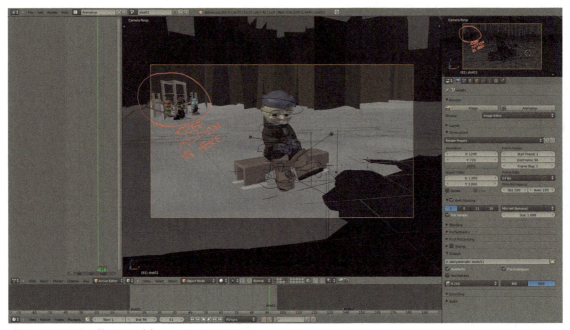

Figure 9.3 *A shot file prepared for an animator.*

4. The shot file itself. The shot file needs some additional assets to work properly, but we'll get to that in the next section. Figure 9.3 shows the 3D view from the shot. Note that I have set it to the proper start frame for this shot, and it is shown in camera view so that it approximates the storyboard. Also, I've drawn some directions right into the scene using the grease pencil. If a character needs to start or end in a specific place, or close to a specific pose, the grease pencil is an ideal solution.

Finally, even if you are working with these animators entirely online, you should have a real live conversation with them. It might be to highlight some characteristic of the action that you would like to emphasize or maybe to give them a chance to ask any questions they might have. If possible, ask them a few questions at the end to confirm that they are thinking the same thing you are thinking.

> **Note**
>
> If your animators have never worked on a shot-wise basis like this before, make sure to give them a buffer zone on either side of your desired frame range. Quite often the action that the characters in the scene are taking is either continued from a previous shot or will be continued into the next one. It is crucial that the action does not appear to begin as soon as the camera starts to roll. The effects of slow in/out and Bezier curves will be apparent, causing your characters to look like they are beginning from a standstill or coming to a stop at the edges of your shots. For this reason, you might even give an additional instruction to your animator, such as "While the shot itself runs from frames 150 through 424, please produce action between frames 130 and 444."

A lot of this sounds very formal, and this part is. However, once you begin to assign animation work, to others, you are truly the director. As the director, you are now a manager, with new tasks that you can add to all of the technical responsibilities that go along with producing a short animation. Get a feel for the animators you are working with. Listen to them. The guidelines that you provide to them will be a springboard for what happens

next, providing concrete milestones that everyone can agree on. After that though, things can get a little hairy. Some animators will prefer more creative freedom, whereas others might feel lost without strong direction. It will be up to your management skills to get the best possible animation out of them, and that will require customizing your approach for each person.

Staying Organized

If you've been following the organizational tips in this book so far, staying organized shouldn't be a problem. When you give your animators the shot file, you will also need to provide them with the original linked asset files (characters, sets, etc.). This should be as simple as zipping up your model and set directories beside a **scenes** directory that only contains the shot file. When creating such an archive, make sure to avoid including any automatically generated backup files with names like **finalset.blend1, finalset.blend2,** and so on. The ZIP (or TAR, etc.) file will have a structure like the one in Figure 9.4.

There are other ways to get the production directory tree to your animators (shared network resource, add everything to some kind of version manager like SVN), but simply zipping everything and sending it all to them via email or upload service is the one with the lowest amount of upfront effort.

When they receive it, they just unzip the thing, go into the scenes shots directory, and open the shot file. Because you've used relative paths for everything, all of the links will be maintained. If they work on a different shot file later, you do not even have to resend the whole thing. They already have the production tree. All they need is the new shot file!

Another feature of using linked assets in this workflow is that, for the most part, it doesn't matter if their local copy of the assets gets a bit stale. If you make a material or texturing change on a character or set, it doesn't matter. Likewise, even a modeling change on a character will probably not make a difference. They can keep working on animation with the older copy in their local production folder. When they are done, all that they will be returning to you is the shot file itself. The *only* local data in that file is the animation data. When you open that file on your own system that contains the updated assets, Blender happily uses the newer versions. It doesn't care that the model looked a little different when the animation was done.

There are a few caveats with this method though. As long as your changes don't affect anything relevant in the animation, you don't need to push them out to your animator. What sorts of things *are* relevant to the animation? Rigging changes, specifically those that affect the proportions of the rig or the set of available rig controls. If you animate on one rig and apply that animation to another differently proportioned or controlled rig, you're asking for trouble.

Figure 9.4 *The structure of a ZIP file to give an animator.*

Also, anything in your models that affects contact points during the animation should be pushed. If you change the depth of the soles of your character's shoes, this could affect whether or not the feet actually appear to touch the ground. If you decide that a set piece with which the character will interact should change (location, size, shape, etc.), that will need to be pushed out to the animator's local production folders too. Animating a character who is leaning against a tree will look awfully strange if the tree has moved in the final files.

Animating in Stages and Getting Feedback

Handing a piece of animation work off to someone else isn't just a black box: you give the other person a file, and out comes finished animation. As the director, you should know how all of this is going to come together, and you should be able to provide feedback to the animators before they take their work all the way to the end. One of the traditional ways to do this is to ask them to produce key poses first.

If you are familiar with the pose-to-pose method of animation (which you should be if you're contemplating producing a short animation), you'll know that the first step consists of setting key poses using constant interpolation. This is a great way for animators to start to block out the action of the piece, and it turns out to also be a great place to review their work. As an example, the animation called *Running Kids Blocked* shows what this looks like. The characters jump from pose to pose without any smooth interpolation. However, the action, poses, and timing are all clear. You'll be able to tell whether your animator is on the right or wrong track at this point. You can return the file to the animator, possibly with markups written using the grease pencil tool. These could be written directions or even a sketch of a tweaked pose, like the one shown in Figure 9.5.

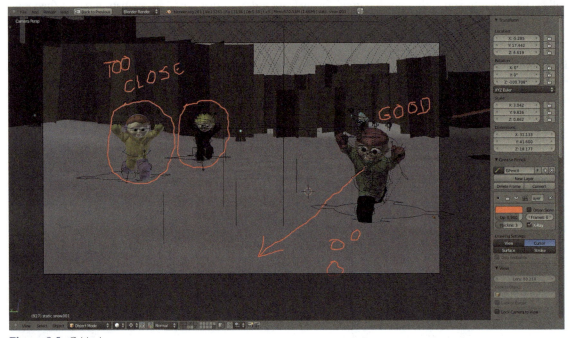

Figure 9.5 *Critiquing a pose.*

If you feel that you need to see another round of poses like this before proceeding, make sure that you make that clear.

Act like a decent person

Obviously, this isn't a book about management skills. If you're working with a team, you'll need some. Just remember: people aren't computers, and they aren't assets that you can or should push around. If they are volunteers, make sure that you treat them with gratitude. If they are paid, you should probably treat them with gratitude as well, because in the end, they are the ones who will make your production come alive.

Once you are okay with their blocking, turn them loose. How often you want to give feedback after that is up to you. Do you want to check in every few hours? That might be a bit much. At the end of every day? If you're only working part-time, maybe once a week will be sufficient. Many animators will do a polish pass (or two, or three) after they have the main animation done. Ask to see the work before they begin this step. Giving your blessing at this stage is really saying, "I completely approve—now take it to the end."

Finally, when they are finished and you are happy with the result, make an OpenGL version of the shot. This will replace the shot's static OpenGL images that are already in the animatic and story reel. Figure 9.6 shows the OpenGL render button. While we will be making final renders to individual image files, at this stage you can get away with dumping the render directly to an animation format. The H.264 preset in the **Render** properties is a good one for this.

Once you have an OpenGL animation for the shot in hand, head over to the story reel file and put it on top of the animatic "render" and the storyboards for it. If you've done your job preparing, the new animation clip should fit perfectly. Figure 9.7 shows one such animation clip in place in the *Snowmen* story reel file.

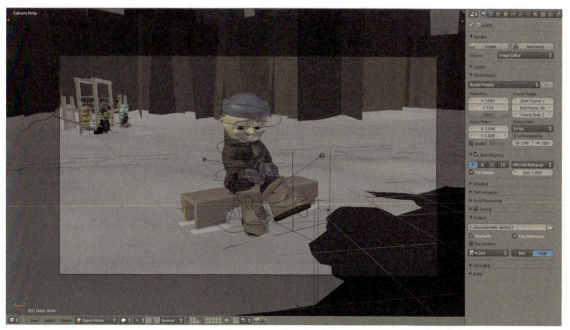

Figure 9.6 *Make an OpenGL animation.*

Figure 9.7 *Adding the OpenGL animation to the animatic.*

Back to the Spreadsheet

Now, the elements that were presented in the spreadsheet at the beginning of the chapter should make more sense. The exact method that you implement in the spreadsheet to track these activities is up to you. For my own work, I usually put an "x" or "o" in the relevant spreadsheet cell. An "o" means that the activity is currently under way (it is "out for work"), and the "x" means that the step is finished. Other methods that I have seen to track production are to use percentage values based on reports ("I'm 45 percent done") and also to color-code them to show additional properties like "on schedule" (green), "at risk" (yellow), or "failed" (red).

Whatever method you choose, you will be able to get an overall sense of the progress of your production at a glance.

Case Study: Background Animation in *Snowmen*

In the very first shot of *Snowmen*, we see children playing in the background. When thinking about working with a team, how would something like this be accomplished? It would be nice, for example, to distribute the shot file with the main character to one of our best animators and perhaps let someone with a little less skill cut their teeth on the background animation that will be both smaller on screen and heavily defocused.

Let's take a look at how I actually structured this shot so that we can not only make separate assignments, but use the background animation in any other shot in which we might need it.

First, even though the children on the playground will be animated, from the perspective of the hero character, they are set pieces. It is true that they move, but the main character does not interact with them in any way. So although they are not truly "set" (as in motionless), they simply provide a backdrop for the primary action.

Recall that in Chapter 7, which focused on developing the master scene template file, we made the background children duplicates of the main character and loaded them as Group Instances directly into the file for purposes of matching the storyboards. Now that it is time to animate, that is not going to cut it. The plan was to use the boy character as a base and modify that character so that each child looks different. As long as the proportions of the armature stay the same, any animation that is done to the boy's rig will map perfectly onto other children. That plan still holds, but if you make a proxy rig for each of the Group Instances, you will find that animating one of them moves all of them. That won't work.

The solution (which we would have to do eventually anyway) is to make several duplicates of the **boy_rigged. blend** file, and give each a different name. Then the duplicates instances can be completely removed from the master scene template file. We will *not* be putting Group Instances of the new duplicate files back into it though, which I'll explain in a moment.

First, let's see what making the duplicates of the character file buys us. If we want to make each character different, we now have an excellent way to start. For each individual child character, we simply modify that version of the file. It will be a good idea to change the naming within the file as well, for groups, rigs, and objects. We know that we will not be changing the character proportions, as we will be trying to reuse animation. So we can now get back to the work on animating, knowing that whenever we (or someone else on the team) has time, we can work on the individual character files without doing any damage. Figure 9.8 shows the other child characters, based on the main boy.

But why don't we bring these new, separate duplicated characters back into the master scene template file? Each of the sets is linked into the master template as an entire scene, so shouldn't we do the same with our animated set? We should. While we distribute the shot file with only the hero character to our lead animator, we will prepare a new set file and give it to our background animator.

> **Note**
> I realize that you might be the only person working on the project. If so, that is fine. You should still consider using a workflow like this, as it maximizes the capabilities for reuse.

As a starting point for this new set file, I use the master scene template, duplicating it in the same way that I did when creating the shot files. In a way, this will be a new, special shot file. I call this one **kids_looping.blend,** as I am planning to create a looping animation that can play forever in the background if need be. When I save the file, I save it into the **sets** folder, not the **scenes** folder. It is important that you use the **save as** function to put it in that directory in order to preserve the relative links. Simply saving the file into the **scenes** directory then moving it "by hand" into the **sets** directory will break the links.

In this new **kids_looping file,** I clean out all of the cameras that I will not need, as well as the main boy and snowman characters. I have the rough set scene linked in already. Thinking about the nature of that scene though, we're going to have to make some more changes. When animating, you need to know precisely your

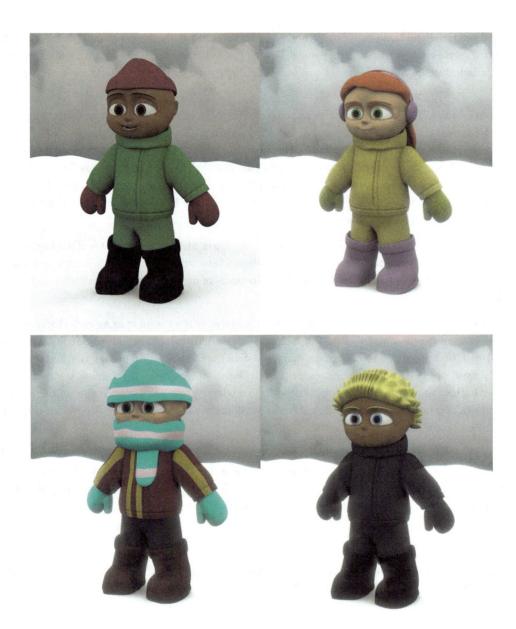

Figure 9.8 *These show about half-hour morphs of the main character.*

touch points between the characters and the set. The kids are going to be climbing on a jungle gym, so we need to know where all of their hand and fold holds will be. We could spend time building a rough model of the jungle gym, but at some point doing that leads to a diminishing return. You are going to have to model the final thing at some point, and it won't take *that* much longer to do so than it would to build a rough one with accurate touch points. So I decide to just build the final model of the jungle gym now. Figure 9.9 shows the model in place.

Figure 9.9 *The jungle gym.*

However, I don't model it directly into the **kids_looping** file. Instead, I follow the organizational structure of the rest of the project and create a new file in the **models** directory called **jungle_gym.blend.** There, I model and surface the equipment, then I put it into a group for linking and instancing. Thinking about the way the rest of the project is organized, because the jungle gym itself does not need to be animated, it should become part of a set scene. So it's back to the **sets** directory, where I make a duplicate of the **rough-set.blend** file and name it **gymset.blend.** This file will contain the rough set, but it will use a linked fully modeled version of the playground equipment. I open the **gymset** file and bring the jungle gym in as a Group Instance, placing it over the original rough set stand in, which is then removed. I rename the scene **roughset_junglegym.**

Now, I am ready to return to my **kids_looping** file where the actual animation will be done. I link in the **roughset_junglegym** scene from the **gymset.blend** file, and select it as the shot's background set (Figure 9.10).

With all of that done, I bring in linked Group Instances of three of the new children. Of course, they all look the same for now, but that doesn't matter. They are each linked to a different file, which my modelers will be changing at a later date into something more diverse. I create a proxy rig for each one, and it is easy to keep track of which is which because I've remembered to change the rig names in the individual files.

Now, it is time for some animation!

In reality, I do a slipshod job of it. I have bigger fish to fry, and these little peeps are going to be small, blurry, and on and off screen in a matter of seconds. If I have more time later, I'll come back and clean it up. (More time! Ha!) But to maximize the effect of even the small amount of animation I've done, I build the animation for only one of the characters, and I make it loopable. In other words, the animation begins in a particular pose,

Figure 9.10 *Switching to the newly linked **roughset_junglegym.***

with the kid looking up at the jungle gym ladder. He climbs the ladder, goes across the monkey bars, then down the other side. Finally, he putters his way back around and ends up about 200 frames later in the same location and pose in which he began. The animation can be played over, in a loop, with no visual break.

Now, the first shot is about 88 frames long. That's way too much animation, you might think. But here's the trick: using the Non-Linear Animation tool (NLA), I am going to show different portions of that same bit of animation on the three different characters.

If you've not used NLA before, here's the synopsis. When switching to the NLA window (Figure 9.11), you will see a listing for every object in your scene that has animation. Just like other animation editors, you can use the arrow button on the header to restrict the display to only those objects that are selected in the 3D view. Each object's animation shows up as the red line item, which indicates that an action is attached to the object.

To break away from using the action that is assigned in the Action Editor, you press the "snowflake" icon, which "freezes" the action into the NLA (not my terminology—I'm just rolling with it!). When you do this, you will see that the original red line is no longer red, and the phrase "<No Action>" appears, as in Figure 9.12. Below it is something new titled **NlaTrack**, which contains a yellow strip in the workspace. This yellow strip represents the action that was previously attached to the object, now found in a movable, scalable format. In NLA, you can use this strip much like you would a strip in the Video Sequence Editor. By **right mouse button** selecting it and hitting the **G** key, you move it forward and backward in time. Of course, you could do the same thing in the Action Editor before, but you would have to select all of the keys in the action first. Also, by doing it in the NLA, you can very easily create different frame offsets for different objects that all share the same basic animation.

With that in mind, we can "freeze" the action for each of our three children. Take a look at Figure 9.13 to see what I've done with it. The object titled **boy_group.004_proxy** is the one that I actually animated first. The full course of the animation is 274 frames, and I've shifted it about 6 frames to the left. For **boy_group_proxy,** I moved the strip 110 frames to the left so that on frame 1 of the shot, the actual animation will be around frame

Figure 9.11 *The NLA Editor.*

Figure 9.12 *Freezing an action into the NLA.*

110 of the action. Then, I duplicated the selected action strip with **Shift-D** and positioned it flush against the original, to the right. Because the animation itself is loopable—when the first strip ends and the second one begins—there should be no visual break in the action. Also, I selected both of the strips for that character and scaled them slightly down, until they were around 210 frames long apiece. This represents about a 25 percent speedup from the original animation. By doing this, we ensured that the two characters did not appear to be moving in sync.

Figure 9.13 *Building three characters of action from one.*

Figure 9.14 *The teeter-totter.*

The last character, **boy_group.005_proxy,** uses the same kind of duplication but a different offset and slightly different scale. You can see the feedback in real time in the 3D view, and using that I was able to make sure that the characters appeared a nice distance apart.

So I was able to only animate once and use the NLA to quickly apply that animation to several characters.

The child on the teeter-totter (the see-saw, or whatever you might call it) presented a different challenge. He was touching the object, and the object had to move. Objects that move are considered props and are brought directly into the animation file as though they were a character. Once again, it makes no sense to build a rough object, as the final one will be relatively simple. So a quick modeling and a very simple rigging job later, and I have a model file with a teeter-totter in it, shown in Figure 9.14. In this case, I placed it within the jungle gym file to keep all of the playground equipment together.

To once again keep work to a minimum, I decided to rig the teeter-totter to the boy so that when I animated his pelvis, it would bring the prop right along with it. That way, I would only have to animate the boy, and

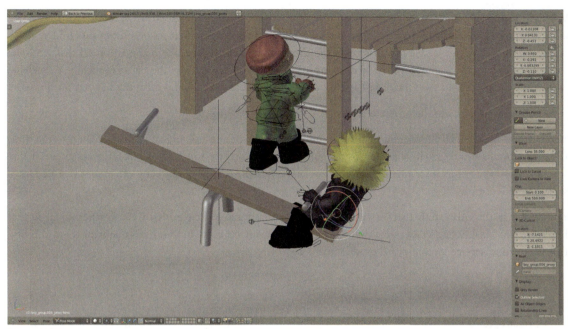

Figure 9.15 *Ready to record animation in real time.*

the teeter-totter would just follow along. As this isn't a book about rigging, I'll leave it to you to examine the **kids_looping.blend** set file to see how it was done (Blender power user code: teeter-totter bone Locked Track constrained to an Empty that is parented to the boy's *torso* bone.)

Have you ever played with a character rig in real time (made it wave, wiggle its hips, etc.) and thought, *Hey that looks pretty good*? I have too. In limited circumstances, and with the right rig, you can actually record those real-time motions into animation. That is what I did here.

First, I set the animation Start and End frames far beyond the scope of the shot, in this case from −100 through around 200. In the timeline view, I positioned the current frame at −100. I set an initial pose for the boy and used the **I** key to set a LocRot keyframe. Then I selected the torso bone (Figure 9.15). I made sure the automatic keyframing was turned on, pressed **Alt-A** to begin animation playback, then pressed the **G** key to enter translate mode.

I had about four seconds to get ready, as the current frame marker sped toward frame 1. Just before it hit, I began moving the torso control so that the boy bounced up and down, his feet never completely leaving the ground. I also kept an eye on the current frame marker and quit the motion soon after frame 88. It created a tightly grouped series of keys. Upon playback, it looked... okay. So I hit **Ctrl-Z** to undo and tried it again. After several attempts like this, I got something that I was satisfied with. I repeated the procedure twice more—once using the upper body controller and again using the head bone. When it was done, I had some motion that actually looked pretty good for the amount of time I had put into (i.e., five minutes).

This technique is rarely appropriate, but every now and then it can save you some time. Note that there are a lot of downsides to this method, not the least of which is that you would have a hard time tweaking the results if they were close to what you wanted, but not quite. You are really doing a series of overlapping puppetry takes as opposed to keyframe animation.

With all of that animation work, it is easy to lose sight of our goal: an animated background. We now have animation for four background child characters in the **kids_looping** file that resides in the **sets** folder. How do we use it? When our lead animator returns the shot file with the finished hero animation, all that we have to do is to link in the scene from the **kids_looping** set file and set it to be the background set. All of the animation, the props, and even the linked-in set from *that* file come through and form the new set for the shot.

It's a long way around, but the problem is solved!

As a bonus—and the main reason that we did it this way instead of just building all of that locally into the shot file—we now have individual asset files for the jungle gym and teeter-totter to use in other instances of the set, and we have a complete animation file that we can use as the background to any other shot that needs to show the kids at play.

You can see in this small study that by sticking to the organizational principles that we've learned so far in the book, we can break what seems like a difficult problem into manageable bits and still maintain the flexibility that we need to service a professional production.

Chapter 10

Dialogue, Sound Effects, and Music

Objectives in This Chapter
* Adding audio strips to shot files.
* Mixing and exporting sound for the final edit.
* Using online resources for sound, textures, and models.

When to Add Audio to Your Master Scene Template

In Chapter 7, we talked about preparing the master scene template file and duplicating and preparing it for individual shot files. We noted that if there will be dialogue or specific sound cues that must match up with animation, they also need to be a part of that master scene file. This chapter discusses when and how to add sounds to your master scene template.

There will be three major types of sounds in your animation: sound events that are perfectly synced to an action that happens on camera (dialogue, a car crash), sounds that aren't synced to events on camera (wind, crowd noise, birds chirping), and music. Of these three, the only kind that you need to add to your master scene template file are the first. Within that category, the only one that is absolutely critical to pass along to your animators with their shot file assignments is the dialogue. If you don't have the sound effects yet for, say, a piano falling off of a building, you can always specify—via timeline markers, grease pencil notes, or in some other way—on exactly which frame the piano needs to strike the ground, and you can include the sound later.

Also, not all synced sounds will necessarily be synced to by the animator. There is a process of adding sound effects after animation is finished called Foley. Foley work consists of creating sound effects with various props in real time while watching the finished product, and recording the audio. How can you tell the difference? What sounds should the animator sync to, and which ones should be generated by Foley to sync to existing animation? This is going to be a judgment call on your part, but a general rule is this: if the motion itself generates the sound (footsteps, falling pots and pans), you should go with Foley. In real life, the action actually drives the sound, so we keep with that in our workflow. However, if the sound drives the motion (people reacting to an explosion), the sound itself or at least a placeholder should come first.

Adding Audio Strips to Shot Files

Before you duplicate the master scene template into individual shot files then, it is a good idea to head to the Sequence Editor and place your recorded dialogue (if any) and sound effects that must be synced to animation.

Figure 10.1 *Sound strips added to the master scene template.*

Figure 10.1 shows what a typical configuration in the Sequencer would look like (there are no sound-synced events in *Snowmen*). Note that the longer strips are dialogue, recorded using the techniques described in Chapter 5. Other sound items like ambient noises and music will be added later in the story reel file.

With the sounds and dialogue added to the master scene template file, the links (but not the files themselves) will automatically come along for the ride when you distribute the shot files to your animators. You will need to include any individual sound files that appear within the shot in the file package that you provide to your animator. It is safe to not send any that are outside the scope of the shot. Their links won't be needed anyway, and losing them won't affect other shots.

There is one more decision to make, and it must be considered in relation to the structure and timing of your overall project. The question is, should you allow your animators to adjust the location of included sound strips on the timeline? If there will be tight cutting between different shots and you are trying to establish a rhythm with your synced sounds, you will want to instruct your animators to not change the timing. In that case, it might be a good idea to lock the audio strips in the Sequence Editor with **Ctrl-L** or by choosing **Lock** from the **Strip** menu.

Mixing and Exporting Sound for the Final Edit

Whether you have several sound clips for a particular shot or just one, you will need to mix and export them into a single sound file that will match the exact frame length of the animation for the final edit.

Using the **Volume** control in the **Sound** panel of the **N-key popup panel** as shown in Figure 10.2, you can increase or decrease the overall volume of the selected audio strip. Although you probably processed your audio before you brought it into Blender, you may find that you need to make adjustments if one strip is noticeably louder or softer than the others.

The Volume control can be keyframed just like all other controls in Blender, so you can have the volume of strips change dynamically.

For directional sound, you can use the **Pan** control in the Sequencer or take advantage of Blender's Speaker objects. Speakers are more work than simply adding strips to the Sequence Editor, but if you don't mind the extra complexity they can be worth it.

Figure 10.3 shows a **Speaker** object, which is accessible in your scene through the normal **Shift-A** "add object" process. Speakers generate sound within the 3D space. The current camera acts as the sound recorder. So if you attach a sound to a speaker object that is parented to a character's head and select that character's dialogue audio file in its control panel, the sound will come from the appropriate location in the stereo space.

Figure 10.2 *Changing the volume of an audio strip.*

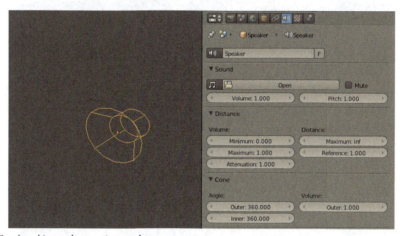

Figure 10.3 *A Speaker object and properties panel.*

Of course, sounds from speakers will also decrease in volume as they move away from the camera. Depending on the settings you choose and what happens in your scene, you may end up not being able to hear anything at all. Even though the speakers and 3D sound are a neat concept, I think that for animation production they have limited utility. Although they don't feature sound reflection or other physically accurate characteristics of sound, they are in a way a simulation of the sound of the entire scene. Once you move into simulation territory, you may find that you are getting an accurate result, but that an accurate result doesn't fare too well in an animation.

For example, depending on the recording conditions on set, some films and television shows have a significant portion of their dialogue recorded after filming, in a sound studio, using a process called ADR. No matter how good the recording equipment is on the live set, dialogue just sounds better if it is recorded in a studio and carefully mixed. Using Blender's speakers for dialogue is probably a bad idea for hero characters, whose dialog needs to be center of auditory attention.

> **Note**
>
> For background noise, the speakers could be a great idea. Having several different clips of people mumbling attached to a bunch of characters milling about would produce a nice result from a sound standpoint.

If you want to try using speakers, here is how.

Figure 10.3 shows the properties panels for the speaker object. Pressing the **Open** button in the **Sound** panel allows you to choose a sound file. Notice the **Mono** checkbox in Figure 10.4. If you want to use the directional capabilities of the system, you need to make sure that this option is enabled or that your sound file itself is a mono (i.e., not stereo) source. If Blender's sound system gets stereo from a file, it assumes that you already have the left/right setup as you like it, and the 3D sound location will not work.

This will not convert the sound file itself to a mono file. It just affects the way that Blender samples and deals with the incoming information.

Figure 10.4 *Choosing the Mono option for a sound file.*

Figure 10.5 *The speaker's cones.*

Figure 10.6 *Speaker sound in the NLA.*

The **Distance** panel lets you specify how the sound falls off as the speaker gets farther from the camera. The default settings are "natural" (i.e., what happens in the real world). **Attenuation** details the actual falloff rate. If you want sound to remain at 100 percent volume regardless of distance, set Attenuation to 0.0. Values very far above 1.0 will have the sound falling off rapidly and will probably not be useful.

The **Cone** panel allows the speaker itself to be directional. When set to its default values of 360 degrees, the sound from the speaker will travel in equal volume in all directions from the speaker. Reduce those numbers though, and you can highly focus the sound. It would be nice to have some kind of visualization of this in the 3D view, such as a spot lamp, but for now you just have to use your imagination. Figure 10.5 shows what this might look like. The area of the inner cone has sound at its full volume (depending on other things like distance and the master volume control). The volume at the edge of the outer cone is set by the Outer Volume control in the same panel. The volume decreases linearly between the boundaries of the two cones.

Playback of 3D sound can be a little "chirpy," especially the first time Blender goes through a frame range. If it sounds weird, let it play through once and it should sound better the second time. If you feel like playing around, attach a few sounds to some speakers and animate them swarming back and forth around the camera. Pop on a set of headphones and listen to what happens.

One of the drawbacks of using speakers is that you can only attach a single sound file to a speaker. So if you have multiple lines of dialogue stored in different files, you would need to have as many speakers in order to make that work. That's just one more reason not to use them for your main dialogue. You *can* make the same sound play multiple times though.

Figure 10.6 shows the NLA Editor. Note the blue strip attached to the speaker object. This strip tells the speaker when in the timeline the sound should begin. The length of the strip is irrelevant to how long the

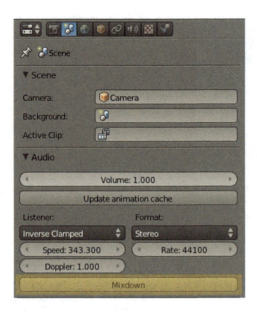

Figure 10.7 *Mixdown.*

sound plays. NLA is only used for the sound's start frame. You can move the strip with the **G** key, just like other NLA strips. You can also use **Shift–D** to duplicate the strip and place the new one elsewhere in the timeline in order to have the sound fire at different times.

So if you're feeling adventurous, give the speakers a try.

The other option for directional sound is to use the **Pan** control in the Sequencer **N–key** panel. It can be animated, with −2.0 being left and 2.0 being right. Once again, if you use a stereo source file, Blender will ignore your panning efforts.

Mixdown

When you are satisfied with the way your audio strips sound, you need to export them, one per shot. You will bring the exported sounds into the master story reel file when you bring in the final rendered frames, and everything should line up beautifully.

This is done with the **Mixdown** button that is found in the **Audio** panel of the **Scene** properties (Figure 10.7). Pressing **Mixdown** creates a single audio file using all of the various settings and information from volume and panning controls and 3D sound. Sounds from any speakers and the Sequencer will be included. Figure 10.8 shows the options in the Mixdown save dialog. As we are at an intermediary stage in the production process, you should choose the uncompressed WAV format from the **Container** control. **S16,** which stands for "signed 16-bit," is the most common format for WAV files and will be perfectly acceptable for your audio. Don't forget to put your mixed sound file into the **sound** directory you created at the beginning of the project, titled with something appropriate like "shot01_sound.wav."

Music

A great sound track can really enhance your animation. The effort involved in finding music for your production can range from grabbing a piece of public domain old-timey music off the Internet to contracting with

Figure 10.8 *Choosing a sound format.*

a composer for a fully orchestrated custom piece. Although that option is going to be beyond the means and needs of most people working on their own, other resources are available.

Several sites online offer music with Creative Commons or other open licensing. This means that you can often use the music legally within your own productions, sometimes even commercially. Of course, it is up to you to read and understand the licenses that come with any resources that you find online. I would go as far as to say that if you cannot determine the source of the music (or texture, or model, etc.), then you should simply not use it.

Know Your Licenses!

Last year, a group with which I am affiliated produced a music video. The video used a bunch of images culled from the Internet. I asked them about the origin of the images, and although they said, "I think they are all free," what they really meant was "Eh, I don't know. Does anyone care?" I advised them to make sure that they had a positive origin for everything that they used. Well, the video itself ended up getting almost 750,000 views on YouTube in just two month's time, and guess what happened? The local newspaper called the group's executive member, complaining that the video used copyrighted material. The fact that the material was found on other sites that were themselves violating the rights of the original copyright holder was irrelevant. The paper ordered an immediate takedown of the popular video. The group offered to pay the paper – who was the copyright owner – a nominal fee for the existing use of the images, to which the paper agreed. Note that the paper did not have to agree to this. The newspaper was fully within its rights not only to demand a takedown, but possibly even to collect damages, as the video had earned the group a nonzero amount of money to that point.

The lesson: Don't assume that just because you found something on a website and there wasn't any licensing notice, that it is free to use. *Always* determine a source and license for anything that you didn't make yourself.

Figure 10.9 *A strip of music added to the overall production.*

Some of these sites are as follows:

- The Free Music Archive (freemusicarchive.org)
- audiofarm (audiofarm.org)
- jamendo (jamendo.com)

Once again, be sure you check the licenses on the individual pieces even on those sites, as their terms can vary. Oh, and do you know what I am not? A lawyer. None of this is legal advice, just a few words to the wise.

When you have music that fits your animation, you will add it as a single strip in the story reel file for final production, like the one in Figure 10.9.

Listen to your final mix, perhaps using the test method noted in Chapter 8, to make sure that everything seems balanced, that the dialogue comes through where it should, and that the music accentuates what is going on in your animation.

Chapter 11

Final Sets and Backgrounds

Objectives in This Chapter

- Understanding the workflow.
- Considering quality versus render time.
- Understanding geometry.
- Thinking about materials.
- Appreciating lighting.
- Learning about organization.
- Getting help.

INBOX

Coming into this chapter, you need:

- A rough set file

Workflow

Even though this book presents the production phase of animation in a linear fashion, it does not have to be so. As mentioned before, the fact that there is so much to do on a project like this can be seen as a strength as opposed to an obstacle. If you are feeling burned out after doing nothing but animation for three days, there is no reason that you can't take a break and work on the final sets. Or take a day to record and play with voice work.

It's important to remember, though, that hard-core animators never quit. Ever. They just go crazy after a few months and melt into a puddle of coffee and keyframes. The lesson? Don't be a hard-core animator.

Break up the schedule. Take a day off, even. But if you find yourself becoming bored, remember that there are a lot of interesting and engaging things to do within the scope of your project that *aren't* what you are working on at the moment. You can almost certainly find something fresh to work on. Of course, this really only applies if you are a one- or two-person production. Those who are running a production as a part of a larger group are just going to have to suck it up and keep pushing through.

With that point about sanity and flexibility behind us, it's back into the maelstrom.

Quality versus Render Time

How much quality should your final renders have? As much as possible.

How long should your renders take? As little as possible.

Obviously, the answers to these two questions are at odds with one another. Although your renders, eventually, will have to take *some* nonzero amount of time to produce, there is no reason to gratuitously jack up the render times with foolish choices. Before we talk about final sets and props, materials, and lighting, we should look at some of the basic principles that will help to keep your render times as short as possible.

Once again, it is worth pointing out that ten seconds saved on a three-minute render time spread over 2,000 frames (which equals just over one minute of animation) will save five and half hours of total rendering time. And that's if you get everything right on the first shot, which you shouldn't count on. During production of *Snowmen,* the render farm was returning about one frame every three minutes on certain shots that could only be marginally optimized, but sometimes as quickly as one every 20 seconds. Following some simple rules can make a huge difference.

Your goal during the creation of the final sets, including materials and lighting, is to obtain the look that fits the style of your animation, while keeping render times to a minimum. Two other factors are at play here though, and they depend on the target and funding method of your project.

If you are, as has been mentioned before, a one-person show, you are probably financing the animation with your spare change and time. Your goal is to produce something nice with an absolute minimum of expense. After all, you're using free software for production and your friends as references and resources, right? Even so, you might find that the computer you have at home just isn't up to snuff for rendering. You do some math and realize that it's going take something on the order of six months to render. Even with frugality in mind, you might decide to purchase the services of a professional render farm that could complete the job in less than a day. In Chapter 13, we'll talk about different render farms and how to use them, but for now, just know that you can purchase rendering time for a price that is not unreasonable.

Maybe you can see where this is going: the more you optimize your renders, the less money you will pay the render farm. It's a simple bit of math, made all the more important because the result of the sums will come right out of your pocket.

On the other hand, if you are part of a production that is financed by someone else, or that is even expected to make money(!), you have a different set of dynamics at play. Yes, you still need to be cognizant of how much of someone else's money you are spending when it comes to render times. However, a project with this target will often have a hard deadline for delivery. If you have such a deadline, you cannot miss it without some kind of penalty. It may be that you will *have to* throw money into rendering to get it done on time. Still, optimization will be key. I have yet to work on a project where the final delivery didn't bump right up against the deadline, and some of whose renders did not come back with glitches. The faster and sooner you get to see things, the more quickly you will be able to make a fix and resubmit for rendering. Hopefully, if you follow the steps and workflows in this book, you will minimize incidents like this, but they are going to happen. In either case, the time that you put into render optimization will pay you back.

Geometry

Following the same rules as character design and development, the geometry of final sets and props should be created at an appropriate level of detail with respect to how it will appear on screen. Items that will only take up a few pixels on screen probably shouldn't be allocated four hours of modeling time. Set

pieces that appear mostly in the background but once or twice in close-ups should probably either have separate versions or should be made following the character design suggestion: a good base shell with a subsurface modifier. This makes it simple to raise the subsurfacing level and consequent edge detail as needed.

As you build your final set, keep in mind that you probably have a limited amount of time in which to finish your production. If it is ever a question of spending time on geometry, materials, or lighting, definitely sacrifice the geometry. Many beginners intuitively choose the opposite, dumping all of their time into creating a set of exacting geometric detail under the assumption that materials and lighting are easy. In my experience, the opposite is true. Good materials and lighting are the bedrock of a great render, and they are far from simple. In fact, getting the lighting correct is both essential and time consuming.

Matching the Rough Set

Remember that although your final set geometry does not need to conform exactly to the specifications of the rough sets, it is crucial that at any point where the characters interact with the set (the floor, a chair, a tree, or a wall that a character leans on), the final set needs to be identical. Most likely, you will have already animated some or all of your shots before you reach this point in the production process. If the final sets change in any material way from the rough sets where the characters interact with them, you will have to go back and adjust your animation to compensate. Obviously, this is to be avoided.

Figure 11.1 shows the rough set from *Snowmen* above the final set. The points of contact between characters and set are the ground, the bench, and the playground equipment. Nonbackground animation was done completely with the rough sets in place, so at those locations, the final sets had to match identically. As the illustration shows, the placement of structural and major elements is almost identical. To create the full set, a duplicate was made of the rough set file, and new geometry was created or imported as Group Instances directly on top of the old to ensure congruence.

In one instance, I messed up, causing me to have to retool some of the animation. When animating the opening shots after the boy stands up, I had forgotten when creating the rough set to add adequate depth for the snow, forgetting that he stood in an area without it. When I switched to the final set, which excluded the snow, I found that the character was floating over the floor. Fortunately, a move and rekey of the boy's master bone downward on the z-axis fixed the problem, although I had to adjust two shot files this way. This is one of the reasons that I generally do not use the root bone for positioning characters throughout their animation. It provides a nice safety valve for high-level adjustments if you do something stupid.

Movable Objects and Construction

If you examine the file **finalset.blend** in the **sets** folder of the production directory, you will see that many objects in the final set are linked **Group Instances** attached to Empties. In theory, you could build your entire set this way. However, I chose to build certain larger elements—the ground and backdrops—all directly within the set file. Anything that was going to be "bolted down" existed as live geometry in the set file. Everything else would come in as linked Group Instances for easy manipulation. In Figure 11.2, local elements are on the bottom with linked Group Instances on the top.

If you are working with indoor scenes, you will certainly want to employ a similar breakdown of objects as well. When I do indoor sets, I generally build the actual structure locally in the file—the walls, windows, floor, and so on—and bring the furniture in as linked Group Instances. Of course, if you are going to have multiple instances of the interior of the building that should share the same structure, you would want to build it perhaps

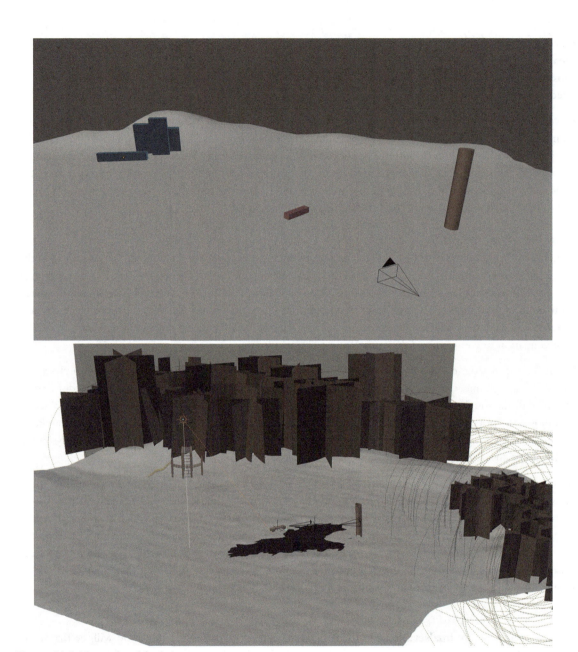

Figure 11.1 *The rough and finished sets.*

into a master file and link in the structure as an entire scene that could be chosen as a background set. One nice feature of Blender is that you can "chain" background sets, as we did with the *kids_looping* set.

For example, if you created the interior of a house in its own file, then linked that scene in as a background to a set file in another BLEND file, you could then link *that* scene—complete with Group Instance furniture and the linked background set—into a shot file and use it as a background set. This would dive down through the different levels of linking, letting you just choose the scene with the furniture for your set, but you could still see everything that was linked through there, including the original interior structure without any additional work.

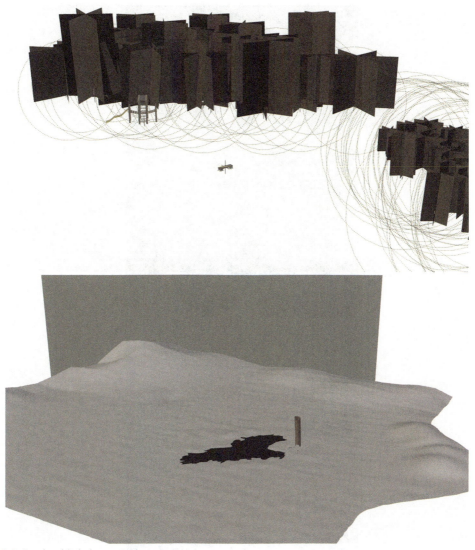

Figure 11.2 *Local and linked assets in the main set.*

Materials

The three material properties that will cost the most render time and which you should use only with consideration are ray tracing, subsurface scattering, and full oversampling.

Ray Tracing, of Course

This discussion applies to both ray mirror and ray transparency, found on the **Mirror** and **Transparency** panels in the **Material** properties. Ray-based transparency produces perfect reflections (as well as nice blurry ones) and is necessary whenever you need accuracy for your shot. It can be faked in most other instances. Allow me to introduce you to the **FakeRef** texture. It's not an actual texture type, but I use it so frequently that I gave it its own name. Figure 11.3 shows the texture properties, with a **Blend** texture selected and the **colorband** set. The colorband is the key. This colorband, when mapped to an object using the **Reflection** coordinates (instead

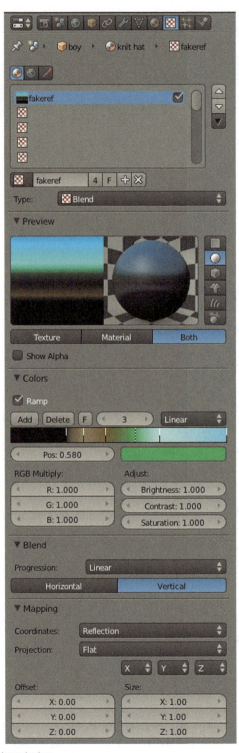

Figure 11.3 *Setting up a fake reflectance texture.*

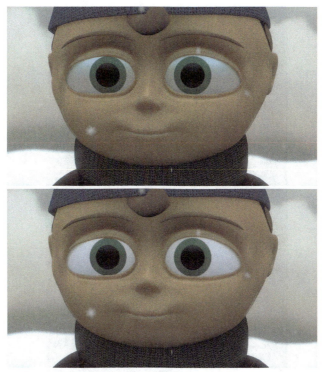

Figure 11.4 *The boy's eyes, with and without the fake reflectance blend.*

of **Generated** or **UV**) and blended properly with the base color, produces a passable reflection effect, as in Figure 11.4. The material settings for the boy's phony eyes are in Figure 11.5. One of the added bonuses of using this method on eyes and other slightly reflective objects is that you don't have to worry about what they are reflecting. If you were to use true reflection, you would have to consider what objects were off camera so that the reflections actually worked. You can also use an image type of textured mapped to Reflection coordinates for more "realism" if you have a picture laying around that is similar to your set.

For most items that reflect their surroundings in a subtle way, this will more than suffice in an animation. The idea was adapted from the way that fantasy painter Boris Vajello stated that he paints chrome and other highly polished metals. His theory is that our own experience with high-gloss metal is mostly restricted to cars, and that is the context in which our eye most easily recognizes it. Therefore, he paints all of his chromes with a "reflectance map" based on a roadway: black on the bottom for the road, then greens or tans for midground, a faded tone for the horizon, light to darker blue for the sky, and sometimes capped at the top with a bright band for the sun.

Before you use ray mirror or even an environment map—which does six mini-renders of the object's surroundings and has its own issues—try the fake reflectance blend texture. Far fewer items need to have accurate reflections than you might think.

Be aware that this technique does not work with perfectly flat surfaces like a mirror and has limited success when a surface only curves around a single axis, like a perfectly cylindrical glass. If you want a slightly more realistic look, you can always find or take a digital picture of a scene that approximates the locale of the shot, blur it, then use it as an image texture with **Reflection** mapping.

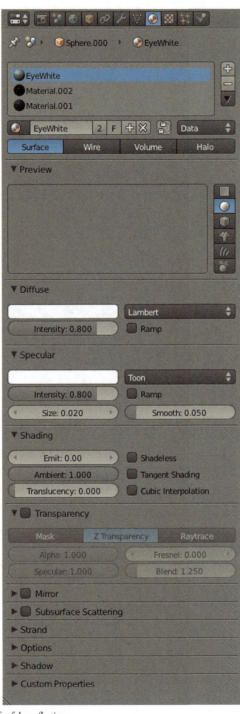

Figure 11.5 *The material settings for fake reflection.*

When it comes to refraction, less is more and none is best. Although adding true ray-traced refraction to transparent objects can add a startling bit of reality to still images, unless the refracting surface is the main subject of your animation, no one is going to miss it. Try your scene without refraction, using only **Z transparency** for your alpha, and see how it turns out. Don't ignore the **Fresnel** setting that can make the transparency fall off at oblique angles. Show it in motion to someone. If you like, render a small test with ray refraction turned on, to show along side it. You will probably find that it doesn't make any difference to your viewer, even though it made a large difference in your render times.

Subsurface Scattering

While Blender's subsurface scattering render is very fast for the high quality it generates, you need to be aware of how it can affect the overall render time on a typical short animation project. Each material that uses subsurface scattering gets its own render pass, regardless of whether or not the object is seen in the final render. Once again, each of these renders is fairly quick, but that time can begin to stretch if there are many shadow-casting lamps or if ambient occlusion (AO) is used.

As an example, in the opening shot of *Snowmen*, the kids in the background have SSS used on their skin. However, with the heavy defocusing and other effects being applied to their distant playground, you never see it. It was wasted render time. In the end, I just removed SSS from the material before rendering those shots, and the eventual production renders did not suffer because of it. It probably only saved five or six seconds per frame, but spread out among all the frames of the two shots that show them in the background, it saved a decent amount of time. I'd say it was worth it. Figure 11.6 shows the shot both with and without subsurface scattering. The difference on the foreground character and snow is obvious, but it is lost in the blur on the background characters.

Of course, subsurface scattering is crucial to getting the proper look for living creatures that are actually in focus, especially anyone whose skin is showing. And, as those are probably going to be your characters and the heart of your story, they are certainly worth the bit of extra time that SSS will cost. Unfortunately, snow looked significantly more realistic with SSS enabled on it, so in my case it had to stay. Thank goodness for modern, faster hardware.

Full Oversampling

Full oversampling is not one of the options you'll be tempted to overuse. It is mostly implemented when a texture that is attached to a material has details that produce an unsightly pattern, either in stills or during animation. Figure 11.7 shows the texture for most of the fabrics in *Snowmen* (the hats, gloves, and scarves). When applied to something like those items of clothing and rendered under normal circumstances, the repetitive nature of the texture image can produce ugly renders, even at the highest Render properties OSA settings. The reason is that the tricks that are used to "shrink" the texture to properly map it onto the model then sample for render can produce inconsistent results. Toggling the **Full Oversampling** feature uses a much stronger but slower sampling algorithm. In Figure 11.8, you can see the difference between the boy's clothes rendered with full oversampling (time: 0:39) and without it (time: 0:27).

How do you know when to use full oversampling on a material? When your renders show an uneven, choppy pattern in a reduced texture that should have a fairly uniform look. Also, you will notice it when animating an object whose texture seems to "crawl" (i.e., looks like random noise) from frame to frame. You can tweak the **Image Sampling** options in the Texture properties, using EWA instead of box, then upping the eccentricity value. Failing that, you might need to bring out the big guns. Although it takes significantly longer to render, full oversampling is the only real solution to this problem, short of entirely changing the texture itself.

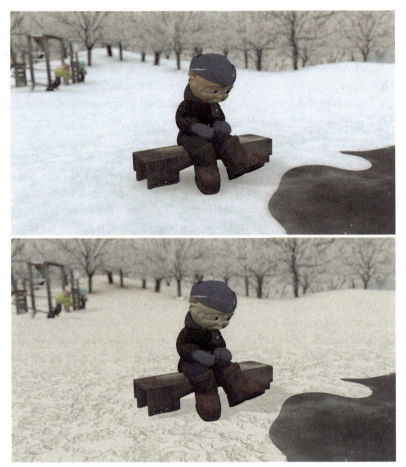

Figure 11.6 *Blurry kids.*

Figure 11.7 *The base texture for the boy's fabrics.*

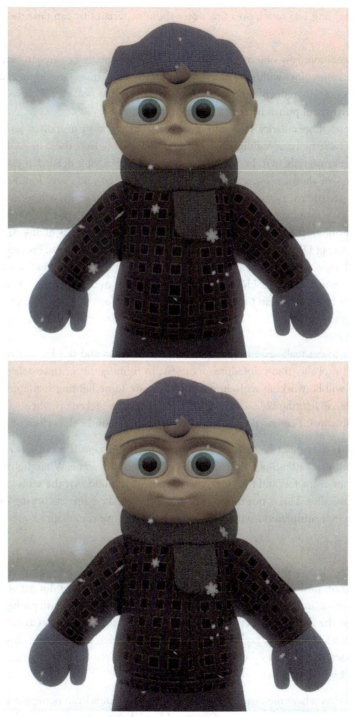

Figure 11.8 *Full oversampling versus regular sampling.*

Before moving on to lighting, let's touch on a few notes about materials that can raise the believability of your objects:

- Turn down the saturation. Few objects in real life have highly saturated colors. Instead of using the RGB sliders to generate your colors within Blender, switch to the HSV (hue, saturation, and value) controls on the Material panel. Slightly reducing the saturation of most objects will also allow you to give your main characters additional visual punch by saturating them a bit more.
- Turn down, or turn off, specularity. Take a look at your immediate surroundings and observe how many things have a noticeable specular highlight, compared to how many have them in your scene. Specularity is a default in Blender's materials, so it shows up much more often than it is needed. If you have a material that you think shows no, or almost no, specularity, try setting the **Spec** value very low, like 0.1, and the **Hard** value as low as 10, so that a very weak specular highlight, only a hint really, will spread over a large area.
- Even if you plan to use simple procedural textures on your objects, take a minute to create ultraviolet (UV) maps. Blender has one of the easiest, highest-quality UV mapping systems of any 3D package, making it possible to create decent UV mapping for background objects within seconds. Procedural textures, if set to use UV space, will appear as surface texturing, instead of having the "carved out" look that they often do.
- Watch the scale of your texturing. Unless you plan to use full oversampling as mentioned previously, a texture whose scale is too small can produce a noiselike effect when rendered for animation.

Lighting

It will be hard enough to get really good lighting on your characters and sets by themselves. To try to light them both at once will probably result in failure, or at least in running out of time before you've arrived at a good solution. As you will be working with animation, there are some lighting techniques that will just take too much time to render, so lighting skills and tools that you may have picked up when working on still images will not necessarily help you. Of course, the principles of what looks good—the artistic side—remain the same.

Good illumination will help to describe surfaces by showing off their shape. It should also give a sense of depth (where depth exists) and draw attention to the important points of the scene. When lighting sets, then, which are a background to your characters and the story, you must keep in mind that the set is (usually) not the most important element of the shot. This is not to say that you should make your sets boring or light them poorly, but they should not be in a competition with your characters for visual dominance.

What Not to Use

Let render times be your guide. While area lamps with high sample values make for beautiful illumination, unless you have a free monstrous render farm at your disposal you will probably not get away with it. Likewise, using ray-traced ambient occlusion with high sample values in complex scenes will probably also cost you too much time. In *Snowmen*, the shot lighting consisted of ray-traced ambient occlusion at only five samples, a low intensity sun lamp with a single sample ray shadow, a hemi lamp (which does not cast shadows), and a few key lamps on the hero characters in certain shots. As my scenes were relatively simple, my render times stayed within a reasonable limit, and I was always aware of the tradeoffs involved.

In shots in your production where the camera does not move and your set can be replaced in whole or in part by a background image (which we'll discuss in Chapter 13), and you will only be rendering the set once for the entire shot, you actually can use these techniques. The problem arises if you light your set with these "high-cost" tools for a shot with a stationary camera but use faster lighting tools for other shots. You will have a hard time maintaining a consistent look across the differing shots.

Lighting Exterior Shots

The easiest way to light an outdoor scene is to enable ambient occlusion with the **Sky Texture** option, throw in a sun lamp, and turn on ray shadows, which is what I did in *Snowmen.*

If testing with ray-based ambient occlusion produces render results that are too slow, take a look at the approximate ambient occlusion (AAO). Another downside of ray-traced AO is the noise. Depending on your materials, texturing and other lighting, and the final look you are going for, ray-traced AO can introduce an unacceptable amount of noise into your animation. You may find that to eliminate it to your satisfaction, you have to raise the samples so high that render times become unacceptable. Those are the arguments *against* ray-traced AO, but are there any positive reasons to use the *approximate method*?

Although the approximate method of ambient occlusion takes more tweaking to get right than the ray-based method, which is pretty much "fire and forget," the results are relatively quick, smooth, and consistent across frames. Figure 11.9 shows both AO methods used on *Snowmen* with no other lighting.

One bonus that you get with the approximate method is relatively cheap reflected lighting. Although it was not used in *Snowmen*, think about the following exercise. Let's say that the snowman had found a patch of grass and leaned over to smell the thawed ground. Under real conditions, green light that was reflected from the grass would cast some subtle green illumination on the part of the snowman closest to the ground. A careful lighting artist would realize this and possibly place a green lamp within the grass to achieve this effect. The **Indirect Lighting** option takes care of this for you.

The options for approximate ambient occlusion are a bit obscure, so let's examine how to use them to fix problems you might encounter with the default values. The AO settings are represented in the **World** properties by four different panels (Ambient Occlusion, Environment Lighting, Indirect Lighting, and Gather), shown in Figure 11.10 with all options enabled and set to their default values. The only change that has been made is switching the ambient occlusion method from **Add** to **Multiply,** which causes AO to play more nicely with the two lighting methods. Note that in *Snowmen*, I used a linked World for all shots so that the look would be consistent and changes could easily be made across the board.

In Figure 11.11, notice how the areas that have been darkened by AAO seem unusually dark. This is one of the downsides of AAO—areas that have faces pointing in the same direction will tend to reinforce the occlusion effect. There are two methods you can use to fix this problem: raising the **Passes** value, which attempts to cull duplicate faces from the solution before rendering, and raising the **Correction** value, which simply tries to reduce the darkness of the final result. Figures 11.12 and 11.13 show both methods used to fix the problem from Figure 11.11. Personally, I have achieved more visually pleasing results with the **Correction** tool. I turn it up to 1.0, the maximum, and work it down from there until it gives the look I'm after.

Remember when working with AAO and looking at these examples that it is meant to be a basis for the rest of your lighting scheme, so it will look dark to begin with.

AAO rendering speed can be greatly increased by increasing the **Error** value. It begins at **0.250** but can be set as high as **10.0**. Basically, the error value represents how tolerant AAO is going to be of nonoptimal conditions within the solution, or how lazy it will be about fixing bad stuff. As Figure 11.14 shows, a value of **10.0** means that it is very, very lazy. You will have to experiment with the setting for your own shots, but I have found that a value of even **0.5** produces a result that is mostly indistinguishable from lower values, but with a significant increase in speed.

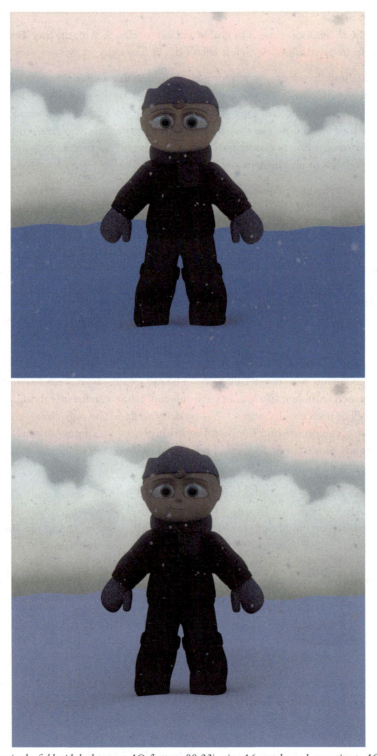

Figure 11.9 *The boy in the field with both raycast AO (bottom, 00:23) using 16 samples and approximate AO (top, 0:19).*

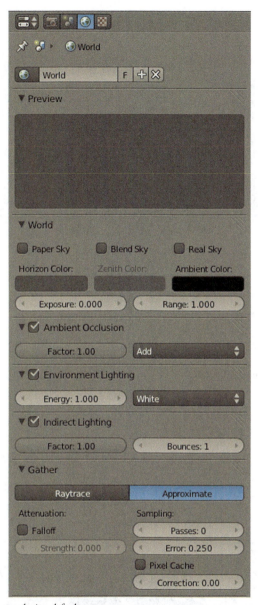

Figure 11.10 *Approximate ambient occlusion defaults.*

Falloff functions much the same way as it does in raycast AO. It is an adjustment from 0.0 to 10.0 that determines how closely AO shadows cling to the faces that create them. A value of **0.0** gives you the default render from Figure 11.13, while maxing it out at **10.0** causes the shadows to really stick close to their base, as in Figure 11.15.

To increase (or decrease) the overall amount of "light" generated by AO, adjust the **Energy** value in **Environment Lighting.**

Finally, try enabling the **Pixel Cache** option, which can dramatically speed up AAO rendering. Be aware that it is an even further shortcut in the rendering process and might produce undesirable results. The best advice,

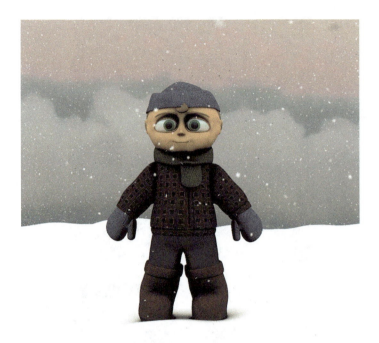

Figure 11.11 *An out-of-the-box render using AAO.*

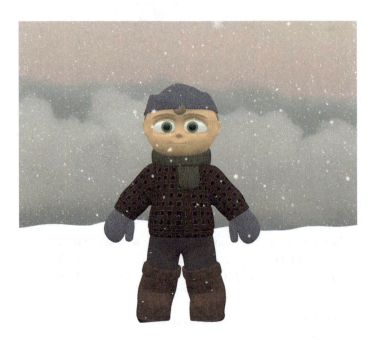

Figure 11.12 *Passes set to 2 to fix over-occlusion.*

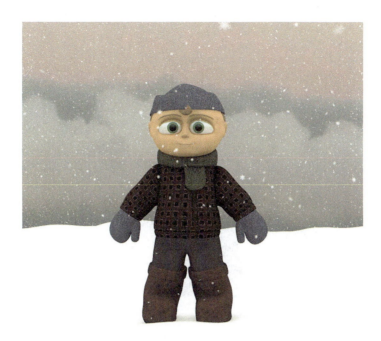

Figure 11.13 *Correction set to 1.0 to fix over-occlusion.*

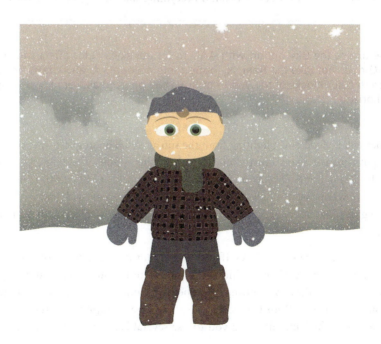

Figure 11.14 *Error cranked up to 10—it's a good thing it doesn't go all the way to 11!*

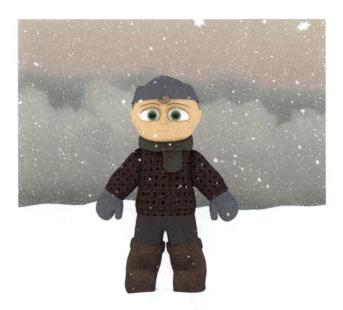

Figure 11.15 *Falloff set to its highest and tightest value.*

though, is to get your AAO settings as you like them, do a test render (possibly even a test animation), then enable **Pixel Cache** and re-render for comparison. If everything still looks good, then go with it!

> **Note**
> You can choose to use the **Sky** option with AAO to let the sky's color affect the solution. Unlike raycast AO, AAO does not take the **Real** sky option into account, so any colors you specify in the Horizon and Zenith color blocks of the World buttons will be used as a simple up/down blend, not as a true color horizon.

Most outdoor scenes will include direct lighting from the sun as well. The simplest way to accomplish this sort of unidirectional light is to use a **sun lamp**. Sun lamps have the option of adding "sky and atmosphere" to your scene, although the vast array of values and options available make it difficult to configure in a meaningful way. Figure 11.16 shows our scene rendered with a single sun lamp, both with and without the atmosphere settings enabled, using the **Classic** set of options (note that the background plate has been removed so you can see the Blender "sky").

Of course, you will need to include shadows. If you don't want the hard edges of a 1-sample ray shadow, the best way to do this in a controllable fashion is to duplicate the sun lamp and change the new lamp to a spot lamp, set to **Only Shadow**. Settings for the spot lamp used to produce Figure 11.17 are in Figure 11.18. If you set the lamp's **Blend** value to 1.0 on the **Spot Shape** panel, the shadows will fade out nicely around the edges of the lamp, allowing you to use several lamps beside each other to shadow large areas if the need arises.

So when setting up lighting for an outdoor scene, approximate ambient occlusion (or ray-based if necessary) creates your base. The sun lamp provides direct illumination, and a shadow-only spot lamp provides direct

Figure 11.16 *A sun lamp added, with and without sky and atmosphere.*

Figure 11.17 *A Shadow Only spot lamp produces the primary shadow in this shot.*

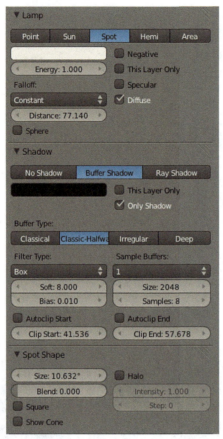

Figure 11.18 *Shadow Only spot settings.*

shadows. The deepest shadows then will be found anywhere the spot-cast shadow and AAO shadowing coincide. A midtone area will be created where the spot-cast shadow falls, but AAO provides full illumination. Finally, the brightest areas will be places where AAO creates the most light, faces point toward the sun lamp, and no shadows from the spot lamp fall. Adjusting the outdoor lighting becomes a process of tweaking the AAO settings to the range of light present in shadow areas, the sun lamp energy and color for the proper amount of direct illumination, and the shadow-only spot lamp's energy and shadow buffer settings for the correct intensity and sharpness of direct shadows. Once again, using ray-traced shadows for the sun lamp can make it simpler, but you will have to accept either razor-sharp shadows or much longer render times. In *Snowmen,* I kept the intensity of the sun lamp fairly low, so even with a ray sample value of 1, the sharpness of the shadows is deemphasized by their relative lack of contrast.

Lighting Interior Shots

Interior shots are significantly more difficult to light believably than exteriors. Many of us (especially computer people) spend an inordinate amount of time indoors and have a well-developed sense of the subtle shading and radiance effects of interior lighting. The best advice for working with interiors, then, is to approach the task as though you are a retail store designer. Take a trip to your local mall or shopping center, walk through some of the more upscale places (as long as security doesn't tail your silly artistic self), and observe the way that the store is given a very natural look even though there is probably no natural light whatsoever. The key? Lots and lots of distributed low intensity lighting.

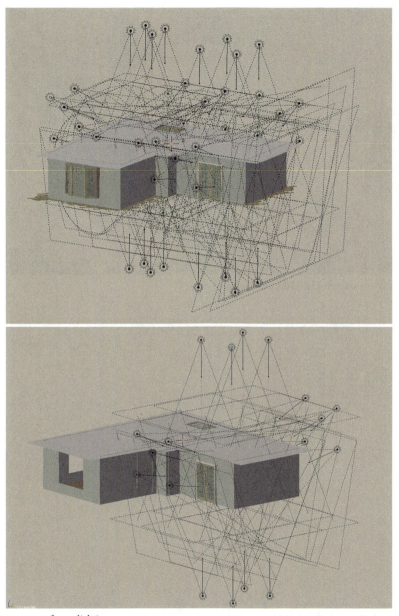

Figure 11.19 *Lamps arrays for set lighting.*

If you've ever been on stage in live theater or, less likely but even better, been on a sound stage for a film or television production, you will notice the gigantic array of lights needed to produce a natural effect. You will be doing the same thing in 3D.

Figure 11.19 shows a large array of spot lamps that can create a decent base for interior lighting. Each of the lamps in this configuration is a spot lamp with very low energy, a relatively small shadow buffer, and high shadow blur. As you can see from the render in Figure 11.20, it gives an *okay* interior ambient occlusion effect.

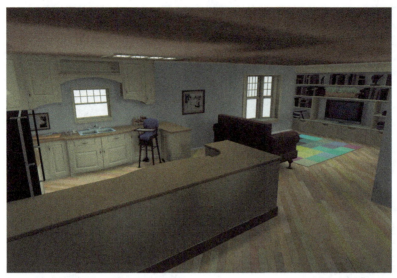

Figure 11.20 *An interior render with no additional lighting.*

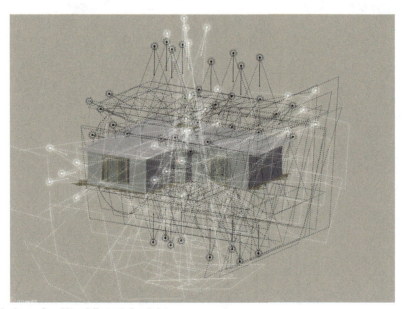

Figure 11.21 *The lamps for adding diffuse window lighting.*

More low-intensity lamps can be clustered outside of windows to provide extra diffused brightness coming from those areas. Figure 11.21 shows those lamps. Note how several overlapping lamps are used so that the light seems to diffuse in a more natural pattern further from the windows. You can see that each wall has four or five overlapping lamps to simulate light diffusing from that wall.

Figure 11.22 shows an interior with the clustered "window" lamps added to the base shading.

Areas in the render that still remain too dark can be brightened with low-intensity regular omni lamps with **Sphere** falloff enabled and carefully adjusted. This only needs to be done on a shot-by-shot basis.

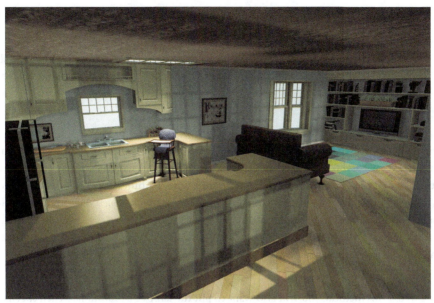

Figure 11.22 *The window lighting added to the base shading.*

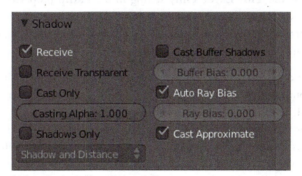

Figure 11.23 *Turning off cast shadows for the walls, ceiling, and floor.*

In an actual shot, additional lamps can be added on an as-needed basis for direct illumination. Why not use the fast approximate ambient occlusion like you did for the exterior shots? Unfortunately, the AAO algorithm does not like the long, thin faces that are used for many of the architectural elements of a set (like the cabinet bevels, floorboards, and crown molding), producing bad results even at very low and slow levels of error tolerance. It is worth a try in your own production to test AAO if there are interior shots. It may be that no ugly artifacts are present, but remember that it will be an all-or-nothing proposition. Using AAO on only some of your shots, but not on others, will produce an uneven finished product.

Although the walls, ceiling, and floor of an interior set are capable of receiving shadows, they should not cast them. This allows you to keep your actual lamps very far away from the set to simulate the proper area of cast light, while not having to worry about the set preventing the light from actually getting inside of it. This effect is set by turning off the **Cast Buffer Shadows** option in the **Shadow** panel of the **Material** properties, as shown in Figure 11.23. This allows the light from the surrounding lamps to pass through the walls on its way into the set, as though the light were reflecting from the wall itself. Notice how the size of the selected lamps

in Figures 11.19 and 11.21 matches the dimensions of the outside edges of the wall and ceiling so that a good simulation of reflected interior light occurs.

Another way to accomplish this effect is to allow the normal shadow casting properties of the walls and other elements, but to carefully set the clipping distance of the shadow buffer calculation so that it begins only inside the walls.

Layering

As you construct your final sets, you should keep in mind that often the camera will not see the whole thing at once. Work through your storyboards and story reel with an eye toward which portions of the set will be seen in which shots. As one of the goals of set design is to minimize render times, it is a good idea to break up your set into layers. Figure 11.24 shows three different layers of the set from *Snowmen*. Although some elements and objects appear on more than one of the layers, major geometry is arranged so that when it does not appear in a shot, it can easily be disabled on the layer buttons. In Figure 11.25, you can see one of the camera views of a shot from later in the project. Notice how only one set layer out of three is enabled, as the others were not needed for this view.

If you are going to use this method, you will also want to put the lamps that illuminate each specific portion of the set on the same layer as the objects. In fact, it can be useful to also change those lamps to only affect objects on their own layer, by using the **This Layer Only** setting in the **Lamp** properties, shown in Figure 11.26. This means that the lamps will not affect your characters, but it is sometimes best to light them independently anyway. Also, if your characters will have hair or fur using Blender's strand particles, the calculation times for shadow buffers on a very high number of interior lamps can be quite large.

Once you have arrived at a scheme for separating your set content into layers, it becomes easy to create multiple scenes within your set file to use as background sets in your shots. From your main scene, choose the **Create Scene** control, which looks like a plus ("+") sign on the main header, as shown in Figure 11.27. From the menu that pops up, choose **Link Objects**. This creates a brand new scene with links to all of the original scene's objects. Enable and disable layers until you have another useful set configuration. For example, your main scene will probably contain all set objects and be called something like *FullSet*. Duplicate that scene, then removing everything but some trees could yield a scene called *ForestOnly*. This is what was done for the close-up and medium shots of the snowman near the beginning of *Snowmen*. Examine the **shot02.blend** file to see which scene is used as a background set. It is just a duplicate of the main set with several layers disabled.

Also important to consider, especially for outdoor scenes, are distance breaks. Most likely, you will not be rendering an entire foreground-to-horizon environment in live 3D for every frame of your animation. Unless the camera is spinning wildly, it would be completely unnecessary. If you will be using a statically rendered distant background, you will need some way to blend that into the foreground. The easiest way to do so is with distance breaks. Consider the image in Figures 11.27 and 11.28. It demonstrates how an entire shot can be seen as a series of overlapping layers. The point is that between two of those layers, you will need to change from live geometry to a prerendered (or painted) still image. Having some sort of physical break line, like a cresting hillside, will give you an excellent place to make the transition.

You aren't required to have a physical breakpoint, and you won't always be able to have to one, but a line of trees, a building, or a hillside can make your later job as a compositor much easier. The actual creation and integration of background images for your shots will be covered in Chapter 13.

Figure 11.24 *The different layer breaks of the* Snowmen *set.*

Figure 11.25 *A view of the forest that requires only one set layer.*

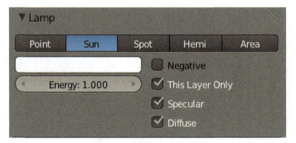

Figure 11.26 *The This Layer Only lamp setting restricts the lamp's effects to objects on its own layer.*

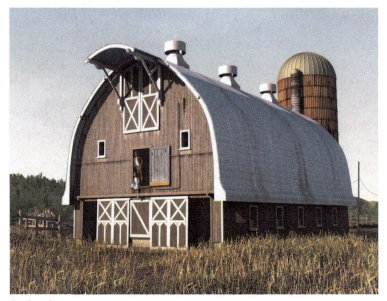

Figure 11.27 *A rendered outdoor scene.*

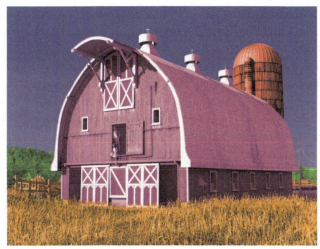

Figure 11.28 *The different production layers.*

Getting Help with Set Building

This is another good time to discuss getting help with your project. We've encouraged you previously to solicit feedback on your story ideas, storyboards, and story reel, but that sort of help can come from anyone with eyes and, at the least, a half a brain. If you have committed to developing the story and characters either by yourself or with a small group, the finalization of sets and props is an excellent opportunity to open the project up to a larger pool of help. You don't have to, but at this point in the production, going from character animation to modeling a shelf full of books can feel like a bit of a let down. It can also take a while. Fortunately, the modular structure of your sets and object files (linked assets) makes it easy for you to farm out these sorts of duties.

The mechanics of doing so are simple. For modeling help, you request one BLEND file per object. As you receive BLEND files, you place them in your **models** directory, or perhaps a subdirectory called **contributed**, and open them for inspection. Make sure that any texture images have been packed and that the artist has obeyed any rules you've given (like, say, no ray tracing). Select all of the objects in the file, excluding any lamps or cameras the artist had used for testing, add them to an appropriately named group, then save and close the file. The asset can be linked into your set or shot files as a Group Instance and scaled and placed accordingly.

Having artists work on materials is even easier. Just send them your single-object asset file, then have them apply textures and materials and return it. As long as they haven't altered the geometry in any way, you can drop that returned file into place in your **models** directory, replacing the original, and that object will now be textured throughout your production.

Of course, dealing with people is neither simple nor mechanical. Here are some guidelines to follow when asking for help:

- Before you begin asking for general help in web forums, try to find some people who are familiar with Blender and whose artwork style seems to fit with your project. You will have a much greater success rate by personally contacting such artists with details about your project and exactly what you need, rather than making an online cattle call. It will help to include in your request a little bit about yourself, how much time you already have in the project, and perhaps a few bits of teaser artwork.

- When artists express interest, show them some more of the artwork you already have finished, as well as a little of the animation. This will help them to decide if your project is something they want to devote their time to. Not every project fits every artist.
- Give those who express interest a small assignment or two to see how they do. You will not only be considering how their finished products actually look, but how well they can stick to a stated time frame. If they say, "I can do it in two days," do they really come through in two days? Obviously, you cannot be a slave driver about it, but it's good to gauge how much time the person has available.
- Don't ask for too much. Remember that you've decided to put your sanity on the line by producing a short animation, but no one else has. Don't be demanding. No one is going to die if someone ditches on adding textures and materials to a picnic table model.
- When giving an assignment, be clear about it. Provide reference images or artwork (web links are fine), as well as a clear description of what you are looking for. Do not say, "Just make whatever you want." Indicate any restrictions you might have (no ray tracing, no blue, whatever). For quality and completeness, ask the artist to use the PNG format for texture images and to pack them into the BLEND.
- If you have one available, provide your stable of modelers and shaders with an FTP site where they can receive and load jobs. Although these sorts of transfers can be done by email, packed files might become quite large.
- As your project progresses, share as much of it with your helpers as you can. It's nice to feel like you're on the inside of something cool.
- You will receive files that are not exactly what you had hoped. Before rejecting them outright or asking for revisions, there are a few things to consider. First, how long will it take you to bring the work into line with your original idea? It might be simpler just to make a few changes than to go back to your artist for a revision. Second, could this idea work better than your own? Try it and see. If the work simply doesn't fit your project, be diplomatic. Examine your original request—it may have been unclear.
- Give credit. Make absolutely sure that you credit anyone who helped in the final production. Before the final edit, send the credit list around to everyone who helped so that each contributor can check the spelling of his or her own name.

Here is a sample message you could send to someone who you have identified as a potential helper on your production:

Hi DarkStarr02—

I noticed some of your great artwork in the blenderartists forum gallery and thought you might like to take a look at my current project. I've been working on a short animation for the past four months. Most of the animation is finished, and I'm starting to create the details of the sets. I was wondering if you would be interested in modeling and texturing a few objects that would appear in the finished production? I really think your style fits well with my animation and hope you can help.

You can see some of the already finished artwork and animation here:

www.super_awesome_animation.com/secret

I know that you are probably busy, so if you aren't interested in participating please know that that is fine.

Thanks!

super_awesome_animation_dude

Also, be sure to include your real name and main email address so you feel less like someone who they just met on the Internet, even though you are.

Summary

Like many other aspects of the short animation process, final set and prop creation is a continuation of the balancing act between resources and results. The sets themselves are created from a combination of local geometry and linked assets. When adding materials to your objects, care should be taken to avoid features that can cause render times to drastically increase. Sets can be lit independently of the characters. Outdoor scenes can be effectively lit for animation with ambient occlusion, a sun lamp, and shadow-only spot lamps. Interior scenes can also benefit from AAO but may require more complex setups to mimic the subtle reflected light we are used to seeing inside. Sets and lighting are broken into layers to facilitate both rendering and background blending during compositing.

OUTBOX

Leaving this chapter, you should have the following:

- Finished set and prop files, fully lit, with materials for all objects
- The set elements broken into layers for exclusion from shots

Chapter 12

Simulation

Objectives in This Chapter
- Understanding Blender's simulators.
- Working with fluids, cloth, rigid bodies, ocean, smoke, particles, and strands of hair and fur.
- Linking issues with simulators.

Blender's Simulators

Blender has a number of simulators available for your animation needs. These simulators can produce accurate results that add a high degree of believability to your animations. Although it is simple to configure the simulators to make impressive demonstrations, integrating them successfully into a larger animation project can be extremely difficult. So in addition to looking at a short example of each type of simulation, we'll also take a look at integration issues and when it might be better to just skip the simulation altogether.

Fluids

Here's the three-step tutorial on creating fluids simulations in Blender:

1. With the default cube selected, enable **Fluid** in the **Physics** properties (Figure 12.1); choose **Domain** from the **Type** selector.
2. Add a small sphere inside of the default cube, enable **Fluid** again for this object, and set it to the **Fluid** type (Figure 12.2).
3. Reselect the original cube, and press the **Bake** button (Figure 12.3).

Simple, right? The Domain object becomes the actual fluid, and the original bounds of the domain become the extent of the simulation. The other options are just as easy too. Setting an object to **Obstacle** does exactly what you'd think—uses the object as a solid obstacle that the fluid will not penetrate. **Inflow** and **Outflow** objects add and remove fluid from a simulation at a constant rate, like a spigot or a drain, respectively. Note that you adjust timing for fluid simulations via the **Start** and **End Time** controls, which are displayed in seconds as opposed to frames. A simple simulation result can be seen in Figure 12.4.

Blender's fluid simulator is impressive, but in reality it is better suited to creating stills than animations at this point. The problem is one of resolution and time. A number of very cool demonstration videos of the fluid simulator are available on the Internet, and most of those were created with a sort of "let's see what we can do" attitude. Even though this is great for testing and for doing technical demos, it doesn't really fit into the

189

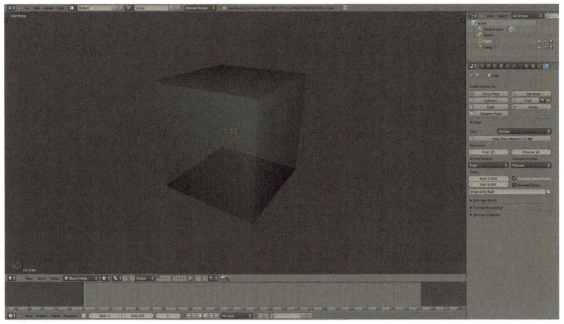

Figure 12.1 *Enabling an object as the overall domain of the simulation.*

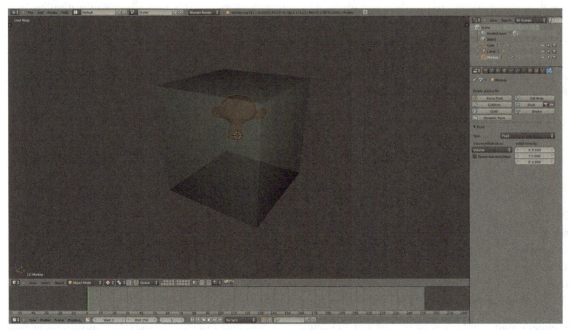

Figure 12.2 *Adding and enabling an object for the starting position of the fluid.*

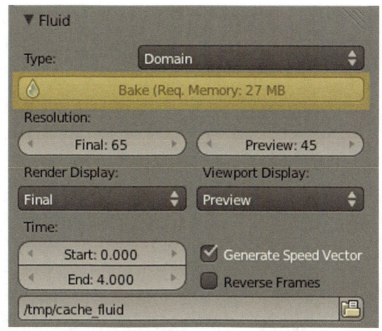

Figure 12.3 *Pressing Bake starts the simulation.*

production pipeline very well. When producing an animation, you will be looking for a specific effect and probably an exact behavior from the simulation.

Although the fluid simulator was not used in *Snowmen*, we can still take a look at it. First, though, let's examine the criteria that can help you to decide whether or not a true simulation will be appropriate.

Detail. This is the controlling factor. You need to be able to put enough detail in the simulation so that it looks realistic. For example, if you are simulating a glass of water tipping over, but there is not enough detail, the liquid will appear thick, like heavy syrup. Increasing detail rapidly leads to drastic increases in both calculation time and RAM usage.

Overall size. As the real-world size of the simulation increases, so do the RAM and time requirements needed to maintain the same level of detail. The size of the simulation must encompass the entire area where the fluids may happen to be. So if you have a splash that flies away from an impact point, the entire area that the splash covers must also be a part of the simulation or the splash will seem to hit an invisible boundary.

Consider a fairly small fluid situation. A character has knocked over a glass, spilling its contents onto the table. For some reason that makes sense in your story, this is a big deal—a very dramatic moment. You decide to show the glass falling and the water spilling in slow motion with a fluid simulation. As a test, I've made such a simulation. You can see the result in Figure 12.5. The setup for creating this simulation can be seen in Figure 12.6. Notice how the domain (the area in which the simulation takes place) has to cover everywhere the fluid might splash or flow, meaning that it is much bigger than just the area of the glass (0.5 meters). Also, because of the trial-and-error nature of creating a good simulation, this particular setup took over two hours to get just right, and it took another two hours for the final sim to compute on a six-core system. Working with simulations is much like setting up a physical stunt or effect on a movie set: you can set up the initial conditions, but it may take hours or days of tweaking and fooling around to get the exact effect you are looking for.

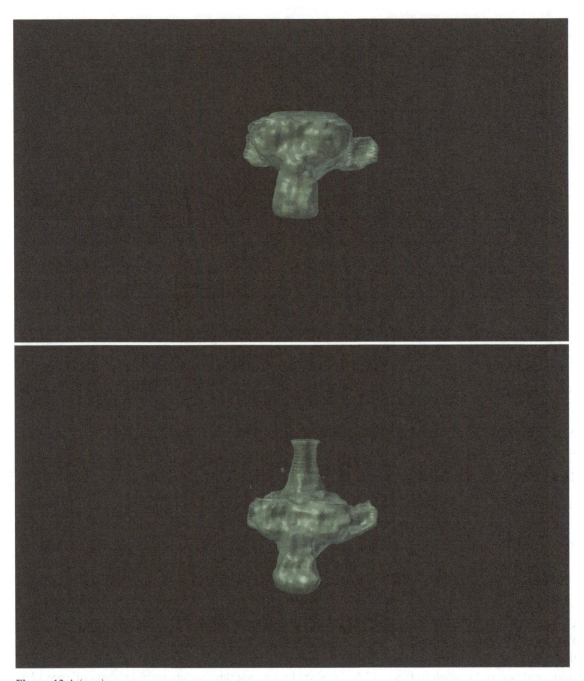

Figure 12.4 *(cont.)*

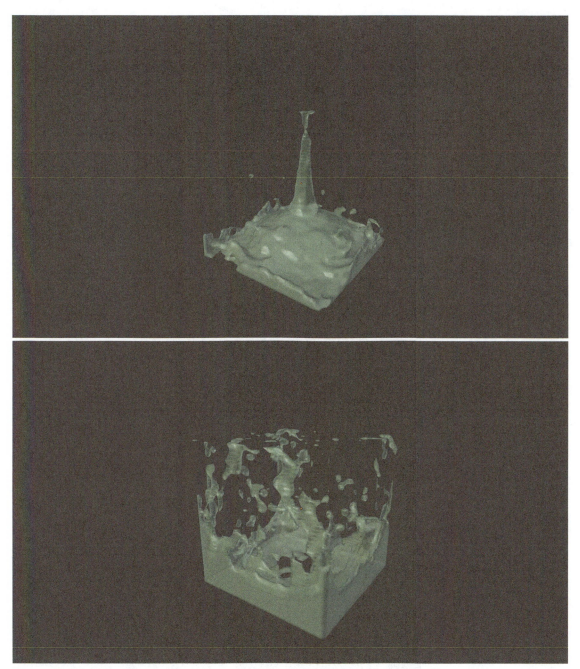

Figure 12.4 *Taste the splashification!*

Figure 12.5 *A spilled glass, before the liquid "soaks into" the tablecloth.*

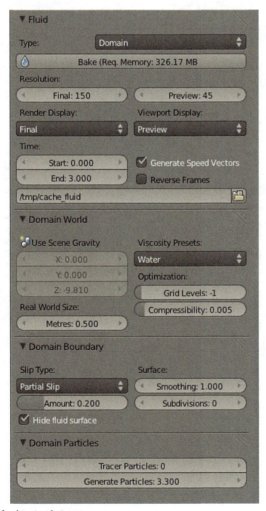

Figure 12.6 *The liquid settings for this simulation.*

Figure 12.7 *Hosing down the competition.*

That kind of time is not bad for something that will be central to a dramatic moment in an animation. However, for a background element in a smaller production, it might be an inappropriate use of resources.

To demonstrate, let's pretend for a moment that I had wanted to use a garden hose in *Snowmen*. In Figure 12.7, the boy holds the hose nozzle. I've used the grease pencil to show what I hope the water will do. With the area of the splash included, and keeping in mind that all water must live within the domain, the actual dimensions of the domain extend over four square Blender units. To achieve enough detail just to see the fluid coming out of the nozzle requires a resolution setting of over 250. This will require 1.47 GB of RAM and starts to come back at over a half hour per frame during calculation. Note that reducing the resolution setting to a tolerable value so that you can do some testing in a reasonable amount of time means that the fluid droplets don't even show up. To see anything, let alone get a decent result, is already beyond the capabilities of my systems. It's surprising how quickly the feasibility of using a true simulation disappears.

So if you have a small controlled situation or something on a larger scale where "anything goes" and the detail does not have to be too high, the fluid simulator can work well. However, if you're doing something more ambitious, you will have to look elsewhere. One of those places to look is at the Particles section of this chapter, using the Fluid physics type.

Integrating a fluid simulation into your animation shot is not that difficult. It's best if it is done directly within the shot file with all local objects, just to avoid any incompatibilities that might be lurking between the fluid simulator and linked objects. Any animation that needs to interact with the fluids should be done before the simulation so that the fluid can react to the moving obstacle. The fluid simulator does not recognize deformation animation, so you will have to come up with another solution if your character needs to splash or otherwise affect the fluid.

The best way to do this is to create a dummy object or two and keyframe them to match the motion of your character. In Figure 12.8 you see the boy plunging his hand into a fluid simulation. As the hand moves, the simulation reacts appropriately. To accomplish this effect, several cylinders were added to the scene and animated at the object level to mimic the character-level motion of the arm and hand. Figure 12.9 shows the dummy object that was used to drive the fluid simulation as an **obstacle**.

The simulation itself is stored in a directory that is designated at the bottom of the Domain object's **Fluid** panel, as shown in Figure 12.10. When you hit the **Bake** button, Blender creates a file for each frame of the simulation

Figure 12.8 *The boy splashing the water.*

Figure 12.9 *The dummy object used as an obstacle.*

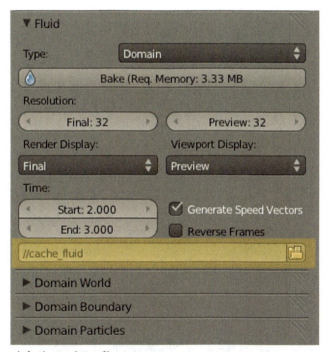

Figure 12.10 *Setting the path for the simulation files.*

and places it in the specified directory. So if you plan to move your BLEND files to another computer or a render farm for rendering, you will need to make sure that those files go along for the ride and that the path is relative.

Cloth

Much like the fluid simulator, a basic cloth simulation is easy to set up but tough to tweak for a specific effect in a production environment. For a basic demonstration of Blender's cloth simulator, take a look at Figure 12.11. It shows a blanket draped over the playground bench. The blanket was created as a subdivided plane then "dropped" onto the bench with the simulator. As cloth appears as a modifier in the mesh modifiers panel, the **Apply** button was clicked on the modifier to make the shape permanent.

Figure 12.11 *A blanket dropped realistically on the bench.*

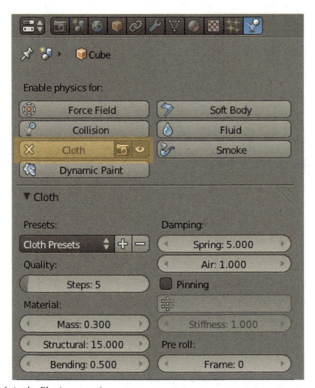

Figure 12.12 *Enabling cloth in the Physics properties.*

Building a cloth simulation is as simple as creating the cloth object itself and any obstacles. The cloth object is initialized by selecting the object and enabling the **Cloth** button in the **Physics** properties, shown in Figure 12.12. For basics, you can choose one of the preset material types from the **Material Preset** drop-down menu. These preset values won't be perfect, but they can provide you with a good starting point for your own simulations.

To create your own simple cloth simulation, add a 32 × 32 **Grid** mesh object above the default cube from a clean BLEND file, like Figure 12.13. Enable cloth in the **Physics** properties, and choose **Cotton** from the presets menu, resulting in Figure 12.14. Enable both the **Cloth Collision** panel and the **Self Collision** option

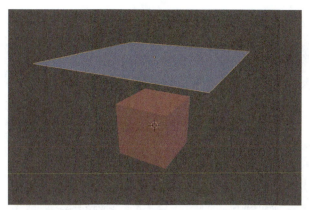

Figure 12.13 *A Grid object added for cloth.*

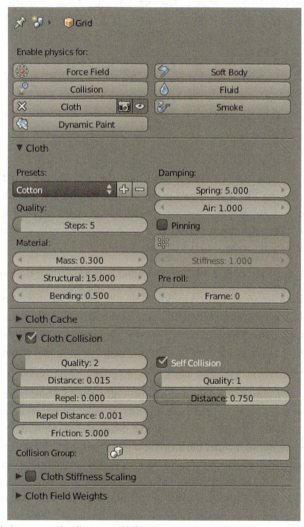

Figure 12.14 *The Cotton cloth preset, with collisions enabled.*

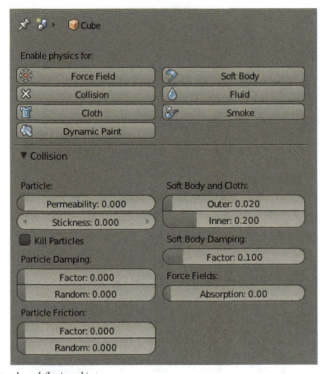

Figure 12.15 *Making the cube a deflection object.*

within it so that the cloth will react to obstacles and not pass through itself as it deforms. Select the default Cube and enable **Collision** in the **Physics** properties, like Figure 12.15. This indicates to the cloth simulator that the cube should be used as an obstacle. Now, select the Cloth object again and press the **Bake** button, which can be found in the **Cloth Cache** panel. After baking completes, you can press **Alt-A** to watch the simulation, several frames of which can be found in Figure 12.16.

In the **Cloth Cache** panel, shown in Figure 12.17, you set the frame range for the simulation.

The most likely uses for cloth in an animation production will be for clothing and environmental effects like curtains. Note that I do not recommend building an entire body structure, draping it with clothing, and attempting to let the cloth simulator handle it. You will only end up frustrated. Although the cloth simulator might be helpful for something like a long dress or cape, for general clothing I would advise the inclusion of the clothes as regular mesh geometry, deformed by an armature or mesh deformer.

To successfully integrate a cloth simulation into a shot, you will need to create your animation in a specific fashion. For cloth attached to a character, your character should be in its starting pose on frame 100. On around frame 60, put a set of keys with the character in its rest pose. Start the sim on frame 60, giving it 40 frames to "settle" into place. If that's not enough time, push the rest pose back even more. Your rendering and action won't really commence until this artificial starting frame. This will let the cloth begin in its native position as well and have from 40 to 100 frames to make its way to a good starting solution. Also, if your character rigging method permits it, you should move your character and clothing as close to their starting positions as possible with object-level animation. This is necessary because the cloth simulator does not allow you to "preroll" the simulation.

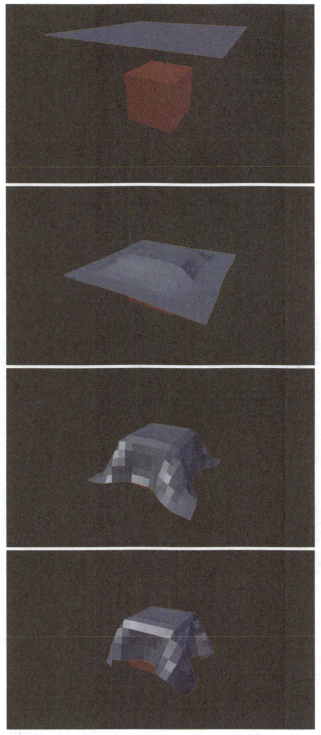

Figure 12.16 *The cloth simulation in action.*

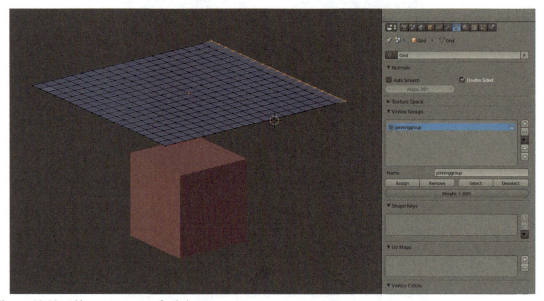

Figure 12.17 *Setting the frame range.*

Figure 12.18 *Adding a vertex group for cloth pinning.*

In the case of a curtain or something like a shirt, there will be certain portions of the cloth that you do not want to follow the simulation. The top of a curtain where it attaches to the curtain rod should remain stationary, even if the wind blows the rest of the fabric. On a character's shirt, you may want the collar and perhaps the area tucked into the pants to move exactly with the underlying body and not deform as part of the simulation. These portions of the cloth act as anchors for the rest of the simulation.

This is accomplished by "pinning" portions of the cloth through vertex groups. Revisiting the simple example described earlier, a vertex group can be created for one entire edge of the grid. The **Pinning** option is enabled on the **Cloth** panel, and this vertex group is selected, as in Figure 12.18. Running the simulation then produces the result in Figure 12.19.

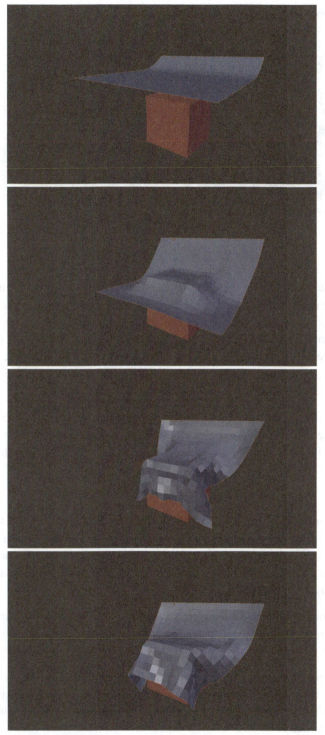

Figure 12.19 *The cloth simulation with one edge pinned.*

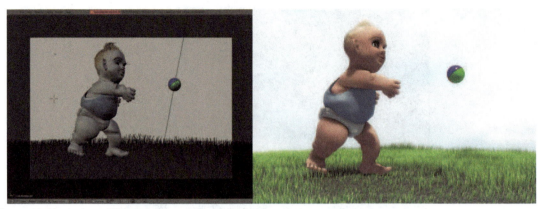

Figure 12.20 *A scary toddler's body showing through his shirt.*

If you do decide to use cloth for general clothing, there will be instances when the cloth collision does not work as well as you would like, causing the character's underlying body to show through. In Figure 12.20, a baby's body is showing through a tank top he decided to wear to protect his delicate skin from the blazing sun. The solution to this problem is to assign any "covered" areas of the skin with another material that has been made completely unreactive to rendering. Figure 12.21 shows such a material. The key parts are **Alpha = 0.0**, **Z Transparency**, **Traceable**, **Cast Buffer Shadows**, **Cast Approximate**, **Receive**, and **Shadeless**, which make it completely unreactive to light, shadows, or rendering. This way, even if a portion of the body accidentally pokes through the clothing slightly, it will not render.

A cloth simulation will not necessarily be the best solution for your character. Like other physical simulations, it can be tough to manage and to force it to do exactly what your shot requires. If you've been working with a cloth simulation and find that it just will not "behave," you will have to simply model the clothing and deform it as a part of the body.

Rigid Bodies

Certain situations arise in an animation that are just too difficult to animate realistically by hand. Imagine a closet full of sports equipment emptying itself into a room, or 200 bricks falling onto a character's head. Even simpler, think of several rubber balls thrown into a kitchen, bouncing and spinning until they finally come to rest. Any of these actions could be animated by hand, but the physical movements are so exact that to mimic their behavior realistically with keyframing would take ages.

In these cases, a rigid body simulation is called for. Setting up such a simulation is a little more difficult than using the Fluid or Cloth simulators, but the results are usually more predictable and easier to integrate into your finished animation.

Figure 12.22 shows several boxes sitting on the bench in the main *Snowmen* set. If we wanted, say, a squirrel to run by, knocking the boxes off of the bench so that they collided and clattered on the ground realistically, a rigid body simulation would be the perfect way to do so. It would be extremely difficult to keyframe the motion of the boxes realistically.

On Blender's main header is a drop-down menu that you quite possibly have never touched. Its default is **Blender Render,** and it chooses the rendering method for your scene. The current options are shown in

Figure 12.21 *A material for bodies.*

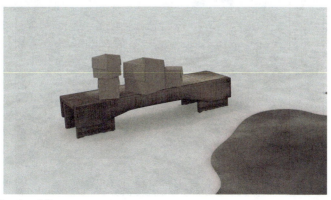

Figure 12.22 *Boxes on the edge of disaster.*

Figure 12.23. Choose **Blender Game Engine.** When you do so, the Physics properties change from the familiar one with the simulation enablers into game physics options.

The physics system works much better with lower polygon objects than with the more detailed levels of geometry than you are probably using for your production. In this case, the boxes will be represented by default cubes, scaled appropriately, the bench by another scaled cube, and the ground by a plane. We'll just use an

Figure 12.23 *Choosing the Game Engine and the Physics properties.*

icosphere to initiate the collisions instead of a squirrel. This original setup is shown in Figure 12.24. You should build this dummy set in a new BLEND file, as the rigid body process will add keyframes to every object in your file. Bring in your base models and perhaps even link in your rough set to get things sized appropriately.

We have to tell the game engine how to consider each of the objects in the simulation. With one of the boxes selected, change the Physics Type from **Static** to **Rigid Body.** The **Rigid Body** option tells the game engine that it will be in control of the object and should use all of its physics knowledge to decide what it will do. When you select **Rigid Body,** a number of new properties are added, shown in Figure 12.25. Below the main Physics panel, you will also need to enable the **Collision Bounds** option and choose the closest shape to that of your object in the drop-down menu that appears. The normal options are box, sphere, cylinder, and cone. This tells the simulation how best to calculate collisions involving your objects. We only need to use this option on our rigid body object, as other objects in the simulation will use their actual mesh shape.

At any point, you can test your simulation by hovering the mouse over the 3D view and pressing the **P** key or by pressing the **Start** button in the **Render** properties. This command starts the physics engine and will continue it until you press the **Esc** key. Of course, pressing the **P** key at this point won't do very much, which, of course, it shouldn't.

It's possible that if you are following along with this setup that activating the physics engine will have caused the boxes to rapidly fly away, as though from an explosion. If that happened, it just means that the objects were considered to be in a state of collision at the beginning of the physics simulation. To fix the problem, try using a different shape for **Bounds** that more closely approximates the shape of your object. Also, you can try to decrease the **Radius** control to make the physics engine think that the object is smaller than it really is.

Another thing that might happen is that the boxes may initially bump upward a bit or fall a little to land on the bench. This is because the tolerances on the boundaries of the objects in the physics engine might not be exactly the same as the real mesh boundaries, causing the boxes to think they are a little above the bench, in which case they need to fall onto it, or even slightly inside the bench and in need of a slight vertical push. In either case, a slight adjustment to either the bench object or the boxes themselves will fix the problem. It is easy and quick to test any new positioning with the **P** key.

So if you can hit the **P** key and not have everything go crazy, it's time to add the object that will knock everything off the counter. In a real animation situation, you would synchronize this object to the actual character

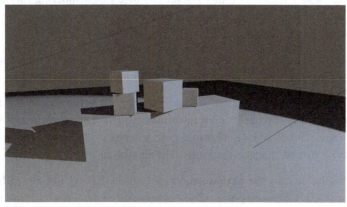

Figure 12.24 *The low-resolution set for the rigid body simulation.*

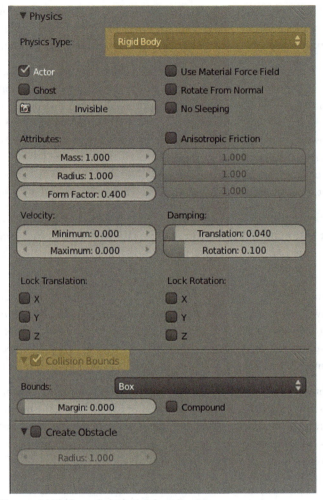

Figure 12.25 *Enabling objects as rigid bodies and setting their bounds.*

who is doing the damage: a squirrel, the boy, or whoever else might be wandering by. The driving motion is done in the normal way, by setting a starting and ending keyframe. Figure 12.26 shows the start and end points of the sphere in this example, set on frame 1 and frame 31.

Unfortunately, Blender's game engine does not just play your keyframed animations when you hit the **P** key. You will need to build a little bit of game logic to make it happen.

Figure 12.27 shows the **Logic** window, which if you have never ventured here before can be a little intimidating. Fear not. We're going to be in and out in a just few minutes. Basically, this editor offers you a way to build behaviors in the game engine. It tells objects what to do and when to do them. In our case, we want to tell the icosphere to execute its keyframed animation as soon as the simulation starts.

The "what to do" part is handled by the **actuators**, located on the right. Click the **Add Actuator** button and choose **Action** from the long list of options. Choose the name of the action that the icosphere animation is stored in *(IcosphereAction* in this case). In the Action or Graph editor, find the start and end frames of your

Figure 12.26 *The sphere keyframed to move across the boxes.*

Figure 12.27 *The Logic window.*

animation and enter them in the **Start Frame** and **End Frame** controls on the actuator. If you hit the **P** key right now, nothing will happen. Why? We haven't told the actuator when to activate.

The "whens" are handled by **sensors**. So add a sensor to the object by clicking **Add Sensor** on the left, and choose **Always** from the menu. This just means "always execute this actuator." Figure 12.28 shows the setups for both actuator and sensor.

The final step is to link the two. The **Logic** window functions like the node editor in this way. Click and drag on the little circular node output on the sensor (highlighted in Figure 12.28), and drag it to the node input on the actuator. A noodle will be drawn between them, and a new controller will be automatically added for you.

Figure 12.28 *Sensor and actuator, ready to go.*

This time, hitting the **P** key will execute your keyframed animation. If you've done it correctly, the icosphere should move across the bench, pushing the boxes off and onto the ground.

As the nongame engine portion of Blender doesn't know anything about in-game motion, we need to record the simulation into F curves. To do this, choose **Record Animation** from the **Game** menu on Blender's main header. Before you execute the simulation, head on over to the **World** properties (yes, this is a lot to do), and change the **FPS** setting from **60** to **24.** The game engine attempts to run at 60 frames per second (fps), but we will only be running at 24 in our keyframed short—that is, we would be recording at 60 fps and playing back at 24 results in slow motion. Setting the FPS control to 24 matches the recording and playback speeds.

With all of that done, hit the **P** key one more time. Wait for the simulation to run its course and for everything to settle down. Hit the **ESC** key to end the simulation.

If you examine the Graph editor or Dope Sheet now, you will see something like the image shown in Figure 12.29. For all objects in the scene, a key has been added on every keyframe. Hit **Alt–A** to play the key-based animation. It should look identical to what happened in the game engine.

Figure 12.29 *A key for every frame.*

If the simulation isn't to your liking, hit **Ctrl-Z** to undo, then reposition the items or rekey the driving objects and press the **P** key again. A new solution is calculated and stored in the objects' F curves. You can also play around with individual object settings like **Mass** and **Damping,** which will affect the way that the objects interact with each other. The physics engine understands things like momentum and density, so lighter, smaller objects slamming into larger, heavier ones will generate the appropriate response and vice versa.

When you are happy with the simulation, jump into the Action editor and give the animation a name. We will be heading back to the main file, importing the appropriate actions, and attaching them to their full resolution objects. Remember that you only need to do this for objects that have received rigid body simulations.

Save the BLEND file with the simulation somewhere appropriate—maybe a new **simulations** directory or even the **models** directory. Open your shot file. Use the **Append** command **(Shift-F1),** and dig into the newly saved simulation BLEND file, going into the **Action** directory and finding the actions that you just named. Figure 12.30 shows the real boxes on the real set in a shot, with one of the imported actions attached to it in the Action editor.

The simulation may end up with items falling a bit into the floor, or, in this case, the ground, but that is easy to fix. As the simulation has been recorded into F curves, all of the curve editing skills you have acquired in Blender apply. For example, if the simulation causes one of the boxes to end up passing through the ground a bit, a trip to the F curve editor and an upward move of the Z-position curve will remedy the situation, as shown in Figures 12.31 and 12.32.

Additionally, if you want to blend the generated rigid body solution with keyframed animation that comes before or after it, the action is now just a normal action like any other one in Blender and can be frozen in the NLA editor and combined with other animations.

Figure 12.30 *Using the generated Action in the shot.*

Figure 12.31 *The box, before and after adjustment.*

Figure 12.32 *Moving the Z-position curve up.*

Unlike other simulation types in Blender that use a cache, rigid bodies bake directly into normal F curves. The solution is entirely portable without any additional effort on your part.

Ocean

The simulation of large bodies of water is quite different than sims of smaller amounts of liquid. As such, it gets its own fairly easy-to-use simulator.

For now, the ocean simulator is accessed by applying the **Ocean** modifier to a mesh object, although I suspect that in the future it will also be possible to add it via the **Physics** properties. We could go into a detailed explanation of all of the different ocean properties that are available, but it really must be seen in real time.

The one trick about the ocean simulator that makes it different from all of Blender's other simulations is that it does not automatically advance in time along with the current frame. Figure 12.33 shows a low-resolution simulation beside the modifier properties. For this example, I have only upped the default **Scale** value from 1.0 to 3.2 to make things more visible. Note that the **Time** control is colored yellow, indicating that it has received a keyframe. The **Time** control tells the ocean simulator which point in time to calculate. If you were to **left mouse button (LMB)** on the left or right of the control, the Time value would change by 0.01 and you would see the simulation begin to move. If you're playing along at home, do it now.

The way that we make the ocean simulator actually move in time is to set keyframes on the Time control at different places in the main scene timeline. To make the ocean move in something like real time from frames 1 through 250 at 24 fps, we would set a Time key of value 1.00 on frame 1 and another of about 10.4 on frame 250. How do we get that value? By taking 250 frames and dividing by 24. Note that you can just enter that equation into the **Time** control (250/24) and Blender will do the math for you, entering the appropriate value.

With the timing keyframed, hit **Alt-A** and the simulation comes to life. If you don't already have it set, change the syncing method on the timeline to **AV-sync** to try to get things to play in real time. Now, with the

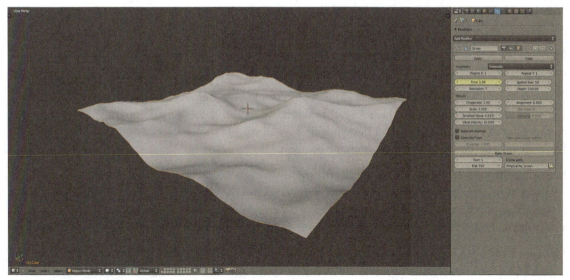

Figure 12.33 *A basic ocean simulation and properties.*

simulation running in the 3D view, you can start to play with the other properties in the modifier and watch how they affect things, once again in real time:

- **Choppiness** controls the sharpness of the peaks on the waves.
- **Scale** designates the vertical size of the waves.
- **Alignment** controls the directionality of the waves, on a scale of 0.0 to 10.0. At 0, the waves are directionless. At 10, waves flow in a single direction, which is specified by the **Direction** control.
- The **Repeat X** and **Repeat Y** controls extend the simulation.

The ocean simulator does not use the familiar **Cache** controls of other simulation systems but instead relies on a simple file path input and a **Bake Ocean** button. Note that because of the way that the simulator handles calculations, each frame is not dependent on the previous one, so you do not necessarily need to bake things to get consistent results on render farms. Baking with the ocean simulator is purely a time-saving function when you get into higher resolutions.

For additional detail, you can enable the **Generate Normals** and **Generate Foam** options as well. These work hand in hand with the **Ocean** texture type, shown in Figure 12.34. Note that to use these special textures, you will need to change the **Geometry** option from **Generated** to **Displace**. The **Generated** option, which is the default, simply replaces the original mesh geometry with a subdivided plane suitable for the ocean sim. To have proper texture coordinates, you need to make a subdivided plane yourself. The more subdivisions you add, the more detail the simulation will have. For purposes of playing around, you can start with somewhere around 12 subdivisions.

After that, you must add a material to your mesh—which you were, of course, going to do anyway—and add a texture. Choose the texture type **Ocean.** In the **Ocean** panel, choose the name of your ocean mesh object in the **Modifier Object** control. The **Output** drop-down menu contains two useful options, along with several others. The **Displacement** option pulls a displacement map from the simulation that can be used with **Normal** influence to provide additional detail to the render. The **Foam** option provides a texture that can be used either as a color or as a stencil to mask some other properties. The pattern of the foam texture is made to mimic the patterns of foam you might see on the ocean. Figures 12.35 and 12.36 show an ocean simulation with a plain material and the same simulation with both Displacement and Foam textures applied.

Dynamic Paint

Although the Dynamic Paint feature isn't exactly a simulator, it can certainly help you create more realistic results in your animations, and it uses a baking system. It is, without a doubt, a "special effect."

Dynamic Paint allows you to turn animated mesh objects into both canvases and paintbrushes. So what, you say? Think of all the situations in which contact between two objects "leaves a mark" on one: rain hitting pavement, a boot in snow, a saucy meatball thrown against a wall. All will leave evidence of their passing. Dynamic Paint attempts to automate this process to some degree.

In *Snowmen*, dynamic painting was used to let the snowman's laser blasts carve sections out of the snow in the final shot. When using the simulator, the object that will receive the changes (the concrete, snow, wall, etc.) is designated as the **canvas.** A mesh object is enabled as a canvas by selecting it, going to the **Physics** properties, and enabling the **Dynamic Paint** button. When you do so, controls like the ones in Figure 12.37 appear.

This object will be the canvas, so press the **Add Canvas** button to bring up the whole set of properties like in Figure 12.38. For a default simulation, the only thing that you might need to change here would be your frame range so that it covers the time period during which the brush will be moving.

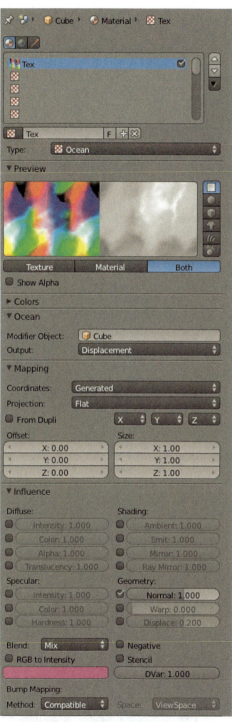

Figure 12.34 *The Ocean texture type.*

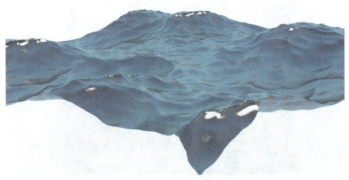

Figure 12.35 *Ocean simulation with plain texture.*

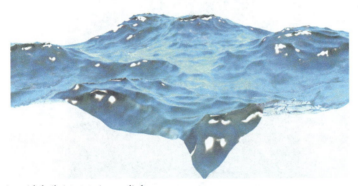

Figure 12.36 *Ocean sim with built-in texturing applied.*

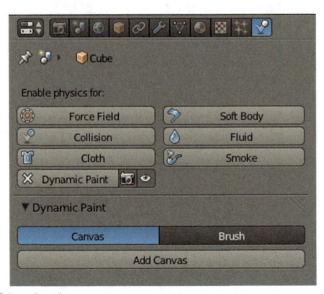

Figure 12.37 *Dynamic Paint main settings.*

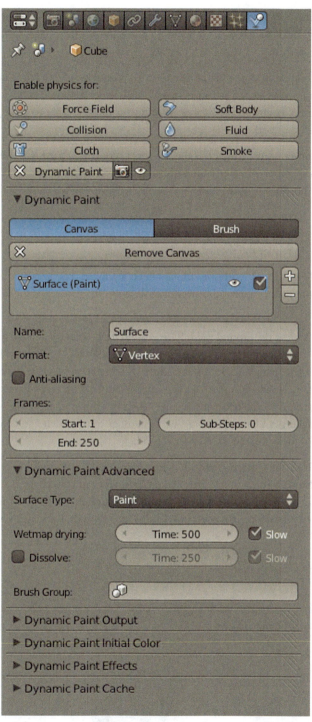

Figure 12.38 *The Canvas controls.*

Moving on to the object that will be the "painter" (i.e., the brush), enable Dynamic Paint for it as well, and choose the **Brush** option. **Add Brush** to it to bring up all of the brush properties. Once again, for a simple test you can just leave the defaults.

Of course, you need to have mesh objects appropriate to the simulation: the brush needs to actually be animated and intersect the canvas object to work its magic. Also, in its default state the painting saves its results into the canvas object's vertex colors, so you will need sufficient mesh density to get a good result. The default plane with subdivision will not work.

Once those criteria are met though, just hit **Bake** on the **Dynamic Paint Cache** panel with the canvas object selected (in terms of other Blender simulations, the canvas is the Domain). The 3D view will show the results, and you will be able to scrub back and forth in the timeline to see it happen in an animated fashion.

Those are the basics. Let's take a look at how this was implemented in *Snowmen* to discuss some of the other options and find out how to render the results.

Figure 12.39 shows a still from shot 9 with the smoke effects removed. The snowman's blasts have carved two gouges into the snow. As the gouges appear dynamically, following the pattern of the lasers, Dynamic Paint was called for.

To begin with, let's take a look at the ground mesh. The ground itself takes up a lot of space, covering the entire set area. To subdivide it to the proper level to achieve a decent result would have skyrocketed the face count for the scene. So as you can see in Figure 12.40, I selected the rough area where the painting would happen and subdivided only there. Yes, this made triangles, but for a static set piece that is only either seen at a distance or an extremely oblique angle, and whose texturing involves the smoothing aspects of subsurface scattering, it was perfectly acceptable. Triangles get a bad rap, but always remember to follow the golden rule of animation (and photography and film): if it looks good on screen, it *is* good.

The lasers were built with particle systems, and Dynamic Paint has the ability to accept a particle as a brush. In the **Dynamic Paint Source** panel of the brush properties, you can choose from a number of methods for determining what aspect of the brush object will define the paint area: the volume of the object, a distance from its center point, the mesh shell, and a particle system. In this case though, I just went with the particle emitter

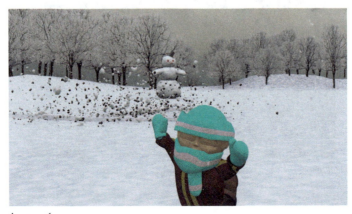

Figure 12.39 *Carving the ground.*

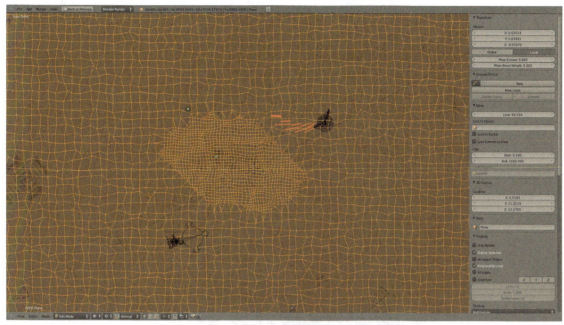

Figure 12.40 *The ground mesh.*

itself—a small sphere—and left the paint source set to **Mesh Volume**. As with most simulations, particle systems do what they are going to do, and I didn't want to rely on having the correct volume of particles hitting the snow in certain places to get my effect. Also, I wanted the snow to be burned away in greater volume as an indication of the heat of the blast.

In fact, as there were two blasts, I used the same settings on the second particle emitter object as well. The canvas doesn't mind if there is more than one brush object. Back in the Canvas settings, I needed to adjust the **Surface Type** in the **Advanced** panel. Dynamic Paint can generate four different types of results: regular paint (called Paint), Weight (which affects the weight paint channel of the mesh), Waves (which generates expanding waves like pond ripples), and Displace (which provides a carving effect). Obviously in this case I need the Displace effect (Figure 12.41).

With Displace, there is nothing extra that you need to do to get the results to render, so I set my frame range for the entire length of the shot and hit **Bake.** The initial results can be seen in Figure 12.42. The top carve-out looks okay, but the bottom one looks like a series of interconnected blobs. This is because the second brush object is moving so quickly that its shape doesn't overlap enough from frame to frame to create a smooth carved shape. Dynamic Paint allows you to fix this with the **Sub-Steps** control on the main canvas panel. Sub-steps tells the paint system to actually calculate and accumulate the results of a certain number of steps between each frame. For this brush object, I found that a sub-step level of 5 was enough to produce the proper smoothness. Also, to further increase the smoothness, I enabled **anti-aliasing** in the same panel. Both of the options take a little longer to calculate, but the result is generally worth it. Figure 12.43 shows the same simulation with both options set.

Let's say that in addition to carving the snow, I wanted to also add an orange glow to the snow in the newly formed trenches. It seems like another perfect application of Dynamic Paint.

Figure 12.41 *Choosing Displace from the Advanced panel on the canvas.*

Figure 12.42 *The default displace simulation.*

Figure 12.43 *The simulation with sub-steps and anti-aliasing.*

You cannot use both the Paint and Displace types on the same canvas, but you can add an additional canvas to your object with the layer management tool in the main canvas panel. As shown in Figure 12.44, I've used the "+" symbol to add a new surface to the ground object.

Figure 12.44 *Adding a new surface for an additional paint effect.*

A whole new set of default canvas properties has been added. This time, we'll use the Paint surface type. Selecting the emitters, I change the paint color, which had been the default bright blue, to an orange by using the color swatch on the main Brush panel, shown in Figure 12.45. The meshes and animation are already configured, so I can just head back to the canvas properties. Making sure that I first enable anti-aliasing and set substeps to 5 on the new surface, I hit **Bake**.

> **Note**
>
> You could also choose to use the paint object material's color and texturing for the paint color by choosing **Use Object Material** in the main brush panel, then selecting an available material from the drop-down menu that appears. Most (but not quite all) texturing and material options are taken into account, although it is important to know that the final color used to paint is not shaded. In other words, it equals the color of the material if the Shadeless material option were selected. Using the material for the paint color would allow you to do things like have a "wet" painting that was a texture-mapped image splat against a wall and leave a "print" of itself.

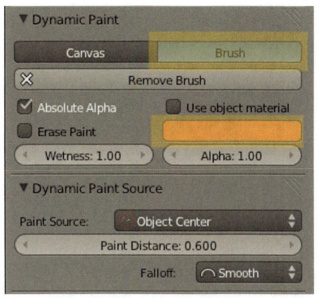

Figure 12.45 *Choosing the paint color.*

Figure 12.46 *Paintmap Layer.*

The baking produces a nice effect in the 3D view, but it will not render yet. Using the paint option with vertex colors, you need to also create a Paintmap layer in the **Dynamic Paint Output** panel on the canvas controls. The default state of the panel is shown in Figure 12.46. By clicking the "+" sign beside the **Paintmap Layer** control, you add a new vertex color layer to the mesh (Vertex color layers can be managed per usual in the Object Data properties panels). As long as you haven't already done any vertex painting on the canvas object, making the paint render is now as simple as enabling **Vertex Color Paint** in the **Options** panel of the object's material properties.

In these examples, we have shown how to use Dynamic Paint with the mesh structure as storage for both displacement and color. But what if we really just want to use a default plane or are in a situation where we cannot alter the mesh structure to support the required detail of the simulation?

Choosing **Image Sequence** instead of **Vertex** in the **Format** panel of the main canvas properties allows the solution to be computed and stored in a series of image files instead. When you choose this option, the controls in the panels change a bit, as shown in Figure 12.47. You must choose a resolution for your stored images. Obviously, the higher the resolution, the better looking the result, but it will cost you both time and storage space.

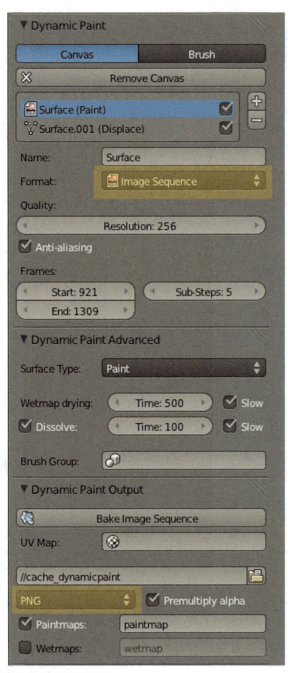

Figure 12.47 *Storing the solution as an image sequence.*

The **Output** panel now contains controls for choosing image type (PNG or OpenEXR), as well as a directory location for storage and a UV Map selector. The UV Map selector is perhaps the most important.

If your canvas object has not been UV unwrapped, you will need to do so. The image painting process needs to know ahead of time how to push the simulation onto a two-dimensional image format. Good unwrapping

rules apply here: try to keep islands to a minimum, keep seams where no one will see them, and try to minimize stretch. If you already have a good unwrap for the object, simply select it here.

Once you are ready and choose **Bake Image Sequence**, the simulation does its work and creates a directory full of images for use as textures in the material and texture properties. They can now be used as "plain old" image textures, just like any others you might have. For this reason the Image Sequence option is more versatile than vertex paint. You can use the resulting images as masks or to influence any of the channels of the material (Specular Intensity, Mirror, Emit, etc.).

This primer will get you started using Dynamic Paint, and you are encouraged to play around with it and check out some of the great demos that can be found online that have been created by other Blender users.

Within the context of a larger project, Dynamic Paint is fairly easy to deal with. The results of the simulation are either baked directly into vertex colors, which follow the mesh, or into images that are used as textures. So as long as you are sure to use relative paths, you don't need to do anything new to support it.

Smoke

Blender's smoke simulator is one of those features that is relatively simple to get fast, decent beginning results from, but can be tricky to take to a great final result. Smoke was used in two shots from *Snowmen*, shots 8 and 9. We'll examine shot 8, which was the less complex of the two.

But first, a tiny smoke primer.

In its simplest form, a smoke simulation consists of a smoke domain (like fluids), a smoke generator (just a particle system), and a volumetric material so the result can be rendered. When I am working with simulations, I will often get the effects roughed out at the correct scale in an empty BLEND file, then I'll append the results into my actual shots for tweaking and finishing.

For the smoke in shot 8, I used a file in the project's **tests** directory called **smoke.blend**. Figure 12.48 shows the file. The smoke domain is selected. The smoke simulator uses cubes for domains. You can scale and rotate the cube in object mode, but don't **Ctrl-A** apply those changes or alter the mesh in edit mode. Doing so will distort the resulting smoke render. Like other simulations, you begin by creating your mesh object, enabling **Smoke** in the **Physics** properties for the object, and choosing the **Domain** option from the main **Smoke** panel (see Figure 12.48).

Important controls to note are **Resolution**, which controls the basic detail, **Density** and **Temp. Diff.**, which both affect how quickly the smoke rises, and **Vorticity,** which adds turbulence. Most modern machinery will be able to display smoke in the 3D in something near to real time with a resolution value around 24. Also, you will need to make sure that the frame range in the **Smoke Cache** panel matches the frame range for your shot. That sets up the Domain object.

Smoke is generated by a particle system attached to another mesh object. The system is created for you automatically when you add a mesh object, enable it for Smoke in the **Physics** properties, then choose **Flow** from the main smoke panel. Figure 12.49 shows the defaults for a Flow object.

The particle system called *SmokeParticles* has been created automatically. It is up to you to make appropriate particle settings though. We'll deal with particles in the next section, but for now, the important thing to know is that a particle will continue to generate smoke for as long as it exists. The older method of faking smoke in Blender that used a continuous particle system with the particles, say, climbing toward the sky

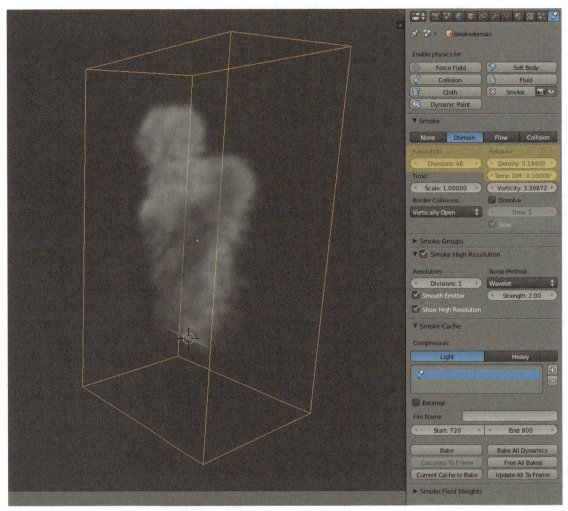

Figure 12.48 *A basic smoke simulation and settings.*

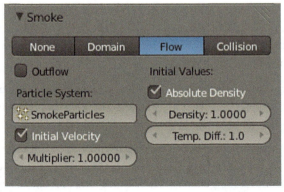

Figure 12.49 *Smoke flow defaults.*

no longer applies. For example, if you wanted smoke to come from several distinct points on an object as it moved around, you might choose to generate a particle for each point and extend the particle life for the length of the shot. For most cases though, it will be sufficient to set up particle systems with particle life set to 1 frame.

So a smoke simulation that required a single burst or puff of smoke like the initial stage of an explosion might use 1,000 particles over three or four frames, with a life of 1. The smoke persists even after the particles are gone, and after those first several frames no new smoke is generated. For the smoke simulator to see the particles, the particle system must be baked. Set the **Frame Range** for the particles in their respective **Cache** panel and bake them. Now, you should be able to see a basic smoke simulation in near-real time in the 3D view, although the timeline may have to play through entirely once before it appears.

Although that looks nice in the 3D view, to render the smoke you have to add a **Volume** material to the Domain object and use the **Voxel Data** texture type.

Figure 12.50 shows a typical Volume type material. The actual density of the smoke in the simulation will be handled by a texture, so just like working with other texture-based properties in a normal material, we set the **Density** control to **0.0**. We'll come back to the **Density Scale** control after we've attached the texturing. For the settings in the **Shading** panel, you'll have to check out some other resources, as they will require a lot of experimentation and tweaking to get just right for your particular situation.

In Figure 12.51, you see a new texture added to this material. It has been set to texture type **Voxel Data**. "Voxels" are volumetric (3D) pixels. When choosing this type, most of the setup for a basic smoke simulation is already done. File format is preset to Smoke and the source is set to Density. You need to find the Domain object for the smoke simulation in the provided selector on the Voxel Data panel. The only other setting you will need to change is to map the texture to affect **Density** on the **Influence** panel instead of **Emission Color,** which is the default. Note that like the particles on the smoke source, the smoke simulation on the domain must be baked in order for the voxel data texture to work correctly.

At this point, you can render your test, and you might see something for a result. The odds are that the smoke will be significantly less prominent in the render than it was in the 3D view. To achieve the same level of visual density, you will most likely have to raise the **Density Scale** value on the material settings, sometimes drastically. Even though the control only runs to 10.0 when manipulated by the mouse, you can hand-enter any value that you care to. Figure 12.52 shows the difference between what a typical smoke simulation looks like in the 3D view rendered with a scale setting of 1.0 and rendered with a scale value of 10.0.

The grittiness in the render can be removed by reducing the **Step Size** in the **Integration** panel of the material, at the cost of render time.

Those are the basics, and we won't get into the nitty-gritty of the rest of smoke settings in this book. However, let's take a look at how to use smoke successfully in an animated short.

In shot 8 (Figure 12.53), the boy has been blasted, and smoke pours from him. He falls forward. To make this happen, we needed to animate the smoke emitter and prevent the smoke from passing directly through his body once he is on the ground.

This is typical of the conditions under which you will use smoke: an animated emitter and collisions with set pieces or animated characters. Because the characters in our shots are linked in Group Instances, we do not

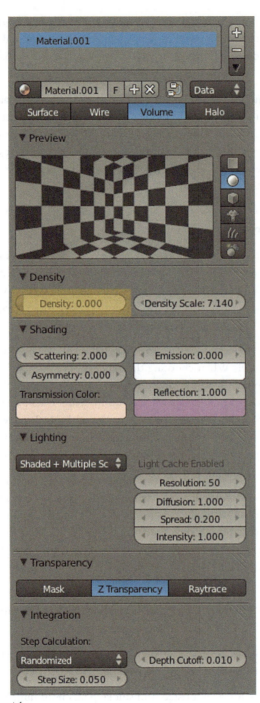

Figure 12.50 *A Volume type material.*

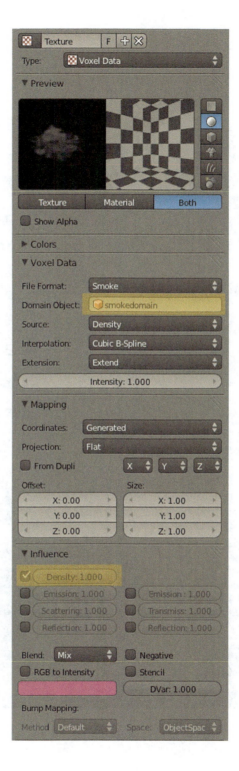

Figure 12.51 *Voxel Data texture.*

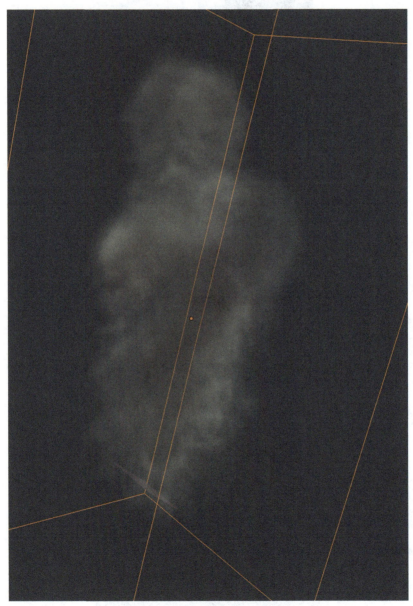

Figure 12.52 *(cont.)*

Figure 12.52 *(cont.)*

Figure 12.52 *Three visualizations of the same simulation.*

have direct access to the meshes within the shot. We could go to the trouble to append the character meshes into the shot file, but there are a number of shortfalls to that plan. It's easier and much better just to add a few new, simple objects to the shot.

In *Snowmen*, I added a default plane to act as the particle emitter for the smoke simulation and made it the bone-child of the boy's rib cage. As his torso moves, the emitter happily follows. The particle system is set up to emit particles with a life of 1, over the course of the shot, meaning that once smoke starts pouring from his

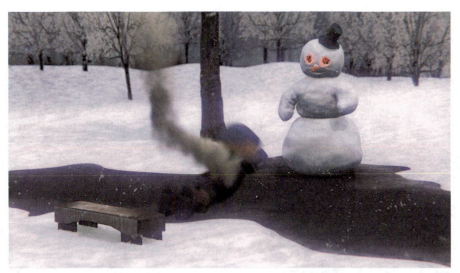

Figure 12.53 *Something very bad just happened.*

chest, it will continue to do so. Figure 12.54 shows the emitting plane selected in the 3D view and the basic particle settings.

Once the boy has hit the ground, the smoke should keep coming, but we don't want it to appear to just percolate up through his body and rise from his back. We need to give the smoke an obstacle to work around. Of course, we could enable smoke collisions on the boy's mesh in the model file, but it is not a good idea to make effects-level tweaks to your base models just for a single shot. What if you need to make an opposing tweak for a different shot?

Instead, we can create a very simple mesh object directly in our shot file that mimics the boy's shape on the ground and bind it to the chest bone again. Figure 12.55 shows this object. A trip to the **Physics** properties, and we enable the object for **Smoke,** then set it as a **Collision** object. Now, baking the smoke domain does exactly what we want it to do: appear to emit from the boy's chest as he falls, then come out from under him once he is on the ground.

The location and size of your smoke domain cube can cause some compositing issues, which we will examine in the study of shot 9 in the next chapter.

Particles

Particle systems are the workhorses of animation effects. However, they are a large enough topic that they can't be fully covered even in a fully dedicated chapter, let alone a tiny section of a single chapter. For that reason, we'll go over the two main uses of particle systems in animation production: strands for hair/fur/grass and what I call "bits o' stuff."

Bits o' Stuff

Flotsam and jetsam found in deep ocean water, pollen wafting through shafts of sunlight in a forest, flying pieces of a shattered flowerpot, magical sparkles falling from a fairy wand, chunks of earth flying away from an explosion—these are all instances of particle systems in action.

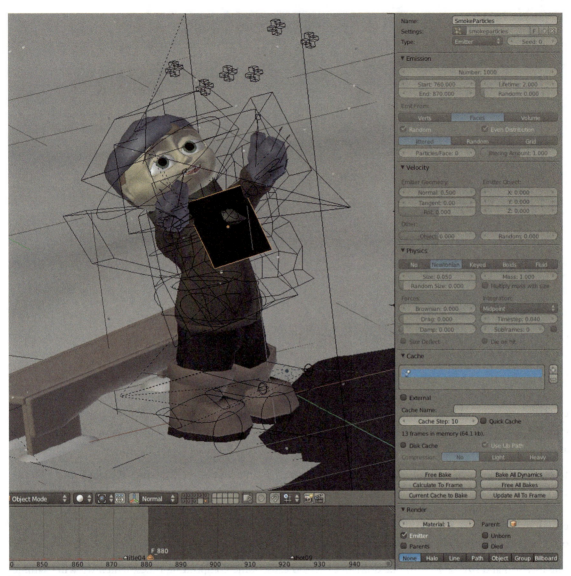

Figure 12.54 *The smoke emitter for shot 8.*

In *Snowmen*, particle systems were used to create the falling snow, the snowman's laser blasts, and the debris from the ground explosions. The two main questions that you will need to answer when dealing with particle systems are how will they move, and how will they render?

Much like the smoke and the other simulations, particle systems are best built directly into your shot files. Figures 12.56 and 12.57 show a render of falling snow and the same shot in the 3D view. It would have been simple to create a single particle system in the set file that covered the entire set area, bake it with a massive number of particles, and have that always get pulled in when linking in the set. No matter where you rendered a shot, you would always have perfectly consistent particle system behavior. In fact, this would have been a valid way to add snowfall to the animation, and if your particle system is truly going to be "background only," such as the sparks from a distant erupting volcano, then build it right into the set.

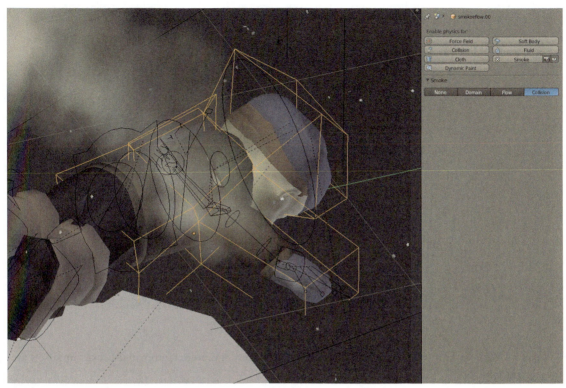

Figure 12.55 *The smoke collision object.*

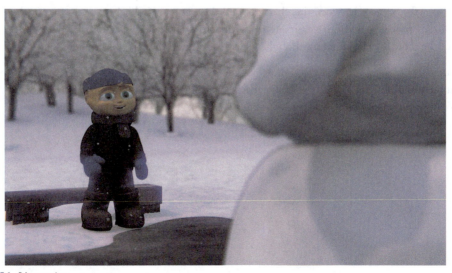

Figure 12.56 *It's snowing…*

Figure 12.57 *…but not everywhere.*

As we saw when working with the children on the playground equipment, animated background sets are 100 percent legal.

However, there were a few shots in which I needed specific things to happen with the snow. For example, the very directional swirling of the snow in the overhead shot required a different type of force field (Vortex) than the general case (Turbulence). Also, there were a few shots, like the close-up of the boy, where I wanted to make sure that no snowflakes came between the character and the camera. Had it been only two or three shots out of thirty or forty, I probably would have proceeded with an overall set-based system. As three shots constituted a full third of the shots in the animation though, I decided to build the systems on a per-shot basis.

Obviously, the laser blasts were built on a shot-by-shot basis. Figure 12.58 shows one of several blasts from shot 9. Multiple blasts were achieved by adding particle systems to the emitter object, with system names set to match the frame numbers on which they began (Figure 12.59).

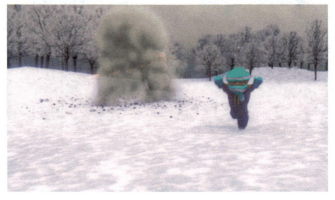

Figure 12.58 *Blasting away.*

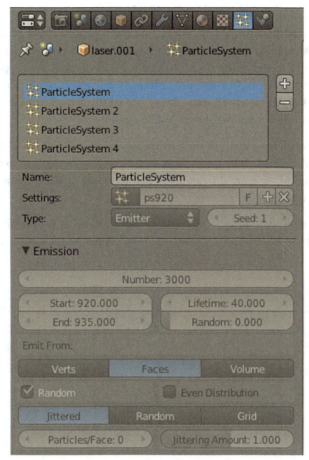

Figure 12.59 *Four baked systems.*

Like the smoke system in shot 8, the particle emitters in this shot have been parented to the head bone of the snowman so that they follow his local animation.

When building particle systems to include in your work, keep in mind the things we've learned about test cycles: the more quickly you can test your settings, the more test cycles you will be able to fit into your available time, and the better your final result will be. For example, a typical snowfall system in *Snowmen* has between 120,000 and 200,000 particles. Although this didn't take too long to bake on my six-core machine, the ideal case is to be able to change a few settings, hit **Alt–A** in the 3D view, and see your results in real time.

In a similar fashion to the smoke simulation, I prepared the initial passes for the snow and the lasers in separate files, outside of the general work tree for the rest of the production. Once again, this allows you to keep things simple while you are perfecting the motion of the particle system. Remember that a system that should cover a large area can often be effectively proven with a much lower particle count (and shorter test cycles) in a smaller area.

When dealing with particle motion, it can be tempting to want to make things too realistic. For example, snow actually falls more quickly than it does in many of the shots in *Snowmen*. However, having matched the snowfall

velocity in the particle system to some references, I felt that it added too much motion to the scene. While it's not strictly realistic, I felt that the more slowly drifting, meandering snow that I arrived at helped to set the feel of the scene better. Likewise, although no one really knows how fast energy bursts from a snowman's eyes would be, practicality dictated the eventual velocity. In shot 8, I wanted the blast to appear fast, but with a clear directional component. After much experimentation, I found that having the blast cross the gap between the snowman and the boy in about half a second seemed very fast yet still allowed the viewer to get that it was not just a "laser beam" but some kind of pulsing, directional energy.

Also note that for the snowfall, the extents of the particle system are only what will be displayed on camera. No extra particles are used. If I had created a single system of similar density that covered the entire set area, I would most likely have had to use more than a million particles. Although that is not a problem from a technical standpoint, it can certainly slow you down.

Figures 12.60 and 12.61 show two different renderings of the falling snow. The first uses Blender's native particle rendering method: the halo material. The second uses a duplicated object to create actual snowflakes.

Figure 12.60 *Snow falling as halos.*

Figure 12.61 *Actual snowflakes.*

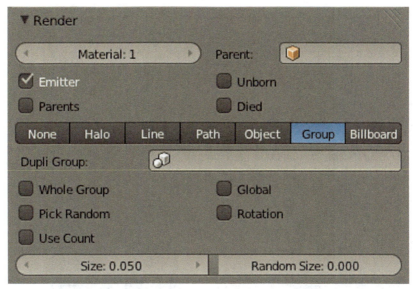

Figure 12.62 *The particle render panel.*

In the **Render** panel of the **Particle** properties (Figure 12.62), you can see that there are a number of options. The three most commonly used when making "bits o' stuff" are the Halo, Object/Group, and Billboard. The **Object** and **Group** options simply replace each particle in the system with an object or group that is set in the corresponding controls. Note that while the **Rotation** controls for particles have no impact on Halo style rendering, the rotations of duplicated particle objects or groups will be affected. The **Group** option has a nice control that allows each particle in the system to be represented by a random object from within the group. This means that if you wanted to have 40 different snowflakes falling, you could create them all, place them into a single group, then use that group as the particle render style, choosing the **Random** option.

The Billboard style creates simple planes that always face the camera. They are appropriate for adding items like distant trees or grasses to your scenes and using a particle system to stand in for their distribution over a surface.

Finally, the Halo style particle makes use of the Halo material type. Figure 12.63 shows the default Halo configuration for a material. Halos are generally used for "magic" types of effects. They can sparkle, glow, and be hard points of light or soft, diffuse globs. The snowman's laser blasts use the Halo material.

Halos render outside of Blender's normal pipeline. Although they have alpha, they do not have Z values, so they can sometimes fail to fit in properly with your renders, especially those that make use of Z transparency or Z-based compositing. We'll look at some of the problems that you can encounter with halos as well as strategies for working around them in the next chapter.

We mentioned earlier that when initially building your particle systems, it can be beneficial to make them in a completely empty BLEND file to reduce clutter and confusion. Another way to deal with "background" particle system creation (i.e., ones that don't connect directly to elements in the scene) is to build your main scene without the particle system first. Then, within the same BLEND file, you add a new scene with the **Scene** selector on the main head and choose **New** from the menu, creating a completely new, empty scene

Figure 12.63 *The halo material.*

Figure 12.64 *Making a new empty scene to work on your particle system.*

(Figure 12.64). Your full scene, including all of its animation, links, and so on, can be brought into the this new scene as a background set in the scene properties. Now, you can work on your particle system in an environment where the whole rest of the shot is completely visible, but unselectable and easy to turn on and off.

Strands: Hair and Fur

The other major use for particle systems besides the random bits o' stuff is as hair, fur, and grass. Technically, those items are still "bits," but they are always attached to something else. The same rules for simulations apply here as they do to others.

When using a particle system for grasses, it is actually okay to build them right into the sets, as long as you are tightly controlling where the grasses are versus where the cameras will be looking. Although no grass was used in *Snowmen*, note the arrangement of the trees in Figure 12.65. Instead of building an entire forest, trees were only added within the areas where the cameras would be looking. Additionally, the stands of trees were configured so that in shots that did not require certain sections to appear, the background set scene did not include those sections. The technique is described earlier in this book, and it applies to ground covers like grass as well. Anything that might be computationally expensive at render time should be made as efficient as possible.

So instead of populating your entire set with a single, gigantic particle system of grass (or trees if you are using billboards or group/object visualization on the particles), you would create several different, overlapping systems, each one individually controllable depending on the different camera angles in your animation.

Note that you can even bake dynamics and motion into the grass, and it will work just fine when you bring it into another scene as a background set.

As hair and fur particles are rooted to a particular mesh, bringing that mesh object in as a part of a linked Group Instance brings the particles along with it (Figure 12.66). You do not have to do anything special for your character's hair to successfully make the journey through the linking and library system. However, there are some restrictions when doing things this way.

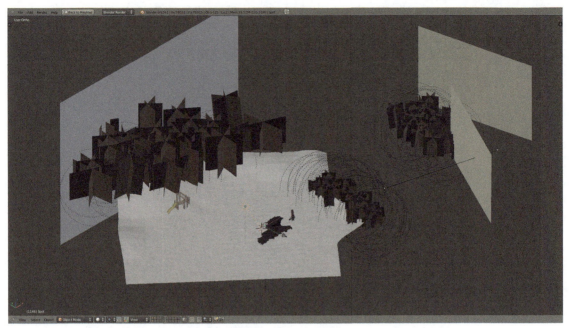

Figure 12.65 *Different sections of background trees for different shots.*

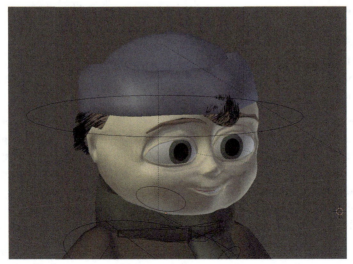

Figure 12.66 *A character with hair.*

First, you will not have access to the styling tools within your shot file. Just like a material or the mesh structure on a linked Group Instance, the particle-based hair or fur is locked to what appears in the original library file. Second, you will not be able to apply local dynamics to the hair. It would be nice if we could set the hair dynamics properties within a library file and have them "come alive" appropriately in each individual shot file. Alas, it is not to be. If you want to use hair dynamics in a shot file on a linked character, you have to do something like the following:

1. In the character's library file, create the hair on a duplicate of the head mesh that is named appropriately (e.g., "hair-head").
2. The particle settings for the hair should disable rendering of the emitter on the **Render** panel. This will prevent the duplicate head from rendering.
3. Make sure that the new head mesh is properly bound to the armature for animation.
4. Create a group for the character that includes the hair-head. This will be used anywhere that you do not need to do shot-level modifications or dynamics on the hair.
5. Create a second group for the character that does *not* include the hair-head.

In your shot file, link in the Group Instance using the second group. Your character will appear, bald. Make a proxy for the armature as you normally would. Now, use **Append (Shift-F1)** to bring the hair-head into the file as a local asset. Position and bind it to the proxied armature. Now, you have local control over the styling and dynamics of the hair. Note that you will have to perform a similar trick if you want to have the hair engaged in dynamic collisions with the character's body. Using a locally built low-resolution mesh like the one mentioned in the smoke section would probably be sufficient for most tasks.

Understanding the Cache Options

Although not all of the simulators use the standard **Cache** panel, the concepts are basically the same. Figure 12.67 shows the panel. The **cache** for a particular simulation is where the results of a **bake** are stored. Why do we even have to bake simulations, as sometimes they seem to function just fine when hitting **Alt-A** in the 3D view? If you were to take a random frame from any of the simulations, the state of the sim within that frame would depend on the state of the simulation in the previous frame. Of course, that frame would

Figure 12.67 *The cache panel.*

depend on the previous one, and so on. When rendering, you cannot always count on having gone through all of the previous frames to get to where you are now. For example, if you are using a render farm, 20 different computers could be rendering frames from your animation. When they are done with that frame, the next one that they work with might be 20 frames later.

Even if you are rendering your animation yourself on a single machine, you still might need to render a random frame. What if you have to stop rendering halfway through a sequence, close Blender, and start again later?

The solution is to bake the simulation. Baking stores the results of the entire simulation in what we call the cache. By default, Blender's simulations are saved within the BLEND file itself. This makes things very portable, although it can lead to very large files. One of the shot files in *Snowmen* was almost 0.5 GB by the time that all of the simulation data had been baked within it.

In its most basic form, cache/bake works like this. Pressing Alt-A in the 3D view with **No Sync** set in the timeline will step through every frame in the animation range and calculate the next state of every simulation on each frame through which it passes. Each of these steps of the simulation is stored in memory. The stored frames are considered "cached." On the timeline, you will see a light line at the bottom indicating the presence of simulation cache data (Figure 12.68). If you have let the animation play through the entire frame range, this means that the whole simulation is now cached. You should be able to place the current frame marker anywhere within the timeline and see the state of the simulation.

However, if you were to close Blender and reopen it now, that cache would be lost. Cache is only an in-memory solution. To actually store the solution, it needs to be **baked**. To recalculate the entire thing into a baked state, simply hit the **Bake** button on the **Cache** panel. The solution to the simulation will be calculated for the indicated frame range and saved within the BLEND file. Once a simulation is baked, you can (after saving) close Blender, then run it again, open the file, and the solution will remain in place. If you don't like the solution and want to rebake with different settings, press the **Free Bake** button that replaces the Bake button (Figure 12.69).

If you have a full cache and you like the results of the simulation, you can take a shortcut and use the **Current Cache to Bake** button on the same panel. It simply stores the current state of the cache as though it had been baked.

Sometimes simulations can take up a great deal of disk space. The **Cache Step** setting can help with this. For certain conditions like falling snow, we don't necessarily need to remember every single frame of the simulation. The snow doesn't collide with anything, and it doesn't need to make frame-by-frame adjustments to its trajectories to give a good visual result. By adjusting cache steps to something like 10, or even 20, we tell the cache system to store only every tenth frame, and to interpolate positioning between the cache steps. Figure 12.70 shows the timeline for a simulation that has been cached with a steps value of 12. Note how there is a bolder indicator every twelfth frame.

Figure 12.68 *The light bar at the bottom indicates cache data.*

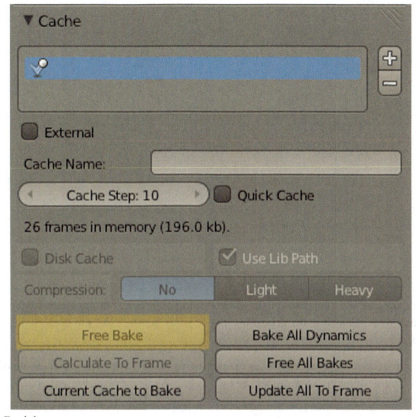

Figure 12.69 *Free bake.*

Figure 12.70 *Using cache steps.*

The reduction in storage space is linear. If a simulation took up 100 MB of space with a **Cache Steps** setting of 1, it will take up only 10 MB of space with a setting of 10. Of course, you need to be careful how you set this option. Fast-moving particles that die or deflect when running into collision objects will miss the collision if it were to occur on a frame that was not evaluated because of a high cache steps value. For example, the laser blasts in shot 8 of *Snowmen* had to collide with a plane, so the cache step for the particle system was set to 1.

Finally, it is possible to save the simulation cache generated in one BLEND file to an external path and then use it in another file. To do so, the **Disk Cache** option must be checked. This saves the simulation into an external folder that will be automatically created and named in the same directory as the originating BLEND file. To use this same set of cache files from another file altogether, choose the **External** option and locate the file path using the new set of controls (Figure 12.71).

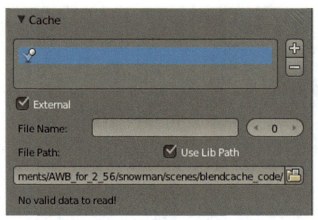

Figure 12.71 *Using an external cache that has been generated elsewhere to drive a simulation.*

Summary

Blender has a variety of simulators to help you add effects to your animation. Most simulators are found within the Physics properties and are applied to one or more existing objects within the scene. The smoke and fluid simulations require both a domain and a generating object, whereas others like the ocean simulator can create their own geometry.

Particle systems can be used to create effects for magic; energy; falling matter like rain, snow, and pollen; and even flying pieces from explosions. They can also be used as strands to create hair, fur, and grass, and as billboards for other kinds of distributed objects.

All of these systems (smoke, cloth, particles, fluid, soft body) store their solutions into a cache, which can be found either within the BLEND file itself or in a specified external directory. Although the ocean simulator can be cached as a series of textures, the nature of the simulation means that it does not have to cache to work properly. Rigid body physics simulations are just an F-curve based recording of the results of Blender's game engine, so they do not require external storage of the solution either.

Because most of the simulations must be "baked," they are usually not good candidates for library linking. If the simulation must react to events or items in a specific shot, it must be built locally within the shot file.

Chapter 13

Rendering and Compositing

Objectives in This Chapter

- Observing the goals and overview.
- Lighting your shot files.
- Compositing for better, faster renders.
- Getting a good render on your local machine.
- Reviewing the final animation.
- Preparing for render farming.
- Setting up and using a render farm.
- Checking the final frames.
- Staying organized.

INBOX
- Shot files with finished animation

Goals and Overview

Great final frames versus *faster render times*. Mutually exclusive goals always make for good fun at parties.

More specifically, your goal as the *art* director of your animation is to produce final frames that help to convey the themes of the story. The images should have a good tonal range, good contrast, and an appropriate color scheme. However, your goal as the *technical* director of the animation is to get the entire job rendered and ready for editing as quickly as possible, with as few technical hurdles, glitches, and do-overs as you can manage.

Many beginners in 3D believe that it is somehow best have a "pure" render. Retouching and postprocessing are forbidden. Nothing could be further from the truth, and trying to work with an animation project in this fashion will almost certainly make you want to throw yourself down a well. If you are not on board this train already, start right this second to think of compositing, color correction, and postprocessing effects as just another part of the renderer. Compositing and postprocessing are in fact integral to solving the conflict between high quality and low render times. Good postprocessing can drastically increase the quality of your final frames, while reducing the large amount of work the renderer itself has to do. Of course, great compositing won't save a shot that has poor models, lame texturing, and terrible animation.

Figures 13.1 and 13.2 show a raw rendered frame from *Snowmen*, alongside the final composited, postprocessed, color-adjusted frame. The render time of the frame without any compositing effects was 2:08;

Figure 13.1 *A raw, noncomposite version of a frame.*

Figure 13.2 *A final frame.*

the composited version was only 2:30. In this case, it did not save any time but produced a better overall effect.

Lighting Your Shot Files

In Chapter 11, you learned about lighting your sets. Quite possibly, this was done without regard to your characters and their actions or locations. Now, as you prepare each shot for rendering, you may need to address the direct lighting of your characters. This new lighting can be integrated directly into the lighting solution for the entire shot, or it can be confined to the characters themselves. In the case of a shot like the one in Figure 13.3, the lighting is added to the scene, illuminating both the characters and the set.

Throughout *Snowmen*, I was able to simplify the lighting for two reasons. First, it occurs on a fairly overcast day, outside. Under real conditions like that, there is very little directional lighting. Even though we don't strictly need it, it could be useful to add lights in order to highlight the characters and draw them out of the background. Note, however, that most of the backgrounds in the animation are very bright, whereas the children are fairly dark, providing a good deal of compositional contrast.

However, in most cases you will be lighting your characters directly. When doing so, there are a few considerations to account for. If the contact points between your characters and the set are visible and you can see the origin of a character's cast shadows as the shot is framed, you will need to light the character and the set

Figure 13.3 *Shot 1, with no additional character lighting.*

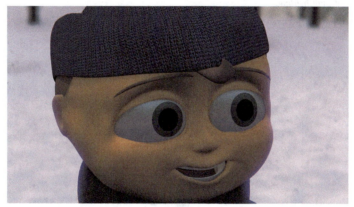

Figure 13.4 *Character and set lighting separate.*

together. In a scene like the one in Figure 13.4, the lighting can be confined to the characters, as their interaction with the set is both minimal and out of frame. Without the need to see a shadow coming away from the feet, you can truly split the character and set lighting if you wish.

When you use separate lighting for your characters, you will almost always use **spot lamps**. Spots provide fine control of where and how light and shadow are cast. For exterior shots that use the existing set lighting scheme, the set lighting will provide most of the illumination that your character requires. If you need to, you can bolster this with an additional spot lamp or two, constrained to light only the layer on which the character resides. Figures 13.5 and 13.6 show the boy, first with the default outdoor lighting, then with an additional spot lamp to give some extra definition. With the way the character already stands out from the background, this wasn't necessary in the production cut of the animation. Note that the new lamp has shadows enabled but is set to only affect the layer that the boy is on. This means that the lamp will light him realistically, but it will not cast a distracting light/shadow pattern on the ground on top of the main light sources.

Because of the potential difficulties of using ambient occlusion with interior situations, indoor character lighting will have to be a bit more involved. The lighting you need to use to achieve a good result on the set can be drastically different than what would make your character look good, so it can be useful to light the character separately, then combine the ambient renders of the set and the directly lit renders of the characters and their shadows in the compositor (Figure 13.7).

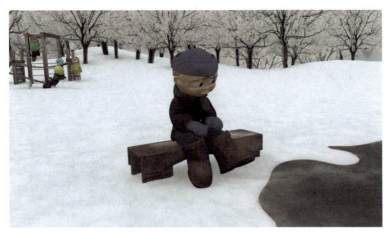

Figure 13.5 *The boy with default lighting.*

Figure 13.6 *The shot set up with an additional spot lamp.*

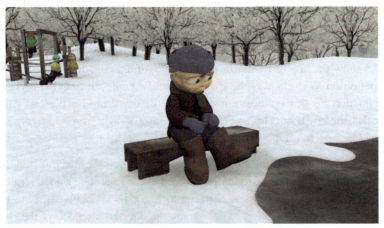

Figure 13.7 *Key lamp on the character composited with the "beauty" render of the set.*

For consistency, these additional lamps can be named (*boy_key, boy_fill, snowman_key,* etc.) and appended to each shot file as you prepare for rendering. Although individual shots may require variations to the positioning, intensity, color, and shadow properties of these lamps, this will give you a good starting point and save a lot of time. Of course, you should try to maintain some level of lighting consistency between your shots. Your shots will all be edited together at the end of the project, and it would be jarring to have different camera angles present drastically different lighting schemes, even if those schemes have been individually optimized. You must keep in mind that you are working on a larger project.

Compositing for Better, Faster Renders

You are about to become a "shot detective." You will be looking for any way that you can save render time by separating the animated from the static, the foreground from the background, dealing with them individually, then putting them back together.

Faster Renders

When your characters do not actually touch the set within the frame as in shot 3, this is easy. Figure 13.8 shows the character from the shot, and Figure 13.9 shows the set render. We can see that the character's shadow does not appear within the rendered portion of the frame. This means that the set can be rendered once and used as a static

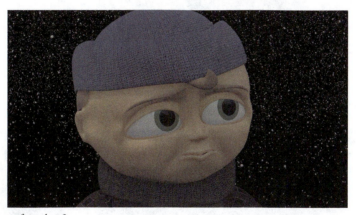

Figure 13.8 *The character from shot 3.*

Figure 13.9 *The set, rendered once for use as a still background.*

background for the shot. Only the character and any effects like snow are rendered for each frame. In Figure 13.10, you can see the final composited frame. The nodes network for building this composite is found in Figure 13.11.

The upper input node, called **characters**, holds the characters themselves. The lower input node does not refer to anything in the scene, but is instead an **image node**. The image used in this node was created by rendering the shot without the characters and saving the result in OpenEXR format. No tricky compositing or other shenanigans were used. Figure 13.12 shows the screen setup just before rendering the background image. The image is then blurred outside of Blender. The boy is located on layer 1, which is disabled. Had I been using specific lamps for the boy, I would have left them in place for the background-only render to give a more visually integrated result. This technique saves a decent amount of time in this shot, as the snow on the ground is "hard" to render because of the subsurface scattering in its material.

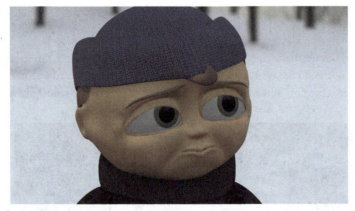

Figure 13.10 *The final composite.*

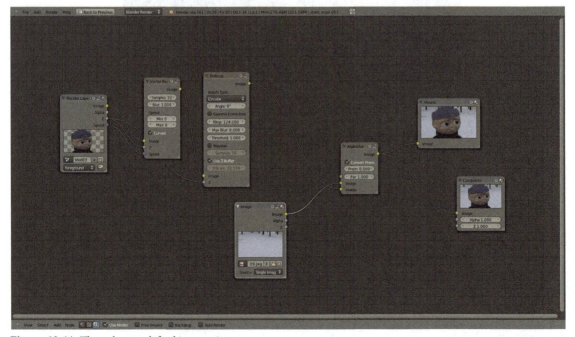

Figure 13.11 *The node network for this composite.*

Figure 13.12 *Settings for rendering the set for a background image.*

> **Note**
>
> Rendering a static background for your shots will only work if the camera does not move significantly. If it does, you will need to fully render every element in the shot for every frame. You can fake simple camera tracking (moving side to side) with a distant background by translating the background image in the compositor with a **translate node**. Pay attention to well-done animation and live-action productions. With the exception of the "handheld" look, you might be surprised at how much static camera work is involved in recorded entertainment. You should attempt to emulate this style of camera work, not only for the sake of believability but also for the benefit it gives you at the compositing stage.

For the final render of this shot, only the layers with the characters and snow were enabled, as seen in Figure 13.13. The renderer only has to prepare and render the characters, then blend the result with the background image as indicated in the compositor. The resulting frame is saved in OpenEXR format. If this is your first encounter with the **Render Layers** panel, you can get an anatomy lesson in the Render Layers sidebar.

Notice that for the compositing network shown in Figure 13.11, only one extra pass has been enabled for the **characters'** render layer. The **Vec** pass, which is short for "vector," allows the use of vector-based motion blur in the compositor. Many people believe, after learning the compositor basics, that one must use all of the passes (Spec, Col, Shad, Mir, etc.) in order to make effective use of the feature. This is not the case. Although those separate passes can be useful in certain situations, you will find that most of the time a simple **RGB** curves node applied appropriately will be enough to enhance and correct your imagery. Blender's compositor has great depth, but don't feel obliged to use every last inch of it just because it's there.

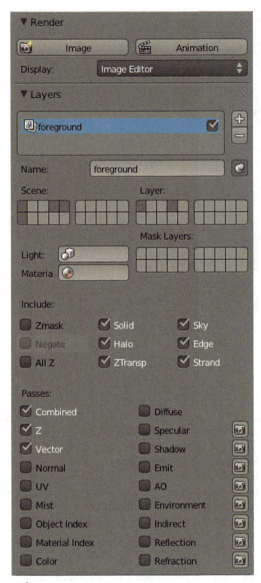

Figure 13.13 *The Render Layers panel.*

Of course, if you have a dedicated compositing artist (or plenty of extra time yourself), you may want to have each of those passes show up individually within the compositor and reconstructed with exacting control over each one's contribution to the final image.

Note

OpenEXR is the preferred format for renders and render elements. Blender renders into a high dynamic range, meaning that the render actually has a much larger gamut of light and shadow than a monitor can properly display ("brighter than white" whites). The OpenEXR format will handle these values properly so that later compositing and color correction will produce significantly better results. Additionally, choosing the **Multilayer** format actually saves to OpenEXR format, but it includes all passes and render layers separately. You could load a file saved in Multilayer format and have several scene renders or passes to choose from within the compositor, depending on what was contained in the original render.

So if you were to build this render/composite tree from scratch, you would do the following:

• Choose **Composite Nodes** from the header on a **Node Editor** window and enable **Use Nodes** (Figure 13.14).

Figure 13.14 *Setting up a Node Editor window.*

• Remove any existing nodes by selecting everything (**A** key) and deleting (**X** key).
• From the **Spacebar** toolbox, **Add** a **Render Layers** node from the **Shift–A Input** menu (Figure 13.15).

Figure 13.15 *Adding a Render Layers node.*

- **Add** an **Image** node from the **Input** menu, click **Open** on the resulting node, and select the previously saved background image (Figure 13.16).

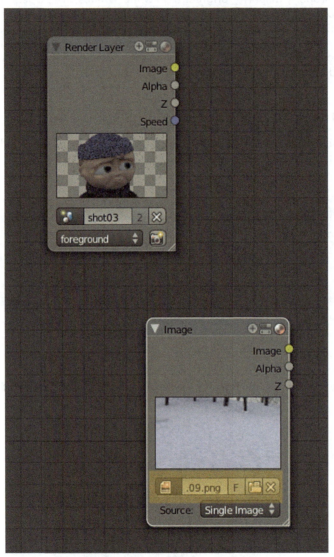

Figure 13.16 *Adding an Image node and selecting the background image.*

- **Add** two **RGB Curves** nodes from the **Color** menu (Figure 13.17), one each for the two **Input** nodes. When each **RGB Curves** node is added, Shift-select both the new node and the original **Input** node. Press the **F** key to connect them.
- **Add** an **Alpha Over** node from the **Color** menu and connect it to the **RGB Curves** nodes, with the result of the **Image** node going to the top **Image Input** socket on the **Alpha Over** node (Figure 13.18).

Figure 13.17 *RGB curves nodes for fine-tuning color.*

Figure 13.18 *Alpha Over node to combine the input layers.*

- Add a **Vector Blur** node from the **Filter** menu. Connect the **character** input node's **Z** and **Speed** output sockets to the **Vector Blur** node's input sockets and the **Alpha Over** node's image result to the **Image** input (Figure 13.19).

Figure 13.19 *The Vector Blur node for motion blur.*

- Add a **Composite** node from the **Output** menu, so that the final vector blurred image is the output. Of course, enabling **Compositing** on the **Post Processing** panel of the The **Render** properties option is required so that the **Composite** node is used as the final result of any render commands (Figure 13.20). Note that this option is enabled by default.

Figure 13.20 *Composite node added, and the renderer set to Compositing.*

When you've rendered once, you can add an **Output >Viewer** node and enable the **Backdrop** option on the **Node Editor** header to show the composite right in the node window. At this point, you can play around with the **RGB Curves** nodes to visually balance the two input nodes for a more natural composite.

Although this seems like a lengthy description, it is really a very simple node network, and it will take only a few seconds for you to create and configure it once you have worked with the system for a few days.

The Render Layers Panel

The **Render Layers** panel in the **Render** properties is the bridge between the renderer and the compositor. It is here that you can create different groups of layers and passes, as well as setting lamp and material overrides and special Alpha settings.

258

Figure 13.21 shows the **Render Layers** panel broken into numbered sections.

1. *Render layer management.* This control set is where you manage groups of render settings that are determined by the controls below. These groups can be selected by name as Input nodes in the compositor. Each group defined here can be enabled/disabled with the check box on the right, renamed with the Name control below, and removed with the "−" control on the far right. Removing one of these defined groups does not affect the scene objects in any way—it just removes the particular grouping of settings created in this panel. The Pin button beside the naming control causes Blender to ignore all other render layers and render only this one. New render layers can be added with the "+" symbol.

2. ***Scene*** *layer buttons.* A convenient copy of the main Scene layer buttons, also located on the header of the 3D view. These buttons, like their header-based counterparts, control which objects are considered during render preparations.

3. *The **Layer** layer buttons* (and yes, the names are getting silly). This set of layer buttons controls which of the available, active layers will be included in this particular rendering group. The result of an Input node set to this render layer will be *only* the objects on the layers indicated on this part of the panel. Layers that are activated on this portion but that are not active on the overall Scene Layer buttons *will not render.* Even though the Render Layer settings allow it, the Scene-level Layer buttons have not passed the information for those objects along for render preparations in the first place.

 This is where things start to get wacky. Active objects in a RenderLayer group will not receive light from lamps that are not on active layers in the same RenderLayer group, regardless of the lamps' particular **Layer** setting in the **Lamp buttons.** However, lamps and objects that are on an active RenderLayer layer can receive shadows from objects that are on in active layers for this particular render group. Figure 13.22 shows a simple scene consisting of a lamp, a sphere, and a plane. The lamp is on layer 2; the plane is on layers 1 and 2; the sphere is on layer 1. Figure 13.23 shows the result of a RenderLayer with only layer 1 active. Figure 13.24 shows the result of only activating layer 2. Note that both layers 1 and 2 must be active in the overall Scene buttons to achieve this result.

4. *Light and material overrides.* The **Light:** field receives the name of a previously created **Group** of Lamp objects. When a valid group name is entered, only lamps from that group are used when evaluating this RenderLayer. Likewise, when a valid material name is put in the **Mat:** field, that material is used for all objects appearing in the RenderLayer.

5. *Mask layers.* There may be situations where you want an object to render but have an Alpha 0.0 generated in places where it is occluded by other objects. Enabling a layer on this set of controls uses the object on the indicated layer as a kind of "cookie cutter" for the actual rendered layer. Figure 13.25 shows what happens when you render the following scene: a cube sits on layer 1, with a sphere on layer 2. The RenderLayer contains only the cube but uses layer 2 as a mask layer.

6. *Include.* This controls which portions of the renderer are used. Generally, you will leave this alone unless you specifically need only, say, **halos** or **strands** to appear in their own input in the compositor.

7. *Passes.* Under normal circumstances, the renderer generates an RGB image, which is often accompanied by an alpha channel. It is possible to access each portion of the render in the compositor though, by enabling these buttons. The **combined** image is still generated, but new sockets sprout on the RenderLayer node in the compositor for each enabled pass, as shown in Figure 13.26.

Let's take a look at a more complicated shot from *Snowmen*, the production challenges it presented, and the compositing solution. Figure 13.27 shows a production frame from the last shot of the animation. The frame actually consists of three different elements, which can be seen as the **inputs** of the compositor in Figure 13.28. They are the set and characters, the smoke, and the laser blasts.

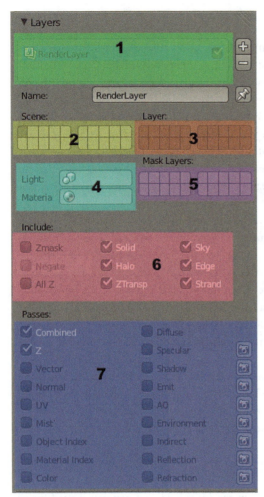

Figure 13.21 *The Render Layers panel.*

Figure 13.22 *A basic scene.*

Figure 13.23 *Rendering a RenderLayer using only layer 1.*

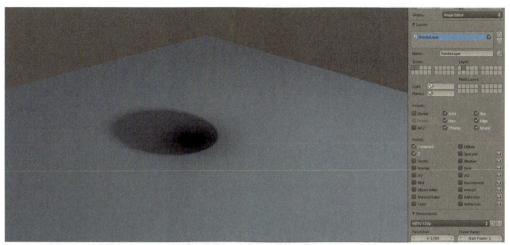

Figure 13.24 *Rendering a RenderLayer using only layer 2.*

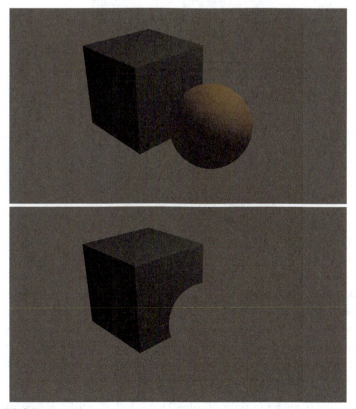

Figure 13.25 *Using a Mask Layer.*

Figure 13.26 *A RenderLayer node with all passes enabled.*

If the scene were rendered in a single pass, it would look like Figure 13.29. Here are the problems that we have to overcome. The lasers from the snowman's eyes are particles that use the Halo material type. Halos do not render currently when there are objects behind them that use Z-transparency. As the trees and sky (which are all images mapped onto planes) use Z-transparency, any time the lasers pass in front of them, they disappear. In fact, if you hover over the **Ztransp** control in the **Include** section of the Layers panel, the following tooltip appears: "Render Z-Transparent faces in this layer (on top of Solid and Halos)."

Z-transparent faces will always render in front of halos. That is bad, especially as halo particles do not come with a Z pass themselves. You cannot even use the **Z Combine** node to render them separately then put them back together.

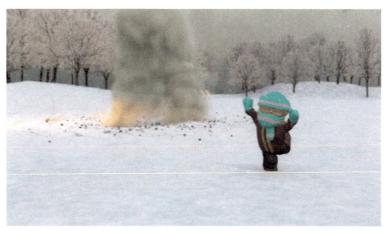

Figure 13.27 *Final composite of shot 9.*

Figure 13.28 *The node network for the composite.*

The solution in this case was to push the lasers into a separate render layer, use the **Mask Layers** controls to properly Alpha mask them, then put them back into the scene with the **Alpha Over** node. Here's a closer look.

Figure 13.30 shows the Layers panel with a new render layer created called "lasers." The particle system of the lasers appears on layer 15, which is the only one chosen for render on this render layer. However, kids and debris will be passing in front of the lasers at various points, so we cannot simply render it this way and throw it on top. In fact, if we did that, the result would look like Figure 13.31. Note how the laser crosses over the girl and boy in the foreground, and even shows past the point where it passes into the ground.

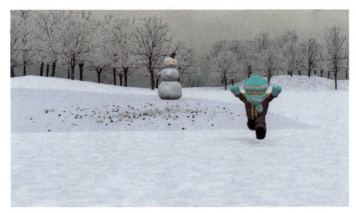

Figure 13.29 *A bad render.*

Figure 13.30 *The "lasers" render layer.*

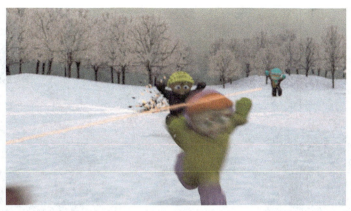

Figure 13.31 *A composite without masking the layer results.*

However, if we select all of the other active layers in the **Mask Layers** section, anything that passes in front of the halos in the scene will "carve" its shape from the rendered layer with **Alpha**. Note that hovering over the **Mask Layers** controls shows the tooltip "Zmask scene layers for solid faces." That's a little bit cryptic, but it does not mention Z-transparent faces. It ignores them when masking, so the Z-transp versus Halo fight will not happen this time.

Figure 13.32 *The lasers layer, with masking.*

So in Figure 13.32, you can see the "lasers" render layer rendered with proper masking. The composited result, built with the **Alpha Over** node, is shown in Figure 13.33.

That's production problem number one, solved. When we try to add some depth of field with the **Defocus** node though, we run into another issue. Figure 13.34 shows an enlargement of the frame. I've superimposed the domain of the smoke object onto the image. Notice how the defocusing within the area covered by the domain is wrong. This is because the Z values of a smoke domain do not correspond to the volume rendering itself. The Z values come from the cube, even though it does not render as a cube.

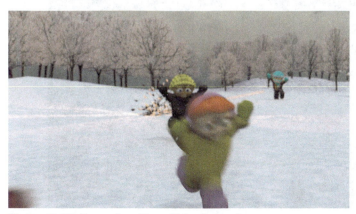

Figure 13.33 *Put together with an **Alpha Over** node.*

Your first inclination might be to put that smoke domain into a different render layer and remove it from the main set render. Unfortunately (as experimentation would show you), this does not work. If the object is in the scene, it will be used for the Z pass, regardless of whether or not it is in the render layer.

The solution to this problem introduces another feature of the compositor: the ability to use layers from any scene in the BLEND file, not just the currently active one. So if we were to

Figure 13.34 *An incorrectly defocused render.*

create a new scene with only a few crucial objects in it, including the smoke domain, we could entirely remove the smoke domain from the current scene and bring in the second scene as a smoke-only render. Then, we would use the Z channel from the first scene only for defocusing, ignoring the smoke. Let's take a closer look at exactly how to accomplish this.

First, create a new scene using the **Scenes** manager on the main header. Simply choose **New** from the menu that pops up (Figure 13.35), as we want to create a blank scene.

Figure 13.35 *Creating a new, empty scene.*

Within this scene, we will renew the smoke domain object and the flow particle system objects. The smoke is already baked, but as we'll be removing the domain from the main scene, we should push the flow objects along with it in case we need to change settings and rebake. We will also need any objects that could potentially occlude the smoke for masking purposes. This would be the children, the snowman, and the ground. To push these objects into the new scene (named *shot09 smoke*), you need to select them in the 3D view then issue the **Make Links** command, which is triggered by the **Ctrl-L** hotkey or can be chosen from the **Object** menu. Figure 13.36 shows the **Make Links** menu.

From there, choose **Objects to Scene**, which provides you with a list of available scenes. Choosing *shot09 smoke* links the selected objects into the new scene. They stay linked to the main scene as well, but a quick trip into scene *shot09 smoke* shows that it has done exactly what we wanted (Figure 13.37).

Because these objects have been linked in, they retain all the settings and functionality that they had in the original scene—animation, layers, everything. With the objects confirmed to be present in the new scene, you can safely return to the main scene and use the **X** key to remove the smoke domain from the scene. If you were to render now, your Z values would be fine, and the **Defocus** feature would now work properly. However, there would be no smoke.

Before we bring the smoke scene in via the compositor though, let's make sure that everything is ready over there. We link in the proper world settings as with all of our other scenes in the production, as well as any

Figure 13.36 *The Make Links menu.*

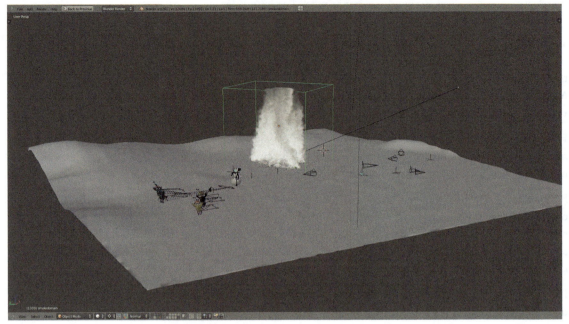

Figure 13.37 *The new scene, with select objects linked in.*

lighting that was in the main scene. Within the render layers panel, we can rename the only layer here something appropriate like *smoke*. Finally, we enable for render the layer that contains the smoke domain and use as mask layers the layers containing the children, snowman, and ground (Figure 13.38).

Figure 13.38 *Render layers set up for the smoke.*

Now, we head back to the compositor and the main scene. Adding a new **Render Layer** node, we select the *shot09 smoke* scene and the *smoke* render layer. The result of this new render can be blended back into the shot using an **Alpha Over** node, because we used the **Mask Layers** feature properly in the smoke-only scene. Also, this gives us an additional level of control, as the overall opacity of the smoke render can be adjusted in the compositor using the **Factor** control on the **Alpha Over** node. The final shot using the two separate scenes and three render layers is shown in Figure 13.39, and the node network is shown in Figure 13.40.

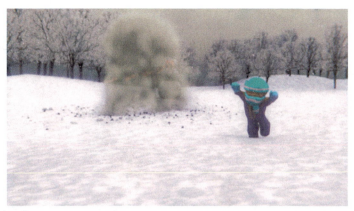

Figure 13.39 *The final render.*

Figure 13.40 *The node network.*

Better Renders

We have already shown how **RGB Curves** nodes are placed after each input node. Let's examine a couple of common uses for an **RGB Curves** node.

Contrast Boost

Figures 13.41 and 13.42 show a frame from shot 7, both before and after contrast enhancement. In nontechnical terms, a contrast boost involves making the darks a bit darker, the lights a bit lighter, and leaving the middle alone. To translate this into RGB curves, the top end of the curve, which represents the highlight area, needs to go up (lighter), and the low end of the curve, which represents the shadows, needs to go down (darker). The curve that made the adjustment between the two previous illustrations is shown in Figure 13.43. This is commonly referred to as an "S" curve, or a standard contrast curve.

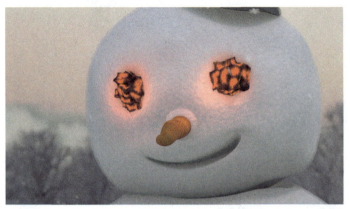

Figure 13.41 *A shot with unaltered contrast.*

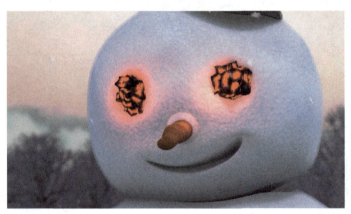

Figure 13.42 *The contrast-enhanced shot.*

More contrast will usually make an image more interesting. However, you must be sure not to overdo it. How much is too much? First, you do not want to lose visible detail in either the highlight or shadow range. If you examine the output of the **RGB Curves** node and the details have disappeared, like Figure 13.44, push the curve back toward a straight line a bit.

One other thing to be aware of is that the contrast of elements from different Render Layers should work well together. They do not necessarily have to have identical contrast curves, but a stark difference in contrast between objects and characters that are supposed to be a part of single, coherent shot will cause those objects to appear out of place. The goal of the composite should be to get everything to look as though it were really all of one piece.

Figure 13.43 *The contrast "S" curve.*

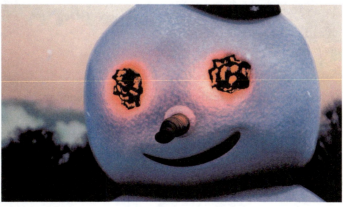

Figure 13.44 *Losing shadow detail from too strong a contrast curve.*

Midtone Brightness

Before you get too far into doing color corrections, make sure that your monitor is displaying things properly. The most basic adjust that you can make to your system will be to ensure that you are working within the correct gamma. Gamma correction can be a very technical thing, and some people will call you bad names if you don't go absolutely gamma crazy and read everything ever written about it and manage your gammas from end to end. A simple but effective layman's resource for adjusting the gamma of your monitor can be found at www.photoscientia.co.uk/Gamma.htm.

With your monitor adjusted properly, you can attempt to adjust the midtones of your images as well. Simply add a control point at the dead center of your RGB curve and, most likely, pull it up and to the left. Figures 13.45 and 13.46 show the difference between a raw and adjusted image, and Figure 13.47 shows the RGB curve that changed it. Moving the middle point of an image affects whether an image is weighted toward highlights, toward shadows, or is balanced.

> **Note**
>
> Gamma experts, please take this as your personal invitation not to write letters about how this bit is a complete travesty of the importance and complexity of gamma in the world of imaging. If the story's good, people will never notice that the gamma's a little off. If the story is awful, the world's greatest gamma technician will never save it. Of course, if you have a gamma expert available, by all means take advantage of what that person has to offer.

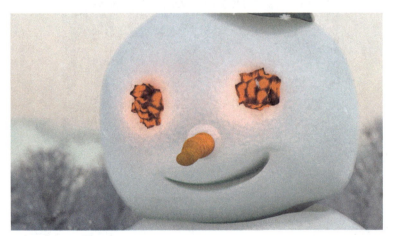

Figure 13.45 *An unadjusted image.*

In lieu of the reams of technical explanations, mathematics, and general silliness that it would take to make you an expert in midtone correction, I will suggest a method that I call "The Optometrist." If you've ever been to the eye doctor and had to get corrective lenses, you will be familiar with the optometrist's technique of finding the exact lenses that you will need. The optometrist will put one lens in front of your eye, then a different one, then will switch back and forth a few times and ask, "One? Or two?" You'll say which looks better. In this way, the optometrist will go through a number of different corrections and will finally narrow it down to the best one for you.

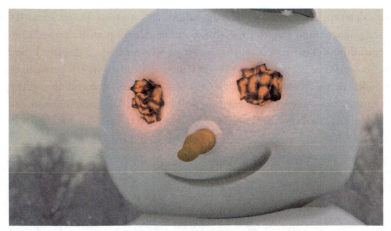

Figure 13.46 *The midtone corrected version.*

Figure 13.47 *The RGB curve for creating this correction.*

The same technique can be applied to making midtone adjustments to your images. In an **RGB Curves** node, grab the midpoint and pull it around. Figure 13.48 shows a node tree for performing an "Optometrist" on your image. The **Background** button is enabled so that the active **Viewer** node is displayed there. In this way, you can set two different midtone curves, one in each **RGB Curve** node, then switch between the two by clicking on the two viewer nodes. Better? Worse? One? Or two? Most likely, you will end up applying a similar adjustment to all of your images, but some experimentation will be beneficial. This technique will obviously work for any kind of judgment call correction and need not be restricted to midtone problems.

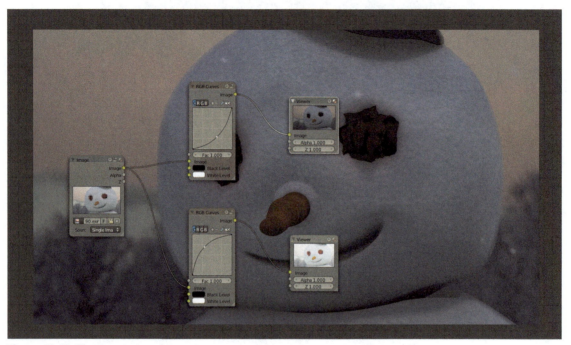

Figure 13.48 *The Optometrist node tree.*

Combining the Techniques

Of course, midtone adjustment can be combined with the contrast curve from the previous section into a single correction curve. Figures 13.49 and 13.50 show the original image that has been used in these sections and a final image adjusted for brightness and contrast. The RGB transformation curve is shown in Figure 13.51.

You can put these curves immediately after their respective input layers so that you can control each render layer element separately, or you can place one right before the final composite so that it works on the finished image. Although the second option is easier, you will need to make sure that all of your inputs combine well. If they don't, you will need to adjust them individually so that they look natural together.

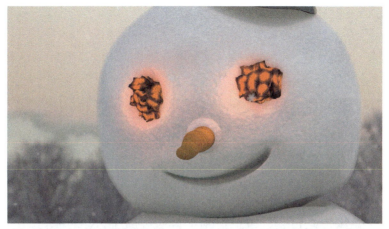

Figure 13.49 *The original image.*

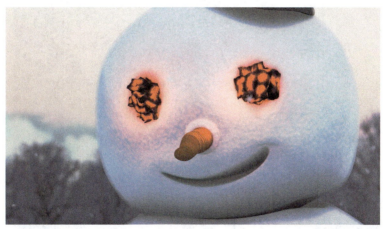

Figure 13.50 *The image adjusted for both contrast and midtone brightness.*

Color Adjustment

A final use for the **RGB Curves** node is to change the overall color of images. Figure 13.52 highlights the R, G, and B buttons on the node. Pressing any of those buttons shows the individually adjustable curve for that color channel. By putting a point in the middle of these curves and pulling them around, much like midtone adjustment in the previous section, you can change the overall color of the image in both subtle and drastic ways. Figures 13.53 through 13.55 show what happens when you move the midpoint for the different color curves.

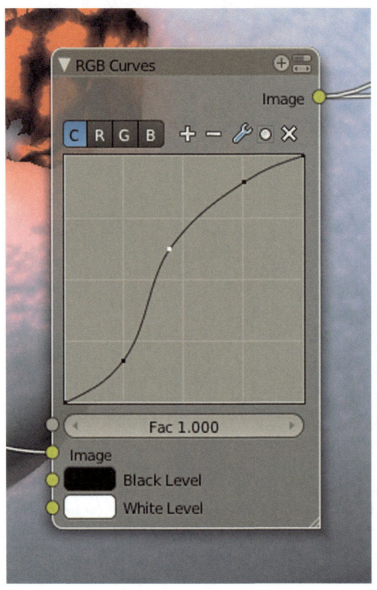

Figure 13.51 *A combined curve.*

Figure 13.52 *The R, G, and B buttons for color changes.*

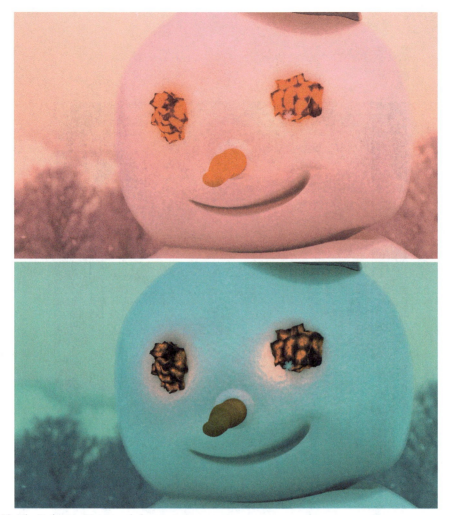

Figure 13.53 *The Red curve: Up casts red, down casts cyan.*

These controls can be used to fix bad coloring that has crept into a render somewhere along the way, or to subtly enhance the feel of image. For example, they can be used to shift the shadows of a "good" character to a slightly warmer palette of colors and push a "bad" character's shadows a bit cooler.

Motion Blur

Unless you want your final production to look like clay model stop-motion animation or one of the stylized high-speed camera action movies, you will want to add motion blur to your composite. Figures 13.56 and 13.57 show the difference between an action-filled shot with and without motion blur. Because of the nature of our eyes, motion blur is something that we see every day, so much so that we don't usually realize or make note of it. However, when it is not present when it should be, the effect is obvious and reduces the believability of your animation.

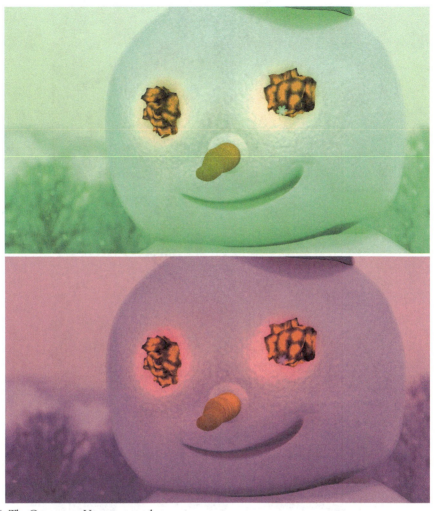

Figure 13.54 *The Green curve: Up casts green, down casts magenta.*

Fast vector-based motion blur is easy to add in the compositor, and a few changes to the default values will produce decent results. The **Add > Filter > Vector Blur** node, shown in Figure 13.58, requires three inputs: an image, a Z channel, and a Speed channel. These correspond to the regular RGB (+ Alpha), Z, and Vec passes in the **Render Layers** panel. For simple composites, all that is required is to connect the familiar sockets on the **Input** and **Vector Blur** nodes, then send the image output either to a **Composite** node, if it is the last item in the node tree, or to the next input. The example in Figure 13.58 shows this simple configuration.

For most cases, you will be able to achieve good results by raising the **Samples** value to 64 and enabling the **Curve** option. The **Samples** feature increases the quality of the blur and should go as high as 256 for objects that are moving very quickly. As most real cameras don't capture an entire frame's worth of blur, set the **Blur**

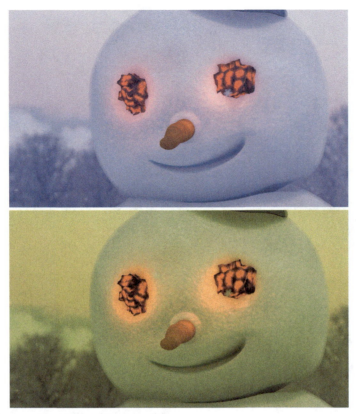

Figure 13.55 *The Blue curve: Up casts blue, down casts yellow.*

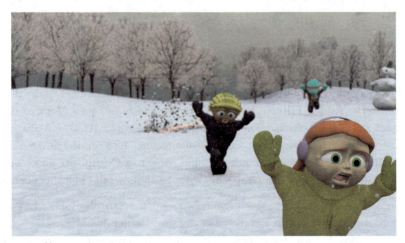

Figure 13.56 *No motion blur.*

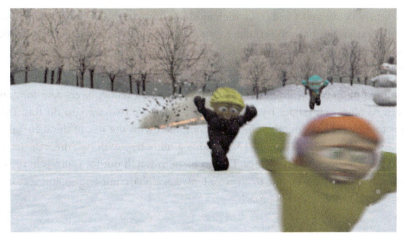

Figure 13.57 *Motion blur.*

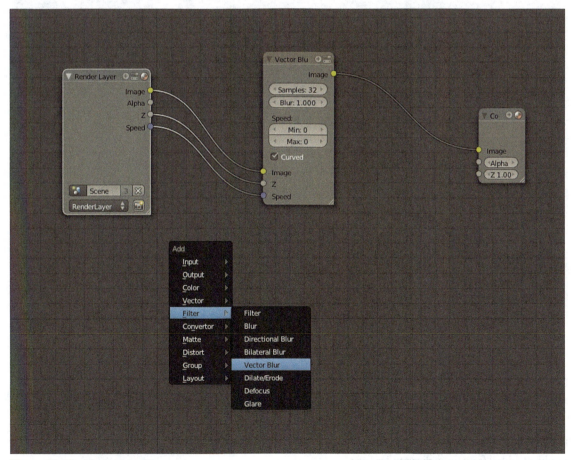

Figure 13.58 *A basic motion blur setup.*

slider itself to somewhere between 0.4 and 0.6, which indicates how much of a frame is sampled. **Curve** allows the node to generate a curved blur for objects that move in an arc during the course of the frame. Without this option, a ball that is flying in a circle will generate a straight-line blur between its beginning and end points instead of a proper curve.

The difficulty in using motion blur arises when objects from different render layers have motion blur. In those cases, you will need to blur each render layer individually. There are two ways to do this. The first, and the most "pure" way, is to blur the node input before it is combined with the rest of the scene, although this can sometimes lead to undesirable artifacts. Figure 13.59 shows a node tree with two different inputs, each vector blurred before being combined with a set image. The problem to watch out for is pixels in the final composite that have gone completely black. This is due to an error between alpha, compositing, and vector blurring. If this occurs, you will have to take a different approach.

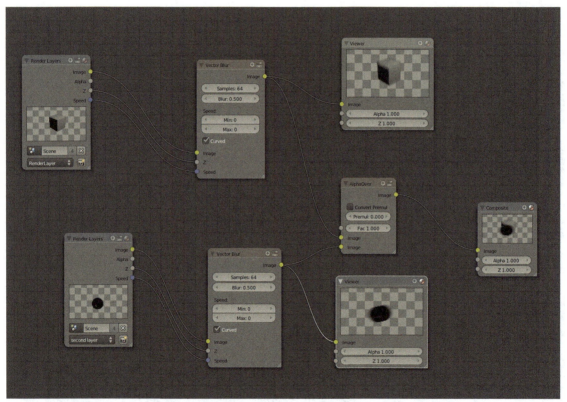

Figure 13.59 *Blurring each render layer before it is composited.*

The slightly less desirable way to do this, and one that will prevent the kind of artifacts just mentioned, is to add each render layer into the growing composite, then blur them in order of addition. Figure 13.60 shows this technique. Note how each render layer is added to the background, then blurred, before proceeding to the next.

The danger of this method is that a moving object from one render layer can blur the already-blurred streak of an object added from an earlier render layer.

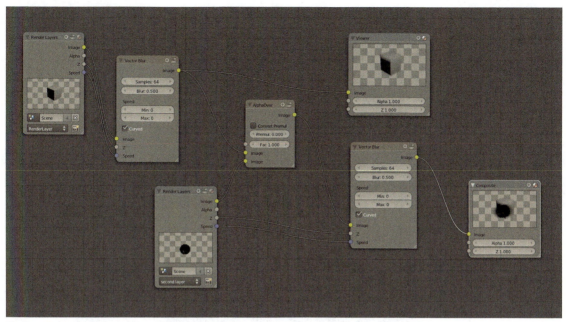

Figure 13.60 *Building up layers of motion blur.*

Getting a Good Render on Your Local Machine

Once you have your shot lit and composited properly, it is time to prepare for production rendering. Here is a list of items to go through before declaring your shot "render ready."

On the **Dimensions** panel of the **Render** properties (Figure 13.61):

* Double-check render size, frames per second, and start and end frames.

On the **Post Processing** panel (Figure 13.62):

* **Compositing** is enabled.

On the **Anti-Aliasing** panel (Figure 13.63):

* **Anti-Aliasing** is enabled, and the OSA value is set appropriately; 16 is the highest quality, but this setting can make the process take longer. Do a few tests to see what you can get away with.
* For high-quality compositing, use the **Full Sample** option.

On the **Output** panel (Figure 13.64):

* Enable **Placeholders** and disable **Overwrite**, useful later for a "poor man's render farm."
* Set the output path. This is very important! Just like asset paths, this too should be relative. A good scheme is to locate the path for your final renders (called, probably, *renders* or *frames*) and add the shot name to it as both a directory and part of the file name. So a good path would look like this: **//../renders/shot05/**.
* OpenEXR format, with Zbuf and Zip(lossless) options.

With the render settings prepared, make sure that all asset paths are relative by choosing **File > External Data > Make All Paths Relative** from the main header menu. Then, run a link check on your file by choosing **File > External Data > Report Missing Files**.

Figures 13.61–13.64 *The Render settings panels.*

Now, the moment of truth. Use the **Render** button to, well, you know...

Of course, you've rendered test frames from your shots hundreds of times over the course of your work on this project, but this time it's almost for real. Check the resulting composite image for artifacts: areas of blown-out or unexpected colors from a bad composite connection, bodies passing through clothes, people passing through the set, and so on.

You should also note any simulations that appear in the shot. Move the frame counter to middle of the simulation and render a test frame to make sure that things are properly baked. If the entire frame passes a visual inspection at this point, you are almost ready to go.

Final Animation Review

Before you hit the **Anim** button for animation rendering or sending your shot to a render farm, it is worthwhile to do one more round of testing on your animation. You dealt with real time previews to check your animation and timing in Chapter 12, but there are some details such as eye movements and blinks that you will not pick up on an OpenGL preview animation. If you have the time, it is worth performing a final animation review.

To do so, change the output format from OpenEXR to AVI JPEG on the **Format** panel, and disable shadows and Subsurface Scattering on the **Render** panel. If your shot involves characters or set pieces with large numbers of strands, you can disable those as well by disabling their renderability in the objects' respective modifiers panels, as shown in Figure 13.65. Of course, if strands are very important to some aspect of the scene instead of

Figure 13.65 *Turning off particle systems for rendering.*

Figure 13.66 *The Simplify panel.*

just window dressing, you will need to leave them on. Turn **Anti-Aliasing** down to the minimum, or turn it off completely if there are no fine details like pupils that matter. You might be able to get away with rendering at 50 percent of the original size as well.

You can also use the **Simplify** panel in the **Scene** properties to set items like a maximum **Subdivision** surface value, a percentage of particles to use, and the ability to reduce the quality of ambient occlusion and subsurface scattering.

As you are preparing this for one last review, you might want to tweak something here or there, so you should also enable **Stamping**, as you did way back in Chapter 4 with the story reel. This will make it easy to identify the frames that might need some extra attention.

So press **Animation** on the **Render** properties one last time before the final launch (hopefully) and let Blender make a lower-quality version of the shot. Watch the result several times to make sure that you are happy with it, or at least not embarrassed by it. After this, you'll be investing lots of computing time in performing the final render.

Preparing for Render Farming

If you will be performing your renders locally (i.e., on the computer on which you've been doing all of your work), there is nothing else you need to do. You've already done test renders to ensure that the render will perform properly and all assets will be found and linked correctly. However, if you will be doing your renders somewhere else—say, on an office network that has agreed to let you use its systems in the off hours—you will need to move your project.

Because you followed the organizational advice in Chapter 3, every piece of your project is within one of the folders in your main project directory. Moving these files now is as easy as copying the entire project directory to the new location. Whether you do it by burning CDs or DVDs, using a flash device or external hard drive, or over a network with FTP or some other protocol does not matter. The crucial thing is that you maintain the exact directory structure that you had on your original workstation.

At your render location, place this directory structure and all of the accompanying files on a machine that will act as a file server. It doesn't need to be anything fancy, just a computer that has the capability to share directories with others on the network. All of the machines that you will use to render will need to have this project directory mounted for local access. On Windows systems, this will mean using the **Map Network Drive...** functionality in the network browser, shown in Figure 13.67. For Mac OS X systems, this involves locating the shared directory through the **Network** panel, which is a bit different for each version of the OS. On Linux computers, you can either attach to the share through Samba or use standard Linux file sharing.

On each machine, or **render node**, you should run Blender, open one of the shot files over the network, and perform a test render. If you get warnings about assets not being found, your renders show up with image textures missing, or simulations go crazy, then you have done something wrong while recreating the directory structure or failed to use **relative paths** at some point.

Once you have a good render out of each render node on your network, you are ready to render. Finally!

Figure 13.67 *Mapping a network drive in Windows.*

Setting up and Using a Render Farm

The most basic way to use Blender as a quick-and-dirty render farm has been enabled by something you've already done. The **Placeholder** and **Overwrite** settings allow you to load a BLEND file across the network on several different machines at once, press the **Animation** button on each of them, and have the final frames populate the output directory without overlap. The **Placeholders** setting causes Blender to create an empty file for the finished frame at the beginning of the render instead of at the end. The **Overwrite** setting requires Blender to look in the output directory before rendering a frame, and, if a file for that frame already exists there, to move on to the next one.

This technique is very flexible, in that there is no limit to the number of render nodes you can add, and no special preparations are necessary to do so. As long as the computer in question can run Blender and can mount the master project directory as a local drive, it will work.

> **Warning**
> It is extremely important that all render nodes in your farm are running the same version of Blender. If you are using official versions, this is easy to ensure. However, if you are using computers on different platforms (Windows, OS X, Linux) and Blender's development SVN builds, it may take you some time to get right. Using different versions of Blender can cause drastic differences in the final renders. Sometimes, the same version of Blender, built with different compiling systems, can lead to different render results, especially when strands are involved.

Using **Placeholders** and **Overwrite** will work when pressing the **Animation** button in Blender or when using the command line to render. Any BLEND file can be rendered by entering a command into your systems command line utility. Windows users will probably call this the "command" or "DOS" window, OS X users will call it the Terminal, and Linux users should know what I'm talking about already or be forced to turn in their geek membership cards.

A typical command line (using Window-style paths) for rendering is as follows:

```
c:\Program Files\Blender>blender.exe -b r:\projects\snowmen\scenes\shot07.
blend -s 50 -e 172 -a
```

The portion that reads "c:\Program Files\Blender" is simply where Blender is located on the hard drive. After that is "blender.exe," which is the actual Blender executable. The "-b" indicates that Blender should be run in "background" mode, so that it doesn't start the user interface. Then, the full path of the file to be rendered. In this case, it is found on drive "r:", which is a network mapped drive of the main project directory on another computer, then within a projects directory, into the "snowmen" directory, and, finally, into the "scenes" directory where the "shot07.blend" file is located. The frame range is set with the "-s" and "-e" flags. In this example, the frame range is designated from frame 50 through frame 172. Finally, the "-a" flag indicates that Blender should do an animation render.

All other render configurations are taken from the settings already saved into the Blender file: image format and size, compositing, and output filename and path. If the output path is set correctly with a relative path, the rendered files will be created on the main shared drive within your project directory.

Using Network Render

If you have easy, constant access to all of the machines in your render farm, this technique will work nicely. Of course, you have to manually start each render job on each machine, opening new BLEND files on each one when it is time to move on to another shot.

The **Network Render** add-on that comes with Blender provides a fairly simple way to use that same network of machines with less intervention at an individual level. It allows you to set up one computer as the master (server) and any number of other machines as render slaves. The entire system can then be controlled for all of your rendering jobs from a single client. The advantage is that you only need to interact with the client machine, and the network rendering system takes care of farming out all of the different frames to available computers and collecting and delivering the results.

To enable network rendering, open the User Preferences **(Ctrl-Alt-U)** and switch to the **Addons** tab (Figure 13.68). Place a check in the box at the far right of the **Render: Network Render** item. Exit the preferences. You should have a new option available in the **Render** chooser on the main header: Network Render. To save its inclusion as a default startup item, hit **Ctrl-U** to save the current state of the user preferences. Obviously, this should be done with a blank BLEND file in place **(Ctrl-N)** so that you don't save an entire scene's geometry as your new file default.

Preparing Your Network Machines

To make this worth it, you will need more than two computers available. With only two (or with three and only a few shots to render), you will probably be better off using the manual technique described in the previous section.

Figure 13.68 *Adding the Network Render add-on.*

The first thing to decide when using network rendering is which computers should play which roles? The machines that will actually be used for rendering will be the slaves. The master computer does not need to have a lot of horsepower, as the master node does not render. In fact, it is quite possible to run the master on either your main workstation or even on one of the computers that will also be used as a slave. Likewise, the client machine can play a double or even triple role. For example, if your main workstation is the most powerful computer on your network, you will most likely want to use it as the client (because it is easily accessible), the master (because being the master takes little processing power), and as a slave (to take advantage of the rendering power as long as you won't be doing heavy processing with some other application).

However you decide to dole out the jobs, you need to configure the master computer before the others. Run Blender on the machine that will function as the master. Choose **Network Render** from the main header, and bring up the **Render** properties, which look much different with **Network Render** selected (Figure 13.69). Set a working path that is network accessible by all of the machines in the **Path** control, then hit **Start Service**. That's it. The render window will appear, but nothing will happen there. The master is now broadcasting on your network, waiting to be seen by slaves, and listening for instructions from a client.

On each of the computers that will function as a render slave, run Blender, set it to **Network Render**, and choose **Slave** in the **Render** properties. If you know the IP address of your master computer, you can enter it by hand in the **Server Address** control (Figure 13.70). If not, hit the large refresh button below it (the recycling arrows) to have the slave listen for the master's broadcast on the network. With a master identified, press

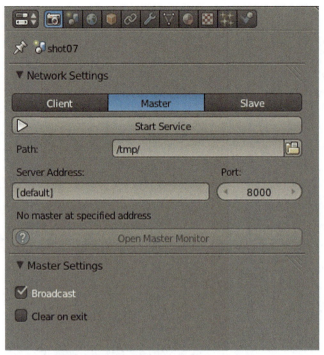

Figure 13.69 *Configuring the master.*

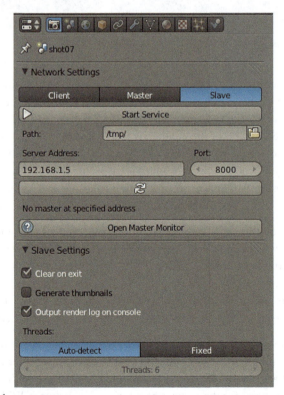

Figure 13.70 *Configuring a slave.*

the **Start Service** button. Once again, the render window appears, but nothing happens. A notice in the render progress area tells you, "Network render connected to master, waiting for jobs." If you look in the same place on the master computer, a notice displays that reads, "New slave connected."

Finally, run Blender on you client machine. If you have decided to make your main workstation master, slave, and client, you will have three separate instances of Blender running at once. Select **Network Render,** and enter the master's IP address in the **Server Address** control (Figure 13.71). When you do so, and if everything is working correctly, a new set of controls for submitting render jobs appears. Figure 13.72 shows the **Job Settings** panel.

Figure 13.71 *Configuring the client.*

Figure 13.72 *The Job Settings panel.*

Using the Network Rendering System

Once those controls are visible, the simplest way through is to press the large **Send Job** button from the client. Doing so submits the currently loaded BLEND file to the master computer, which begins to assign rendering jobs to all of the available slaves. If you will be sending several jobs to the master, you will want to name them something appropriate in the **Name** control on the same panel.

Figure 13.73 shows two more network render panels. The **Slaves Status** panel shows you all of the slaves that the master has available. Clicking on individual slave names provides additional information about the

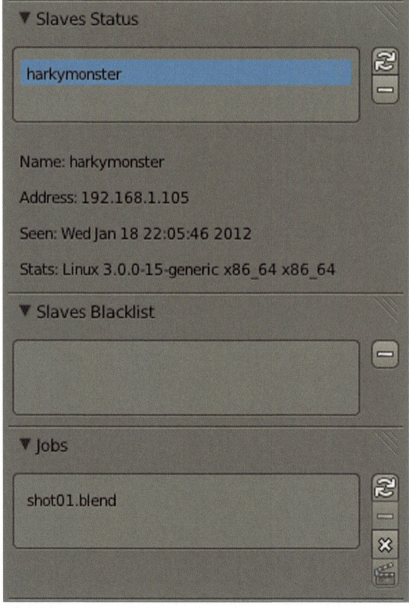

Figure 13.73 *Monitoring the network from within Blender.*

computer such as its IP address, its last check in, and what sort of operating system it is running. The **Jobs** panel provides information about all of the currently queued render jobs. Clicking on individual jobs in the list shows the full length of the animation, how many frames have been rendered, and how many errors there have been. From here, you can also cancel particular jobs by selecting them and pressing the "−" (minus) button to the right of the controls.

At this point, the different slaves on your network are rendering away and delivering the results to the master node. How do you get the frames back to the client? First, you need to select an output format—PNG, OpenEXR, h.264—as though you were about to render locally. When you hit the "movie clacker" control on the **Jobs** panel, all of the currently available frames will be retrieved from the master and saved per the instructions in the standard **Output** panel (Figure 13.74).

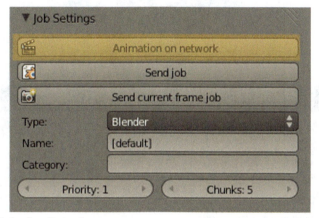

Figure 13.74 *The movie clacker for collecting frames.*

There are some more technical features under the hood, but for most jobs these instructions will get you up and running with the **Network Render** feature. Be sure to check out the **Open Master Monitor**, which opens a web-based interface for monitoring and controlling queued render jobs. The web address that is used points to a little web server running on the master instance of Blender and is accessible to any machine on your local network. This means that once you have submitted your jobs, you can access the interface from any web-enabled local device such as a smartphone or pad computer. If you wanted to, you could even punch a hole in your local firewall to allow remote monitoring and maintenance of your jobs.

Checking the Final Frames

Once each computer in your render farm has delivered at least one frame, you should check a sample from each one to make sure that things are working properly. As you've been eating, drinking, and sleeping Blender for the past many weeks or months, it makes sense to open and check the OpenEXR frames within one of Blender's image editor windows. If you're on Linux, you can try CinePaint as well. The easiest way to do this in Blender is to add the rendered frames to a **Sequencer** window as an image sequence. Then, you can split off a **Sequencer** preview window and scrub over the timeline to view the frames. Figure 13.75 shows the setup. The nice thing about using the Sequencer in this fashion is that you can simply use the **Sequence** button in

Figure 13.75 *The Sequence editor used as a frame viewer.*

the **Post Processing** panel of the **Render** properties, set a frame range and appropriate output format, and export the frames as a full animation with the **Animation** button.

If you are reviewing all of the frames for a particular shot, be sure to check them over carefully. The next time you see them will be during editing when you are concentrating on things like syncing the per-shot sound files to the final edit and creating transitions and cuts. It's better to find a problem, fix it, and send it back for a re-render right away than it is to wait, when you've mentally moved on to other things.

Finally, if you see something bad that appears in just one or two frames like a hair that goes wild or a black or white dot compositing artifact, remember that Blender's image editor is exactly that: an editor. Although the paint tools are limited, as we learned in Chapter 4, they still may be good enough to touch up a few rendering mistakes. Of course, a large number of commercial and Open Source tools are available for image editing as well.

Chapter 14

Final Edit

Objectives in This Chapter

- Tweaking the timing of your shots.
- Using transitions, transformations, title cards, and color plates.
- Applying postprocessing effects offline.

Adjusting Timing

As you have been completing the different stages of the production process and filling out your progress chart, you have hopefully been adding new layers to your master story reel BLEND file: first, the OpenGL animations for each shot, then perhaps the rough or low resolution renders. As I proceeded through production on *Snowmen,* the Sequencer began to look like Figure 14.1. Occasionally, I would reexport an animation file to view the overall state of the project.

As you do this, you may notice some glitches in timing or editing that you had not seen before. It is also possible that some things really won't grab you until you have final renders in place. What kinds of things are we talking about?

Take shot 8 as an example (Figure 14.2). At the end of the shot, the snowman is supposed to look to his left, off screen, and see the other children. As originally staged, he does this. It looked fine in the animatic and even worked with the shot rendered by itself. However, when placed in the timeline with the rest of the shots and title screens, it turned out that the cutaway at the end of the shot was just too fast.

The viewer did not have time to "read" the pose before the animation cut to the next shot. Likewise, it seemed that the pose the kid held before he gets blasted was too short. I needed to extend both. That could mean adding a little more animation, or just spacing some existing work out a bit if it looked okay. It could also mean recalculating some simulations (smoke and particles), which might be tricky.

Before I did all of that though, I wanted to make sure that any changes I might make would actually make the shot work better within the larger context of the entire short. Enter the power of the Sequencer.

Figure 14.3 shows a Sequencer strip created from the image sequence for shot 8. Because it is composed of a fixed number of images, each of which is shown for one frame, it has a finite length (164 frames in this case). If I were to grab the rightmost handle of the strip and drag it to the right, it would simply make the last frame display for the additional length. The purple area in Figure 14.3 shows where the actual frames are located, whereas the white portion on the right of the strip indicates the held area.

Figure 14.1 *The Sequencer, midproduction.*

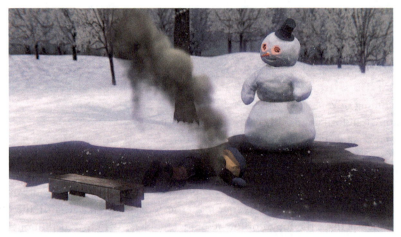

Figure 14.2 *End of shot 8.*

Figure 14.3 *Preparing for speed control.*

If, however, I select that same strip, use **Shift-A**, and add the Speed Control effect strip, the behavior changes. Figure 14.4 shows the original strip with Speed Control added above it. When played back in the Sequencer or rendered, Speed Control forces the image sequence to fit within the entire width of the strip. So the image sequence that originally took up 162 frames now takes up 194 frames.

How does it do this? Not very well, it turns out. Blender just repeats certain frames along the way to fill in the gaps, until the full length of the strip is achieved. In a similar fashion, reducing the width of the strip below the frame count of the original sequence will cause it to drop some of the frames. Although this is not a beautiful solution, it can give you a quick sense of how your animation might work within the larger context if it were to take a longer or shorter period of time.

In shot 8 though, I just wanted to slow down both the beginning and ending of the shot, leaving the rest intact. You can accomplish this through cuts.

Figure 14.4 *The Speed Control effect.*

Figure 14.5 *Before a soft cut.*

Figure 14.6 *After a soft cut.*

Figure 14.7 *The reference to the image sequence remains the same.*

Existing sequence strips can be cut in two ways. The first, called a "soft cut," is achieved by placing the current frame marker where you would like to cut the strip and pressing the K key. It splits any selected strips into sets of two, meeting at the current frame. Figures 14.5 and 14.6 show before-and-after views of the process. If you were to move one of those strips away from the other, you would see that the rest of the image sequence is still "there" and can be exposed by dragging the right or left handles outward (Figure 14.7). The overall reference to the image sequence (i.e., which frames it includes) remains the same. It is the crop of the strip that has changed.

Figure 14.8 *Hard cut and speed controlled.*

The other method is the "hard cut," which is done with **Shift-K.** The hard cut actually changes the references to the image sequence. There will be no expansion indicators on a strip following a hard cut.

So if you had an image sequence strip that consisted of images labeled "image_001.png" through "image_100. png" and cut it with a soft cut at frame 50, you would have two strips, each with the same image range, but different crops. One would show the first half, and the other would show the latter half. However, performing a hard cut would create a strip with images "image_001.png" through "image_049.png" and a corresponding one for the second half.

To selectively speed up or slow down portions of a strip then, you need to hard cut them. Figure 14.8 shows the shot 8 strip. It has been hard cut twice, once before the lasers fire and again after the boy has hit the ground. The two new end strips have been expanded and Speed Control effect strips added to them. Now I can play with the timing of the entire thing by making these two strips longer or shorter until I get it just right.

Of course, a render like this would look bad. The smoke and snowfall would change rates midshot. However, using this as a guide, I now know how many more frames I need at the beginning and the end of the shot in order to make it work.

In shots 3 and 6, I actually extended them slightly using the Speed Control effect. They were expanded in their entirety, so there is no apparent changing of rates within the shot. Should I have gone back and re-rendered them with recalculated particle snow? Probably, but I was out of time and determined that a frame-doubled expansion was better than having the shot be a little too short and fast to read.

Transitions

Blender offers a limited palette of transition effects. Transitions are how you move from one shot (or title card, etc.) to the next. In most cases, there will not even be a transition. One shot will end and the next will begin. This is most often seen when cutting between different camera views of the same piece of action. Of course, just because the Sequencer offers transitions does not mean that you have to use them. In fact, you should go watch a couple of your favorite movies before you head into this territory and note how often the camera simply cuts away without any kind of fade, wipe, or fancy effect. Unless you are watching music video–inspired, experimental, or horror films, the odds are that you will see only two types of transitions: a direct cut and a cross fade. These are the two techniques used in *Snowmen*.

Figure 14.9 shows two image sequence strips, overlapping by 10 frames. During the period of the timeline that they both occupy, we would like the resulting image to fade from the first to the second. This is the cross effect. To add it, select both strips in the order of the cross fade, press **Shift-A,** and choose cross from the **Effect Strips**… menu.

Figure 14.9 *Making a cross fade.*

Figure 14.10 *A color plate and controls.*

Remember that when setting transition effects, the order of selection before the effect is added determines the order of the transition. If you were to select the second strip first, the effect would begin the second strip at "full strength," transition to the first, then appear to cut back to the second after the transition. Transitions are also "live" effects. Once they have been added, you can still adjust the crops and locations of the two transitioning strips, and the transition strip will grow and shrink to accommodate the overlap.

Adding Titles and Color Plates

In *Snowmen,* I used two common Sequencer techniques: title cards and color plates. Both are easily applied.

The title cards used throughout the project are simple PNG files, generated outside of Blender. To use them, they were added to the Sequencer as individual images and adjusted to fill the proper amount of time.

Three color plates were used. Color plates are solid colors that fill the entire workspace. They can be useful for fade-ins and fade-outs, and on a limited basis with the blending strips to influence the color and look of your work. To add a color plate to the Sequencer, use **Shift-A** and choose **Color** from the **Effect Strip** menu. The color strip, shown in Figure 14.10, is resizable like any other strip in the Sequencer. The color itself can be adjusted in the **N-key** properties panel, in the **Effect Strip** section. Incidentally, the color can be keyframed by pressing the **I** key with the mouse over the color selector, as can most of the other properties in the panel.

In several places, *Snowmen* uses cross type transitions of varying lengths to move between two color plates, animation and a color, or a color plate and a title card.

Transforms

You know the "Ken Burns" effect, which has become so iconic that it was appropriated for slideshow viewing software including Apple's own default screensaver. A series of still images are displayed, and the camera appears to slowly pan and gently zoom across them, each image completely filling the display.

A more animation-oriented instance would be if you were using a still plate for a background with a fully rendered foreground and wanted to give it some life. You could subtly move the background image to match any light camera motion. Both of these effects can be accomplished with the **Transform** strip. Figure 14.11 shows a title card (single image) strip, with a **Transform** strip applied to it. The controls for the transformation are on the right, in the **N-key** properties panel.

Like other controls for effects and strips, you animate these properties by keying them directly with the **I** key over the control. So to zoom into a still image using the **Transform** strip, you could set keys on the **X and Y Scale** controls on the first frame of the strip for 1.0 (100%). Then, you could advance the current frame marker to the end of the strip, adjust both of those values to 1.1 (110%), and key them again. This would produce a 10% zoom-in over the course of the image strip. Feedback to the adjustment of these controls happens in real time in most cases, so while you are working directly with the controls, the effects can be judged visually in a preview window.

Figure 14.12 shows what happens if you reduce the strip scale below 1.0 or translate it off of center. Whatever is behind the strip in the Sequencer stack shows through. If there is nothing there like the figure, you get black. For most applications, this is undesirable. Make sure that you have some kind of suitable background there. Often, a matching color plate can be used if you are transforming an image with a solid background. The Sequencer recognizes alpha too, so you can use a foreground plate with alpha for smooth or irregular transitions to the background.

Note that when you set keyframes on strip properties like this, should you move the strip within the timeline, the keys will not move with it. The keys follow the timeline, not the strip, and remain on the original frames where they were set. There is no way in Blender currently to lock the keys relative to the location and length of the strip. If you move a strip on which you have already set keys, be prepared to move those keys as well in either the Graph editor or Dope Sheet.

Figure 14.11 *Using transform on an image strip.*

Blending and Opacity

In addition to transitions and transformations, you can adjust the opacity of strips and set different blending modes. Both actions work best if you have another strip of some kind below it in the stack to blend with.

The **Opacity** control works just like alpha—higher values are more opaque, and lower values are more transparent. At an opacity of 0.0, the strip does not show at all in the final render. Opacity can be keyed, so you could build your own custom fades if your production required it.

The Sequencer also provides not quite a handful of blending modes as well. The compositor and texturing system have many more, but when working in the Sequencer you have access to Replace (the same as "Mix" elsewhere in Blender), Add, Subtract, and Multiply. It's a restricted palette, but in a pinch these might be able to help you out. For example, adding a light color plate of low saturation on top of an animation strip, then setting it to the Multiply type, is a quick-and-dirty way of adding a color cast to the animation. There are much better ways to accomplish something like this, but it gives you an example of the kinds of things you can do.

You can set blending modes in two ways. The first is to select two strips, then add the appropriate blend-type strip to them through the **Effect Strips...** section of the **Shift-A** menu. This produces a third strip that, like transitions, is as wide as the overlap between the two original strips. The second is to simply change the

Figure 14.12 *A pullout and translation.*

original strip's blend mode via the drop-down menu in the **N–key** properties panel. The second solution is simpler and keeps clutter in the Sequencer's workspace down. However, it applies for the entire length of the affected strip, regardless of what is below it. If you need to have a certain blend mode applied selectively, use the strip-based effect.

More Complex Work

Although the Sequencer also includes some effects for putting multiple plates together (Alpha Under and Over), anything more complex than the simplest of goals will be better accomplished in the node editor. Unfortunately, there is no way to, for example, bring in an image sequence as a Sequencer strip, then link it to a particular node setup for additional processing. You will have to do that sort of thing "offline."

In *Snowmen,* I rendered frames to the OpenEXR format but did not include any Z or other layer-based data. I still had some additional processing that I wanted to do, but I wanted to make sure that the effects at that stage were unified across the animation. So before final export, I created a new BLEND file specifically for image processing.

Figure 14.13 shows the node network I used for final processing. Notice that the only input is an image node—not the usual scene/render node. In turn, I opened each set of rendered shot images, tweaked the node parameters to give the desired effect, then rendered them out into a separate directory. These are the "renders" that were imported into the Sequencer for the final export.

To make a system like this work, you need to know two tricks. First, your frames have to be named correctly. This was covered in Chapter 7 but bears repeating. Frames should contain the shot name and end with some kind of nonletter/number breaking character like a period (.) or underscore (_). A name like "shot07_" will work, resulting in frames named "shot07_0789.exr" or something similar. The reason for doing this is that Blender's image reader is picky when it comes to image sequences. As long as there is a separating character

Figure 14.13 *The image-processing network.*

like the underscore, Blender can tell that you are referencing frame 789 from the image sequence. If you omit the underscore, it gets confused (is shot070789 frame number 70789?).

The other trick is a little bit of voodoo with the actual image node, shown in Figure 14.14. The way to properly load an image sequence into the node is to hit the **Open** button and select the first image of the sequence. Note the frame number on the image. Back in the image node, change the **Source** control to **Image Sequence** and enter one less than first frame's number in the **Offset** control (if the first frame is "shot07_0789.exr," set the Offset control to 788). Also, enable the **Auto-Refresh** button so that the images advance when you change the current frame. Finally, set the **Frames** control to some high number; 1,000 will probably do. It indicates the total number of frames in your image sequence. As you'll be controlling what actually gets rendered by the **Start and End Frame** values in the **Render** properties, there is no need to fine-tune this one.

Be sure to place your new set of processed frames into a different directory than your originals, so as not to destroy them. In *Snowmen,* I created an additional directory within each shot's render directory to hold the processed images.

Final Export

Once colors are tweaked, effects have been applied, titles and credits have been put in place, and you are satisfied (or just out of time), choose one of the animation formats, double-check your render settings (start and end frame, fps, directory), and hit the **Animation** button. If all of your source material is the exact size that it should be (720p, for instance, or 1080p) and you haven't used any Sequencer-based transformations, you can disable anti-aliasing to speed things up.

If you plan to distribute your video on the web, pretty much any format will do. The popular video-hosting services (YouTube, Vimeo) have a robust set of converters that will handle just about anything you can throw

Figure 14.14 *Setting up the image node.*

at them. At the time of this writing, there is wide support on many devices for the h.264 format. Don't forget to choose an audio codec on the Encoding panel of the **Render** properties. If you forget, your exported animation will not have sound. Most systems will support sound playback in MP3, MP2, and AC3 formats. If all else fails, PCM will play on anything, although it increases file size.

Wrapping It Up

Watch your animation. Show it to your real-life and Internet friends. Ask them to pass it around if they are so inclined.

Regardless of how it is received, you will have done something that few others have accomplished: completed a full short animation project. It is a daunting task that requires organization and dedication. If you've come this far, send me a note and a link at animation@harkyman.com. I would love to see what you've done.

Index

Note: Page numbers with "f" denote figures; "b" boxes.

Index

W

Wacom, 35
Wireframe model, of character, 5f
Workflow, in production phase of animation, 159

Z

Z Combine node, 262
Z transparency, 167, 204, 262
Zelazny, Roger, 13
ZIP file, structure of, 139f